installationview
Ryan McGinness

ESSAYS BY

JEFFREY DEITCH

AA BRONSON

CARLO McCORMICK

RANDY GLADMAN

RIZZOLI
NEW YORK

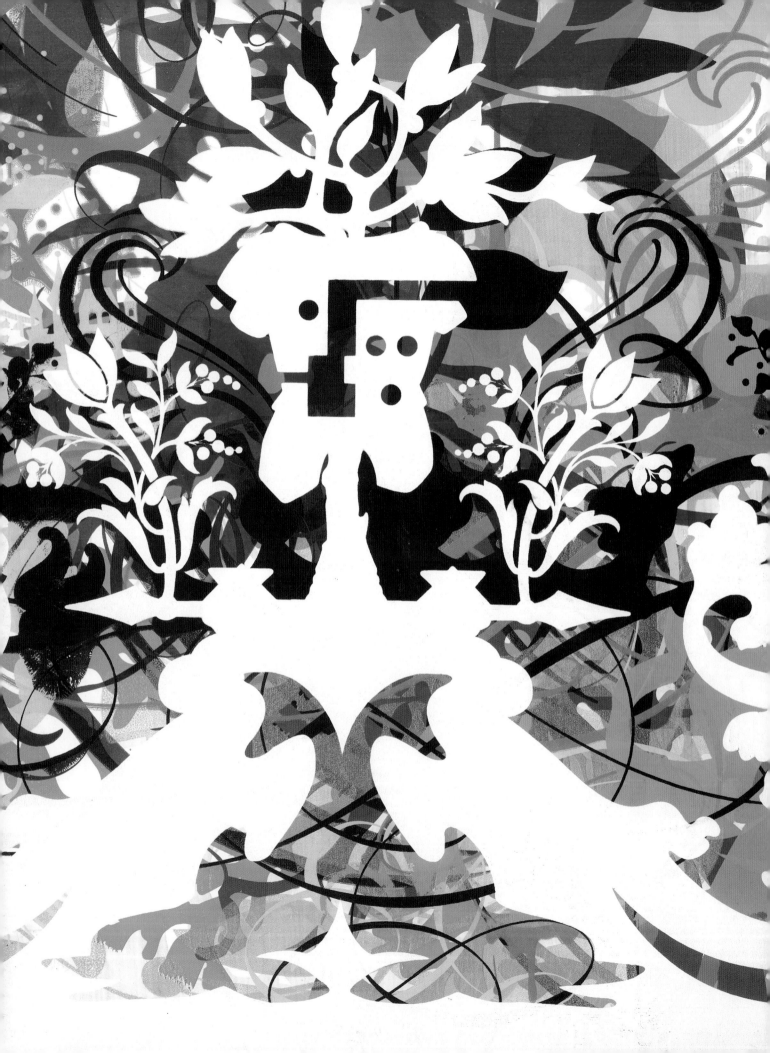

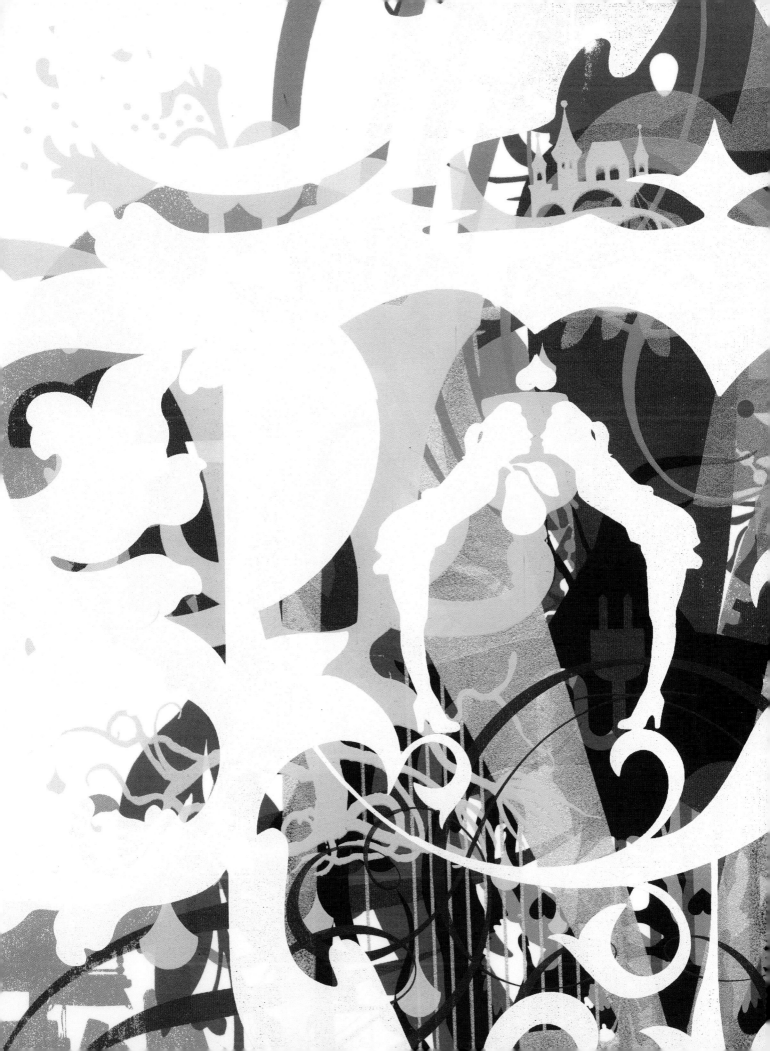

First published in the USA in 2005 by
RIZZOLI INTERNATIONAL PUBLICATIONS, INC.
300 Park Avenue South, New York, NY 10010
rizzoliusa.com

ISBN: 0-8478-2721-6 / Library of Congress Control Number: 2005930313
Printed and bound in China
2005 2006 2007 2008 2009 / 10 9 8 7 6 5 4 3 2 1

PUBLISHER Charles Miers
EDITOR Eva Prinz
PRODUCTION DIRECTOR Anet Sirna-Bruder

Cover:
EXCUSES AND CURSES Detail, 2004,
oil enamel and silkscreen ink on linen, 48 x 36 in.

Back Cover Photograph by James Rexroad / © 2003 James Rexroad
Front Endpaper Photograph by Dirk Westphal / © 2005 Dirk Westphal

Previous Spread, Left:
UNTITLED (PROJECT RAINBOW SERIES) Detail, 2003,
oil enamel and silkscreen ink on wood panel, 12 x 12 in.

Previous Spread, Right:
FABRICATED CULTURAL BELIEF SYSTEMS Detail, 2003-2004,
acrylic on paper, 48 x 27 in. ea., varied ed. of 100

Essays & Interviews

013 *Ryan's Forest of Signs* by Jeffrey Deitch

027 Interview Intersections, 2001-2005

077 *From Low to High and Back Again:*
Zen and the Art of Being in Consumer Culture
by AA Bronson

201 *Hybrid States: The Migration of Content*
and Context in Ryan McGinness' Art
by Carlo McCormick

211 *Art and Entertainment* by Randy Gladman

Beauty comes in many forms

Enjoy the artwork

Love, Ryan McG

EVERYTHING COMES FROM

THE SAME PLACE,

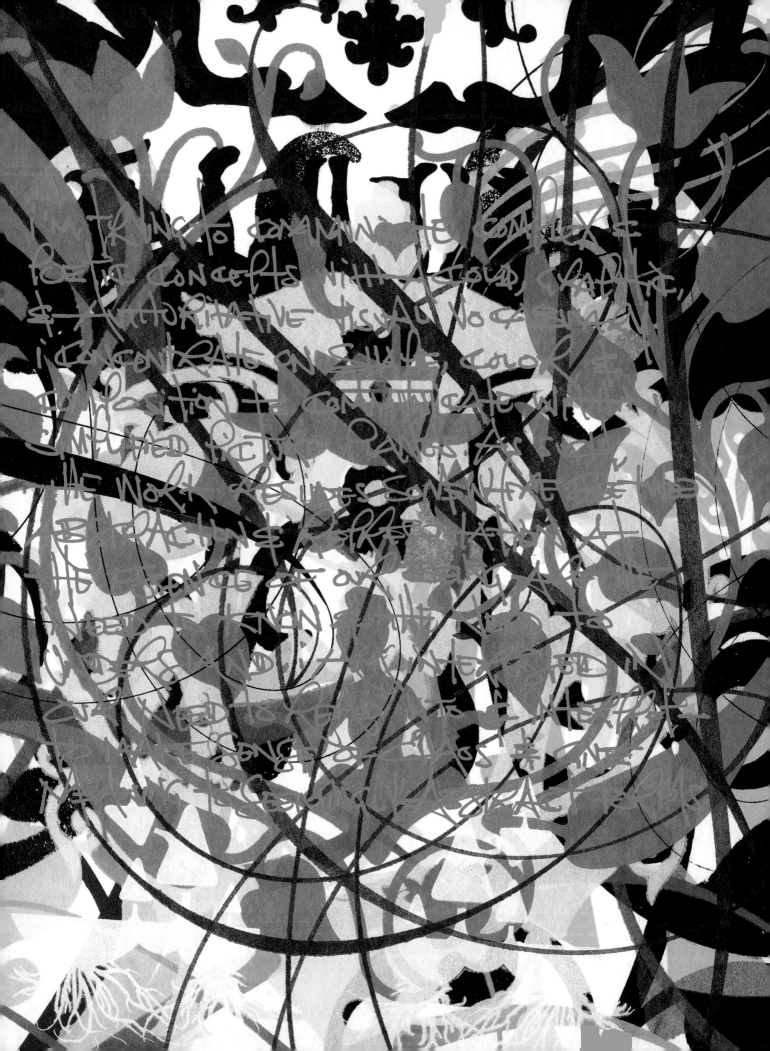

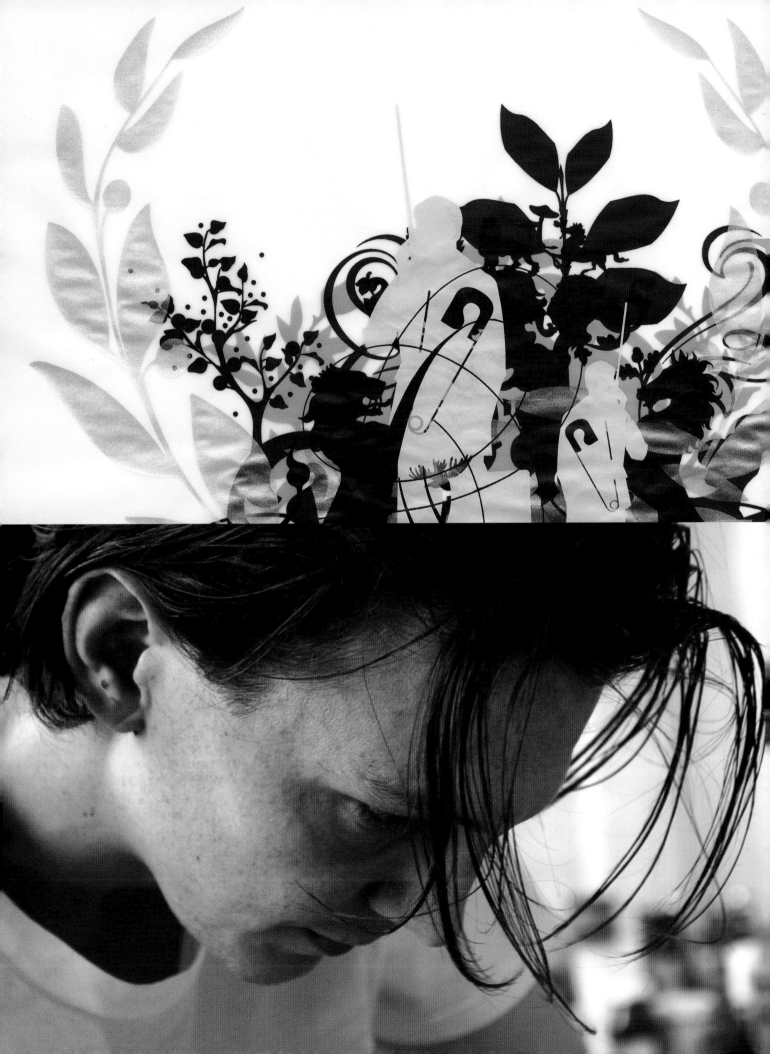

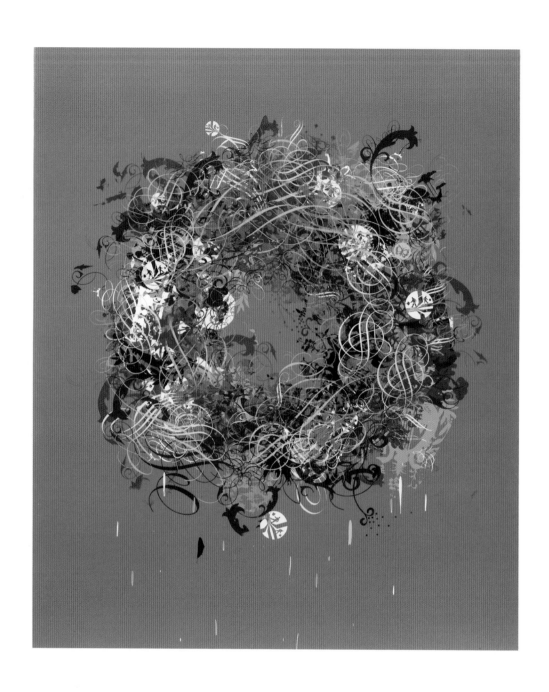

SHOWCASE SHOWDOWN
2004, acrylic on canvas, 72 x 60 in.

Ryan's Forest of Signs

Jeffrey Deitch

An insight in a surf shop in his boyhood home of Virginia Beach gave Ryan McGinness his first appreciation of the power of art. He noticed that T-shirts with logos silkscreened on them sold for more than plain T-shirts. The pursuit of this insight led the teenaged McGinness to an after-school job in the art department of the local Navy base and continues to inspire his unique artistic vision.

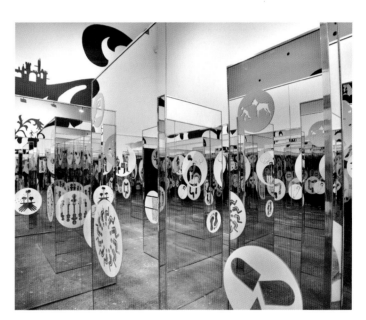

WORLDS WITHIN WORLDS 2003, mirror maze installation (detail), Deitch Projects, New York

I first became aware of Ryan McGinness in the late 1990s when his work as a graphic designer began to be perceived as some of the freshest art in New York. At first, McGinness separated his commercial design work from his "art." Another life-changing insight came in 1998 when McGinness decided to stop trying to make "art" that was separate from his innovative expansion of graphic design, but to just instead make whatever he wanted. The two sides of his creative practice were merged into a completely contemporary approach to art, which continues to generate unexpected innovations.

Some artists achieve artistic ingenuity by doggedly pursuing traditional approaches to painting and sculpture, until only after years of diligence, they are able to deconstruct and reinvent artistic conventions. Other artists arrive at innovation by applying the approaches of related disciplines to fine art practice, arriving at hybrid forms that yield imagery different from anything that has been seen before. Ryan McGinness has created a new, seamless, artistic hybrid that is simultaneously

painting, design, and mass communication. He is one of the rare artists who is pushing the boundaries of the definition of art and the artist.

McGinness expands his artistic output like a benign computer virus. His work takes the form of paintings, wall murals, sculpture, books, and products, but it is all generated from his personal language of visual icons. His concepts begin with hand-drawn sketches, are developed into more finished drawings, and are then digitally scanned. They are cleaned up on the computer screen, stored, and then regenerated as silkscreens, decals, slick metal signage, and projections to be painted onto wall murals. At its foundation, all of McGinness' work exists as digital information.

The work is digital in its conceptual structure and in the way it is generated, but it is not digital in its ultimate form. McGinness processes and recombines his visual icons like a deejay cuts and pastes samples of sound. The end result is not ephemeral artwork that is watched on the computer screen, but complex paintings and signage, built up through successive hand application of silk screens and room-sized walk-in installations built up with vinyl decals and hand-painted elements. Computer technology is fused with traditional approaches to painting.

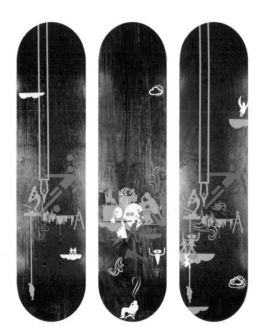

FANCY IS A VERB 2002, vinyl and wood stain on skateboards, 32 x 8 in. ea.

A Forest of Signs, the title of an influential 1989 exhibition at the Museum of Contemporary Art in Los Angeles, came to mind when I viewed McGinness' most recent series of paintings. *A Forest of Signs* was famous for articulating the intersection of art and semiotics in the late 1980s. Rather than just illustrating this relationship like some of the best-known art of an earlier generation, this intersection is at the very core of McGinness' approach – part of its conceptual DNA. He has integrated his vocabulary of visual icons into a painting process that merges Andy Warhol's off-registered silkscreens with Jackson Pollock's webs of poured paint. The result can accurately be described as a "forest of signs," a compelling integration of mass communications and nature. The digital and the natural are fused in an uneasy balance.

McGinness once declared that "products are the new art." His T-shirts, soccer balls, books, skateboards, and sneakers do not simply feature reproductions of his art. For McGinness, they *are* the art. The visions of Andy Warhol's Factory and Keith Haring's Pop Shop have been articulated into a practical philosophy. As Warhol's background as a commercial illustrator extended itself into a new approach to art, McGinness' early career as a designer of corporate logos opened new possibilities for artistic expression. His products are part of his expansive artistic vision, conceived as rigorously as his paintings and flawlessly executed. Rather than diluting his artistic statement as reproductions might do, they serve to build his vision as an artist.

It is a great achievement to produce distinctive paintings and sculpture. It is an exceptional achievement to be able to create an entire aesthetic universe. Ryan McGinness can be described most accurately not as a painter or as a hybrid artist-designer, but as a creator of an integrated artistic vision. From the moment you step into McGinness' studio you are aware of having entered not just an artist's workshop, but a unique artistic world. It is an orderly laboratory designed for the invention, development, and replication of his images.

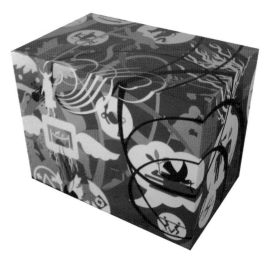

D4D SOAP BOX 2004, vinyl and oil on wood construction, 18 x 18 x 30 in.

McGinness' installations at my gallery have allowed him to share his world with the public. *Dream Garden* (with artist Julia Chiang) was a non-linear, non-narrative surreal environment of wall paintings. The fantastical garden grew from seeded memories of childhood, dreams, and hallucinations. *Worlds within Worlds* featured a walk-in, mirrored labyrinth with his complex decals of mini worlds reproduced infinitely in mirror image. These reproductions of reproductions reflected the concept of McGinness' infinitely reproducible digitally based visual information. Like his mirror maze, McGinness' confounding universe seems infinitely expandable.

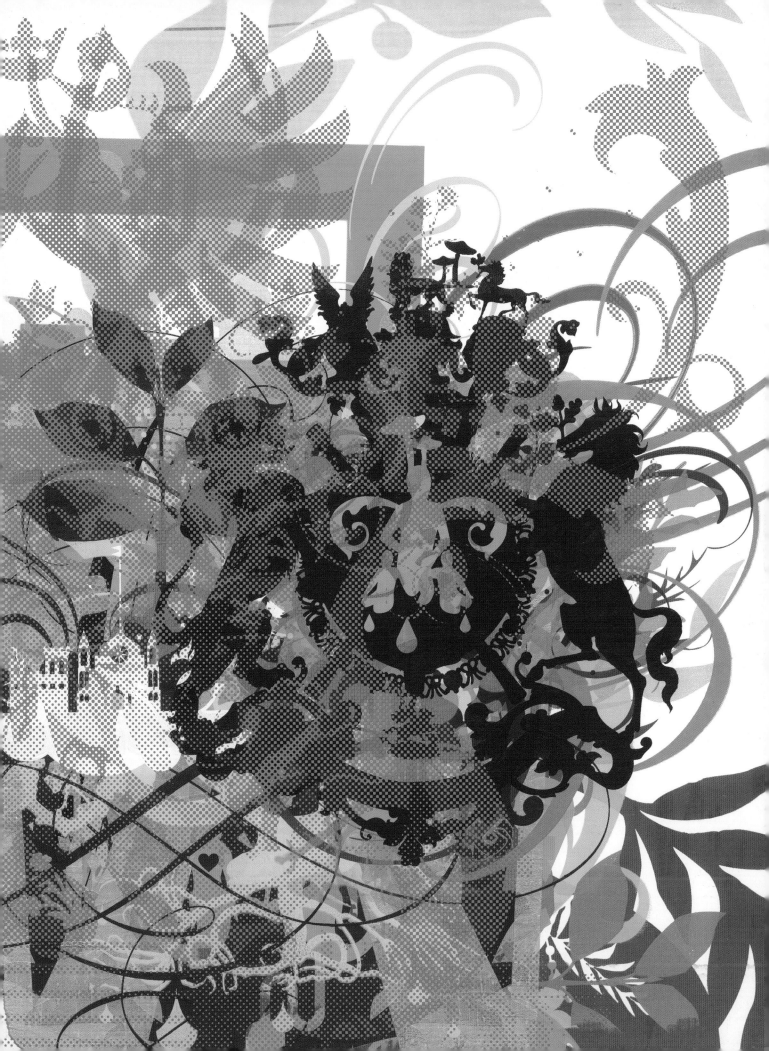

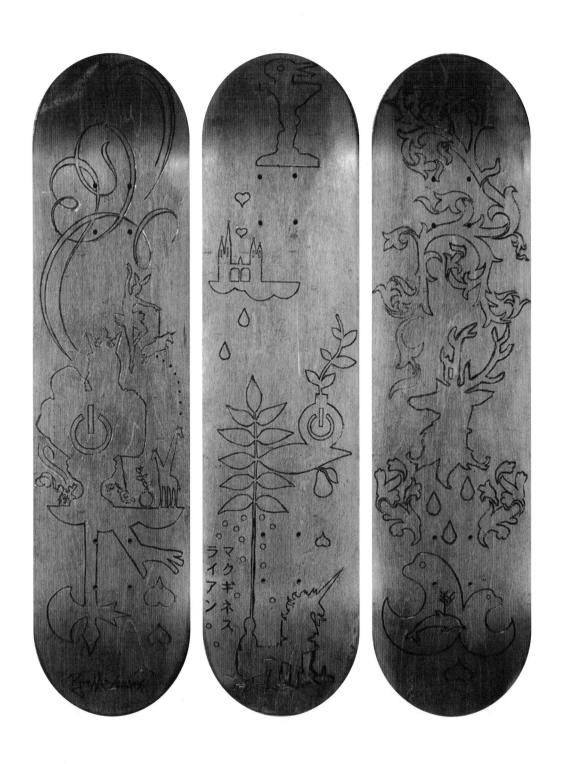

WHEN THE HAND GOES UP, THE MOUTH GOES SHUT
2002, woodburned and stained skateboard decks, 32 x 8 in. ea.

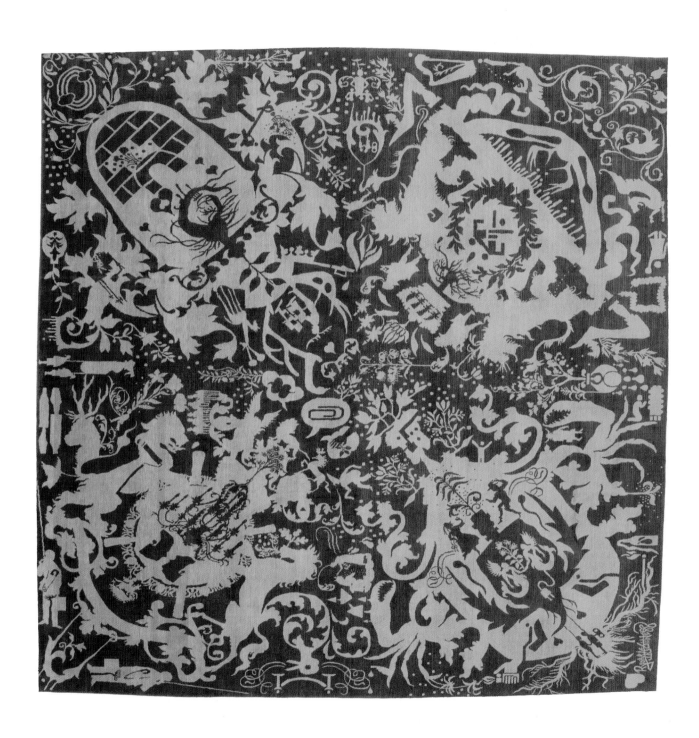

UNTITLED
2004, hand-woven wool rug, 15 x 15 ft., Published by Rugged Art, ed. of 10

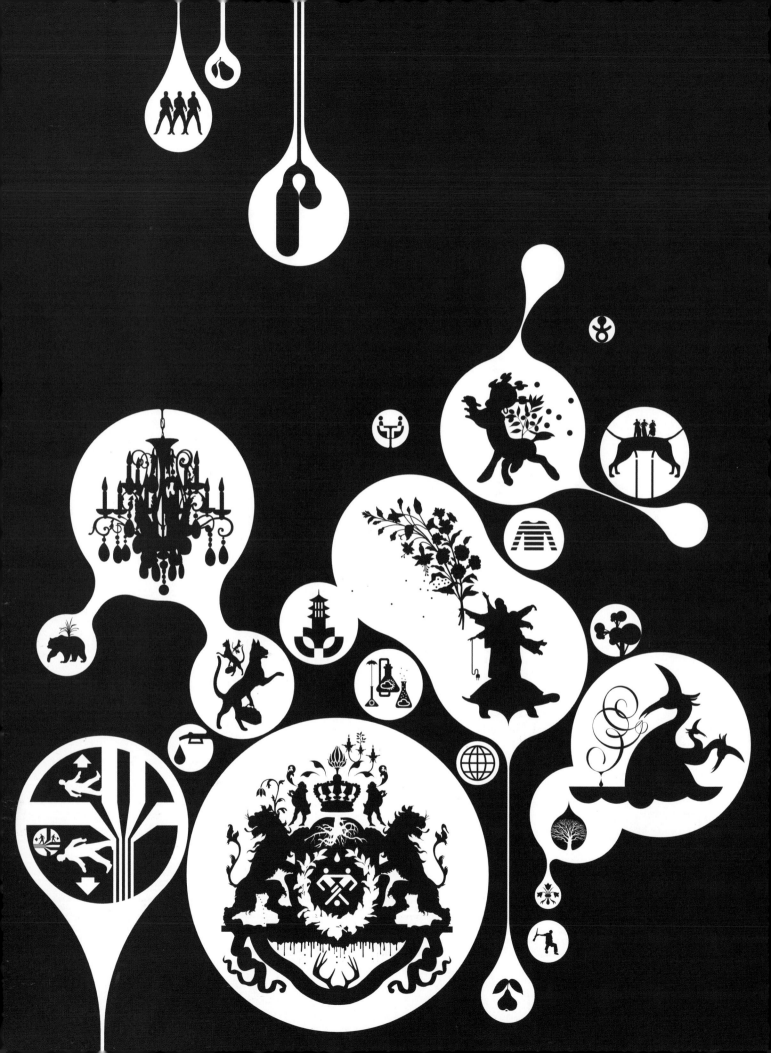

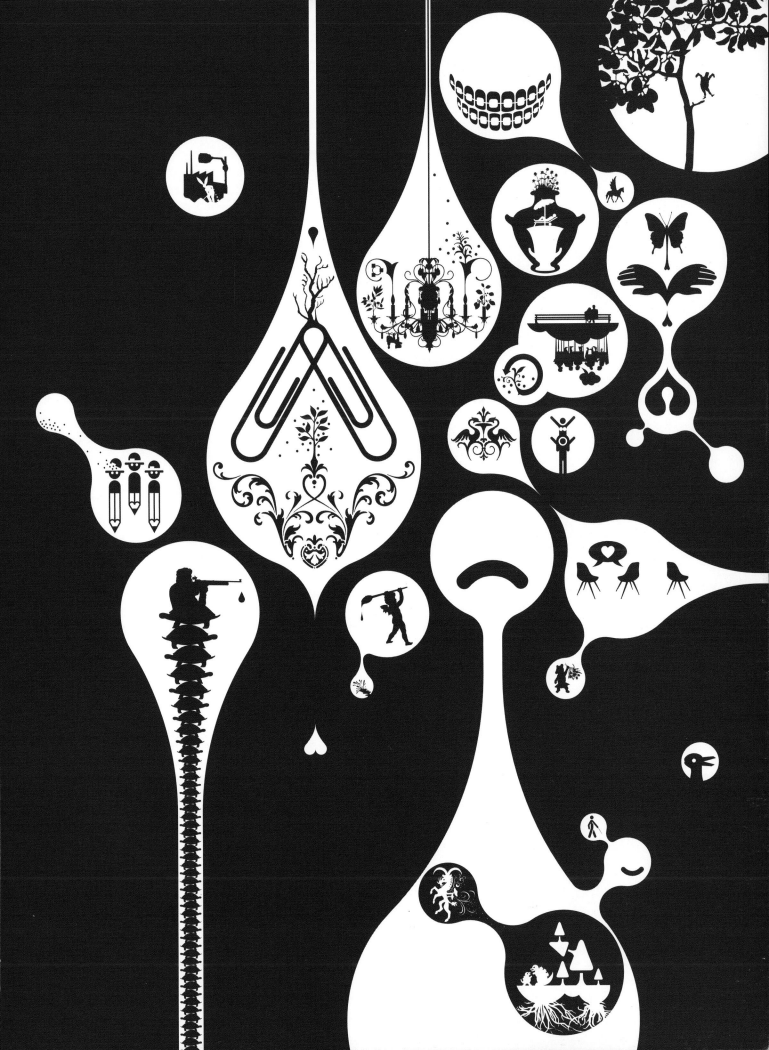

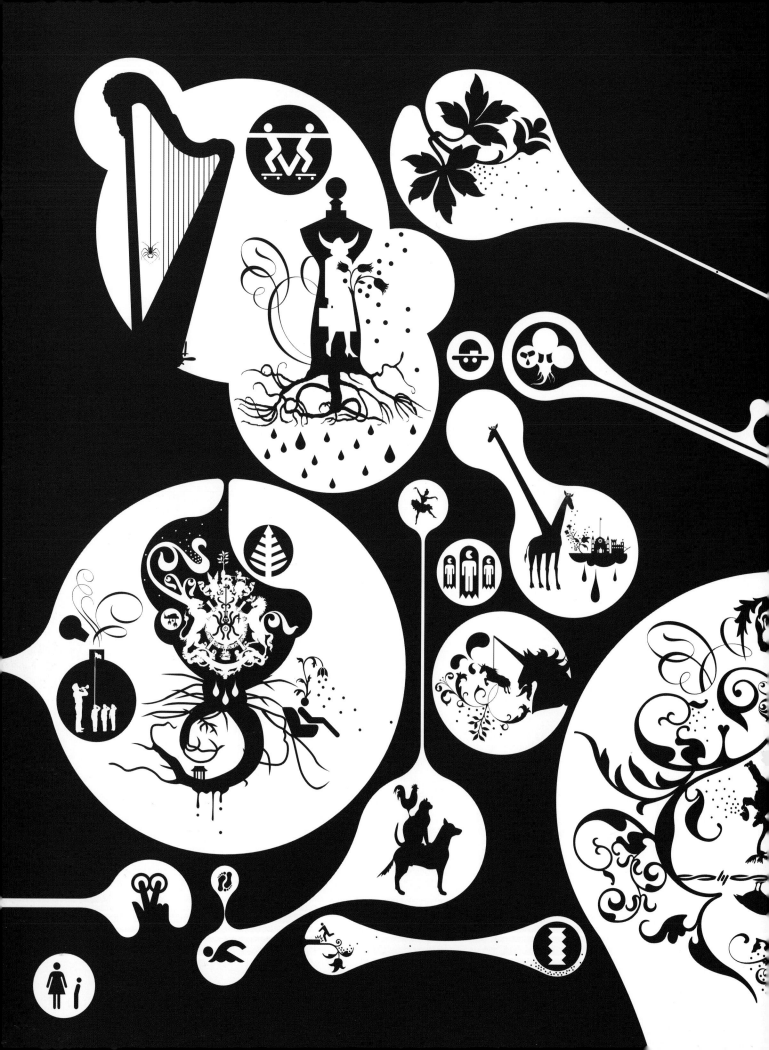

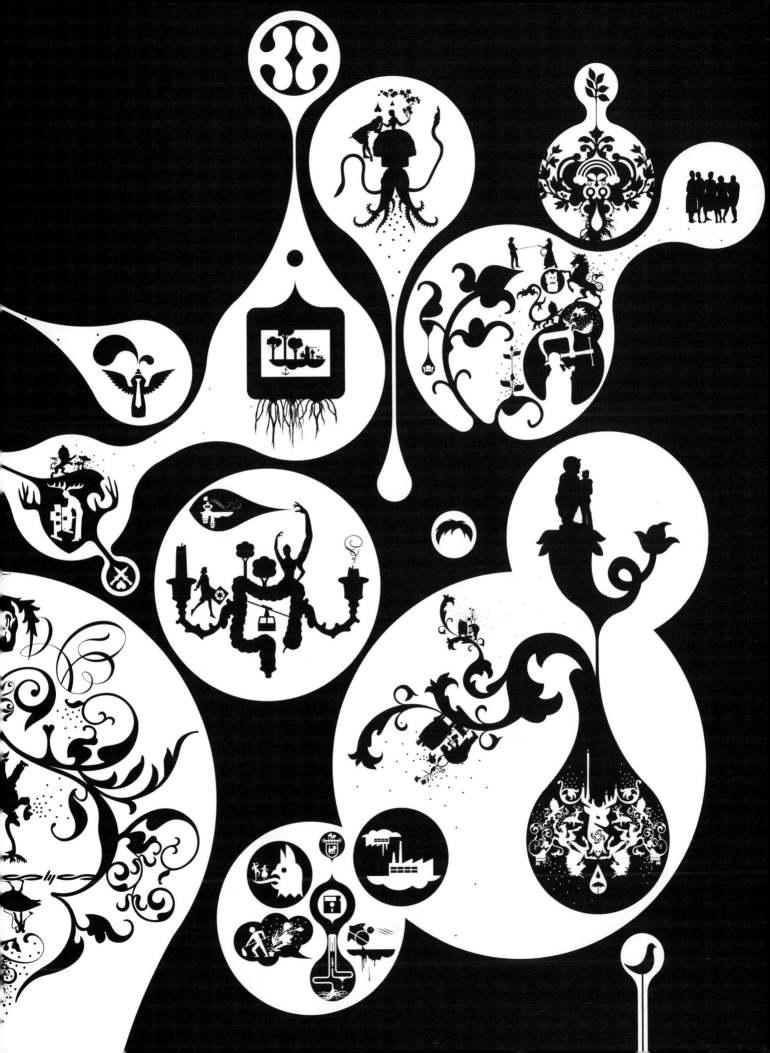

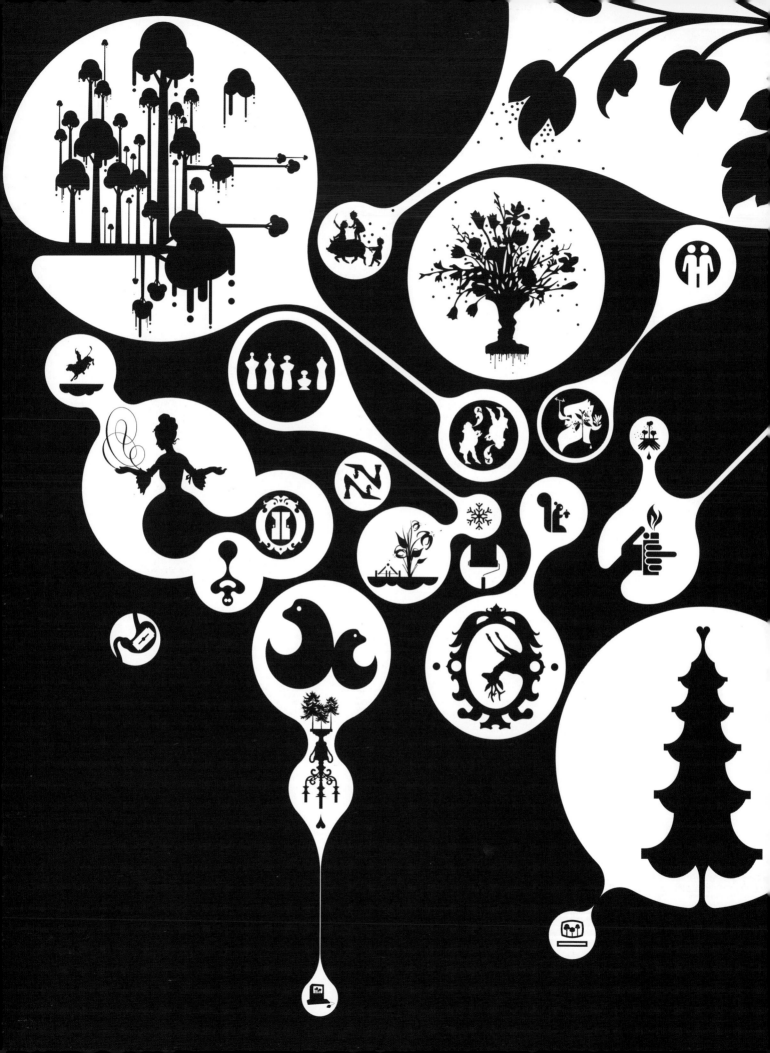

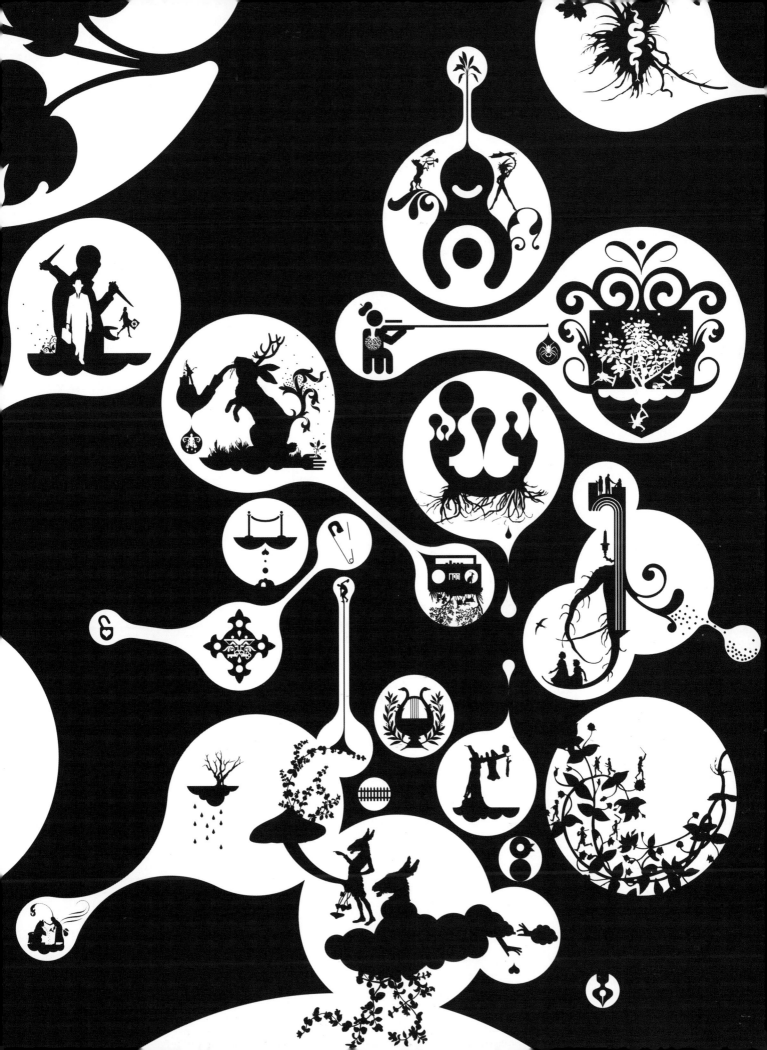

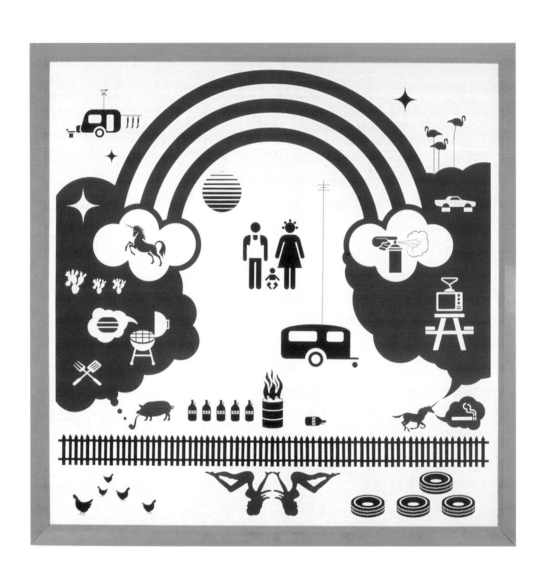

KEEP HONKING ASSHOLE, I'M RELOADING
2001, vinyl on aluminum panel, 36 x 36 in.

Interview Intersections

2001-2005

Giant Robot: When did you start making art? Were you the kid who always drew?
RM: I always made things. There were always arts and crafts materials around the house. In elementary school, I went to an art school for gifted and talented children through the public school system in Virginia Beach. At an early age, my pursuit of art was taken seriously. Our creations were critiqued by our teachers and our peers. So, while this was a great opportunity and experience for me at such an early age, the program also instilled a very serious, almost intimidating attitude toward art. For better or for worse, this is something that has always remained with me. I continued to pursue art in high school, and actually worked for the Navy as an illustrator after school and on weekends. I got to work with Kroy lettering machines, copiers, wax machines, etc., doing paste-up layouts and making drawings. This was before computers, so everything was done by hand. I made posters and menus for the Navy base mess halls and flyers for recreational activities.

BIJUTSU TECHO 2003, No. 829

Educated Community: When did you first know you wanted to be an artist?
RM: I studied graphic design and fine art at Carnegie Mellon University. Most of my studio classes were in graphic design and my fine art courses concentrated on postmodernism, language, and independent studies. I was always pursuing design and art in parallel, and the two just merged for me. Nothing in particular drove me toward being an artist. Making work is not a choice, but rather a default state or way of life. It's not really something I have control over.

Tokion: How did you choose artistically to get to where you are now?
RM: I went through a process of becoming comfortable with who I am and simply recognizing what I like to do. I made a conscious decision to stop trying to make art and to just make the kinds of things I like making and am good at making.

Zink: Why do you embrace flatness in your work?

RM: I am interested in using the inherent properties of two-dimensionality to communicate. Imagery that does not try to deceive or trick the eye has a more honest relationship with the picture plane. This integrity translates to the communicative power of the imagery and increases the speed with which it can be absorbed.

Educated Community: Can you describe your fascination with icons?

ANTHEM MAGAZINE Spring 2003, No. 8

RM: I guess it just has to do with simplifying the world around me to bare essentials. I don't like having extra things around. I try to live as minimally as I can. I think it relates to that in some way; it's an extension of how I organize the world around me—always looking for the essentials.

Art Prostitute: Is the use of flat shapes, iconography, and geometric forms an attempt at a more universal way of communicating with a global audience?

RM: Yes, but this is not my sole reason for concentrating on such forms. I'm simply most proficient at creating this kind of visual language—so much so, that often my drawings are mistaken for having been sourced elsewhere. Flat shapes, iconography, and geometric forms is a very personal aesthetic for me that has been evolving for almost two decades.

Lodown: You often use images from clip-art catalogues and pre-existing logos in your work. In that context, a recent essay in a comprehensive Japanese collection of your work states that "It is evident that appropriation and sampling are the foundation of his art." Do you agree with that? Please explain.

RM: I actually wouldn't use the word, "appropriation" as that connotes an illegal use of protected imagery. I'm certainly not opposed to that strategy, but I've been more interested in public domain images. When I first started making this stuff called "art," I was interested in taking images from that clip-art world which usually show up in newsletters and sales flyers, and recontextualizing them into an "art" environment. I have a strong connection to these clip-art compendiums since my days in high school working at a Navy base creating flyers and posters. I was fascinated with these image books with topics like "Birthdays" and "Holidays" or "Work."

Recombining them and bringing them into my work was a way to personalize these über-theme drawings that were created anonymously. And that's another reason why I was so fascinated with them—they were credited to companies and not individuals. Personalizing them, assuming accountability, and putting a human behind this work felt empowering. Eventually, my interest in the formal aspect of these images shifted from line to shape. For the past few years I've been concentrating on shapes. Yes, I'll take apart corporate logos and recombine the shapes to suit my needs, but this is really out of necessity, and not part of some faux-po-mo agenda. So, while I would agree with the sampling claim, I'm afraid appropriation is passé. We've arrived at a point in culture where this kind of shape-shifting plastic imagery is par for the course.

GIANT ROBOT Spring 2005, Issue 36

Anthem Magazine: Does the computer have the capability to kill what is historically defined as art?
RM: No more than any other tool has killed art.

Zink: Your work uses screen printing in a painterly way, building up stylized marks and symbols creating fantastical mindscapes. How do you see the process of painting in relation to your approach to layering silkscreens?
RM: I paint with icons. My brush is a squeegee, and my stroke is a pull. In doing so, my work exists somewhere between mechanical reproduction and a more human approach where intuition plays an important role. I am the machine using the silkscreen process to make marks on the picture plane, and I respond to those marks by making more marks. I've made a conscious decision to share the process of that mark-making by showing the smudges and imperfections.

Vanidad: Besides these schematic figures you also use very baroque organic forms. Why this recovery of historical forms?
RM: Over the past few years, my paintings have been growing in a very organic fashion that I have not been able to control. I have a lot of plants and roots in water in my studio, so I assume this has had some affect. Furthermore, I am very interested in baroque forms that have come to signify wealth and importance. Many of these forms are derived from nature, and I find that curious.

Giant Robot: Do you want to move toward telling a cohesive story?

RM: No, not at all. I'm not interested in creating a narrative; I'm primarily interested in nonlinear interpretations and nonlinear patterns of thought. I often use the analogy of written language when describing my work: I create iconic drawings that can represent a singular idea like a word does; those words can then be strung together to form a sentence; those sentences turn into paragraphs, and so on. However, I will often break apart the initial words into syllables and combine them with other syllables to make nonsensical words or even break apart sentences and juxtapose them with other sentences—not unlike a Tristan Tzara or William Burroughs cut-up. Because my drawings exist as digital information, I am able to do this quite fluidly.

STRENGTH January/February 2002

Anthem Magazine: It appears that you espouse subjectivity with your audience's interpretation of your art. Is that something you work toward when you're creating a piece?

RM: Yes, although I'm not so calculated in the approach. One cannot control the design of a Rorschach ink blot. One allows for it to be created. And of course, one cannot control or fabricate the interpretation of the ink blot. In many ways, as goofy as this may seem, I allow a lot of my work to simply flow out of me without trying to control it. In this way I hope to tap into some collective unconscious themes that can be universally understood.

Zink: Are the compositions preconceived or process-oriented?

RM: I start out with sketches of compositions and work toward those. However, the paintings always take on a life of their own, and the compositions always grow in their own ways. My role then is to simply guide the compositions and prune them while being respectful of where they want to grow.

Educated Community: In producing your art, what kinds of things do you find yourself struggling with?

RM: I have to constantly remind myself to create the work that I like to make, that I'm good at making, and that makes me unique. I have to constantly struggle against falling into any preconceived ideas about what a fine art aesthetic is, and struggle against making stuff that I think looks like art. Instead, I struggle to make things that are honest. I'm always trying to pull myself back to me. This has not

only to do with my visual language, but also with the forms of the work. I don't want to be shy about my desire to make a range of objects—from paintings and installations to skateboards and T-shirts.

Anthem Magazine: There are many artists from numerous backgrounds whose philosophy support art and design as a communication tool that has the capability to change the way people think. Yet, mass culture seems so entrenched in ideology. In your opinion, does art have the power to change the way people think on a grand scale?

RM: Yes, and I think you've hit upon an important and timely issue with the words, "art," "design," and "communication." Herein lies the crucial difference between art and design. By "design" I don't mean advertising or any client-driven message interpretation. I mean pure and formal manipulation of shape, line, color, composition, and form with visual communication as the goal. This is my only interest in design, and these are issues most noticeably absent from most art programs in schools. Art students are rarely taught how to communicate visually, as ironic as that may seem. Furthermore, the separation of the author from the form-giver is of no interest to me, and designers assuming the role of the author is absent from most academic design programs. I believe that most art fails to communicate. Most art is not intended for a popular audience. I want to create work which exists on all ends of the culture scale. I believe that a lot of art is boring and inaccessible, and that a lot of pop culture stuff is just plain dumb and insulting. I am trying to bridge that gap.

QUEST MAGAZINE July 2004

Art Prostitute: Where do consumer goods fit into what you produce?
RM: I've always produced works that exist throughout the price-point range. I've been making skateboards, T-shirts, books, videos, stickers, etc., while producing paintings, prints, and installations. Exercising artistic expression through this range of output is a model of production that a lot of younger artists are embracing. What I want to be most careful about is inflating or fabricating value. The value of an object is directly proportional to its inherent properties, such as material integrity and object scarcity. Market demand and perceived value, of course, are factors that are more variable and subject to context and environment. Additionally, an object that is made as a direct result of the existence of an indi-

vidual human at any given space and time (on one end of the spectrum) is certainly valued differently than a mass-produced object that has been made by a corporation throughout a broader space and time (on the other end of the spectrum). This brings us to the prophetical Duchampian idea of the point-and-sign artist with the ready-made. While choice and context may define art and reduce it to mere style in a consumer culture, the human element still plays an important role as the artist's signature and title fulfill the final requirements for art (according to Duchamp). Exploiting different methods of fabrication while taking advantage of distribution channels (especially made possible within the last ten years by the internet) has allowed artists like myself to share work with a broader audience than was once possible. The Warholian strategy of incorporating methods of mass production into art is now being flipped: artists are incorporating art into methods of mass-production. The difference is subtle but important, and the strategy provides a way of actually injecting mainstream culture with content that is hopefully more thoughtful than what would otherwise be available.

FLAUNT MAGAZINE 2003, No. 44

Giant Robot: You make a lot of products. How do you choose?

RM: I just make things that make sense for me to make. I used to paint my own skateboards growing up, so it would make sense that I make skateboards now. Same with T-shirts: growing up, my friends and I would always design our own shirts with paint, silkscreening, or bleach and dyes. I play soccer, and I needed a new soccer ball, so I made one. I enjoy making things that I need or really like—things that are natural extensions of what I do or who I am. Even on a simple daily level: I drink coffee, and it's usually out of a mug, so I made mugs.

Art Prostitute: Besides the overall strangeness of it, how do you feel about your work being so widely imitated?

RM: Children learn through imitation, and I accept the role of being a teacher.

joie de vivre

my ball
Let's play bowling

READ MANY BOOKS!

The dishes today are a big hit after a long interval.

Just for you
MECHA #01

Hello!
Sun Flower

Our life has become rhythmical.

Hello!!

One day I wish to have this kind of time.

les dons de la nature

Hungry makes my stomach churn.

focus your camera on her

Hi!

relax

COFFEE WITH ME?

Because I want see your face with a smile!

I'm Ghost

His Dreams come true
EAT INTERNATIONAL

over the rainbow

Hello!!

STIMULI (stickers found in Tokyo)

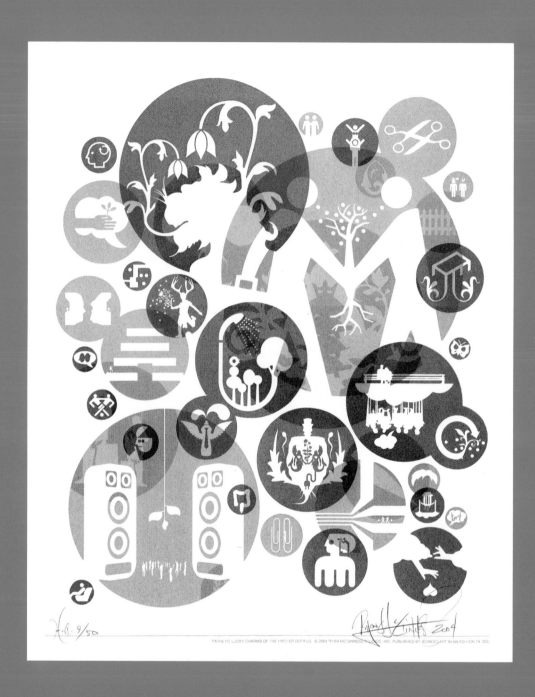

PATHETIC LUCKY CHARMS OF THE HIPSTER DOOFUS
2004, silkscreen ink on paper, published by Iconoclast, 20 x 16 in., ed. of 200
(H.C. ed. of 50)

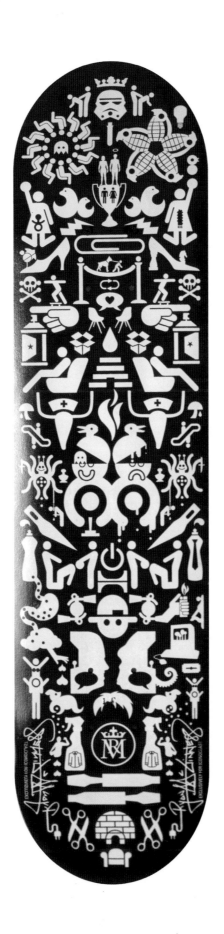

HOPELESS GIFTS TO OFFICIAL CULTURE
2003, silkscreen ink on skateboard, published by Iconoclast, 32 x 8 in., ed. of 100

STIMULI (various plants, signage, and icons from around the world)

STIMULI (various plants, signage, and icons from around the world)

STIMULI (various plants, signage, and icons from around the world)

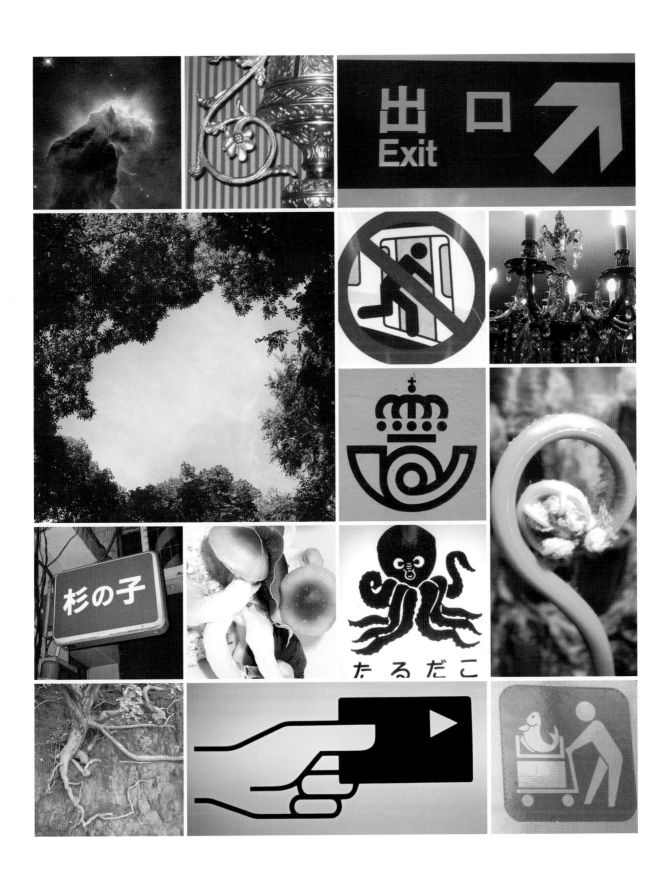

STIMULI (various plants, signage, and icons from around the world)

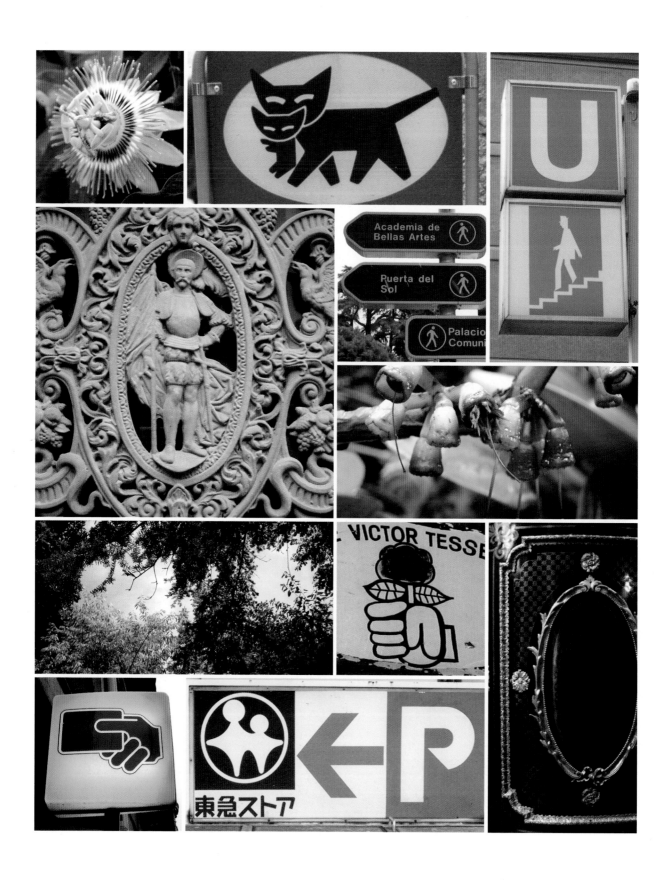

STIMULI (various plants, signage, and icons from around the world)

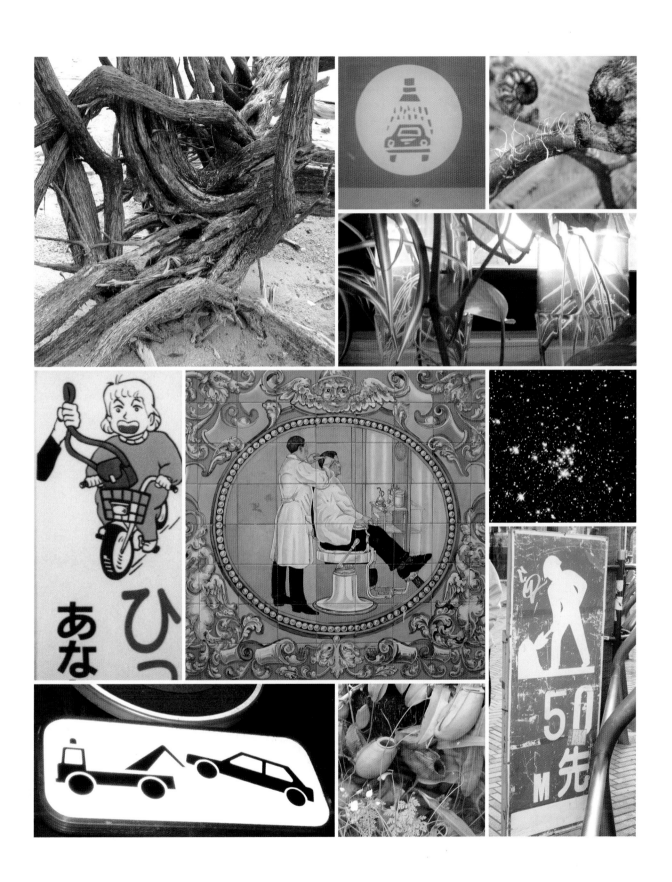

STIMULI (various plants, signage, and icons from around the world)

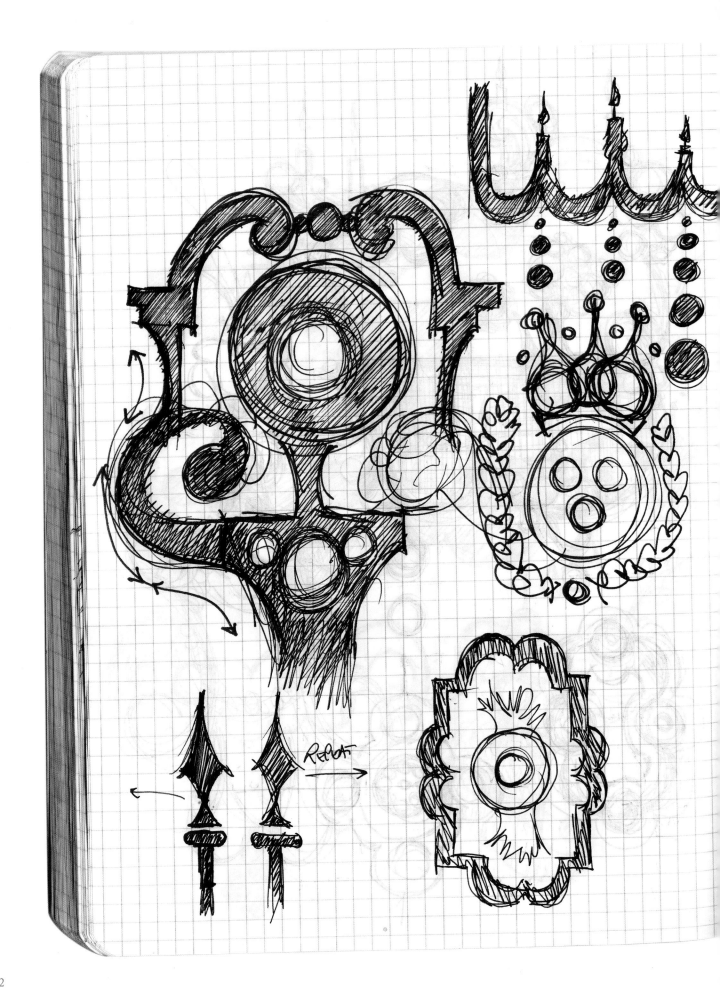

REPEAT

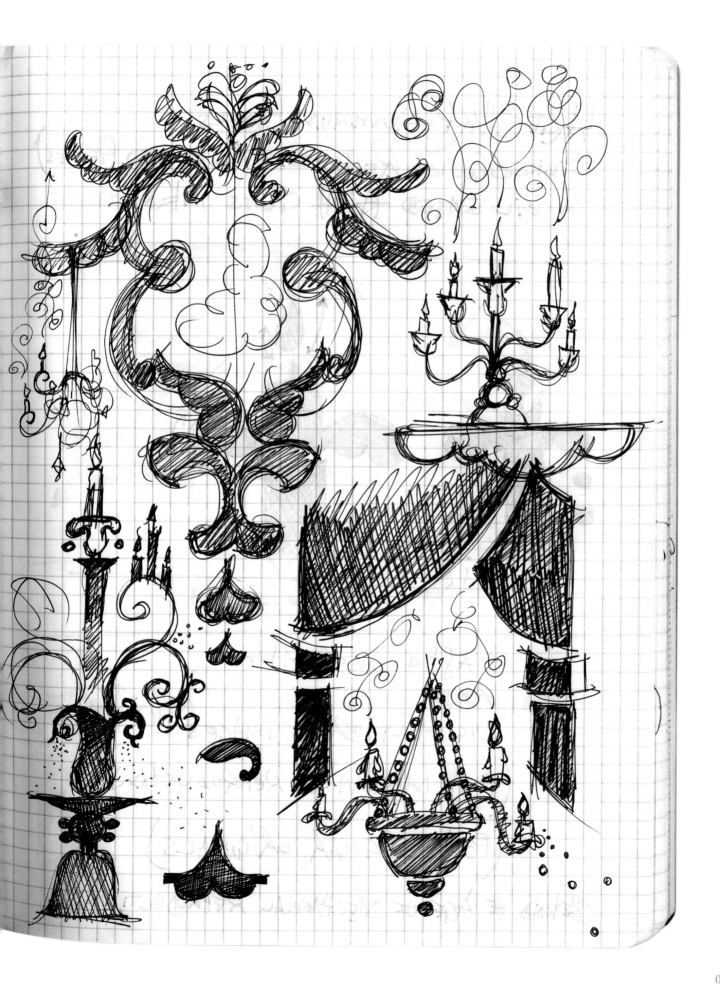

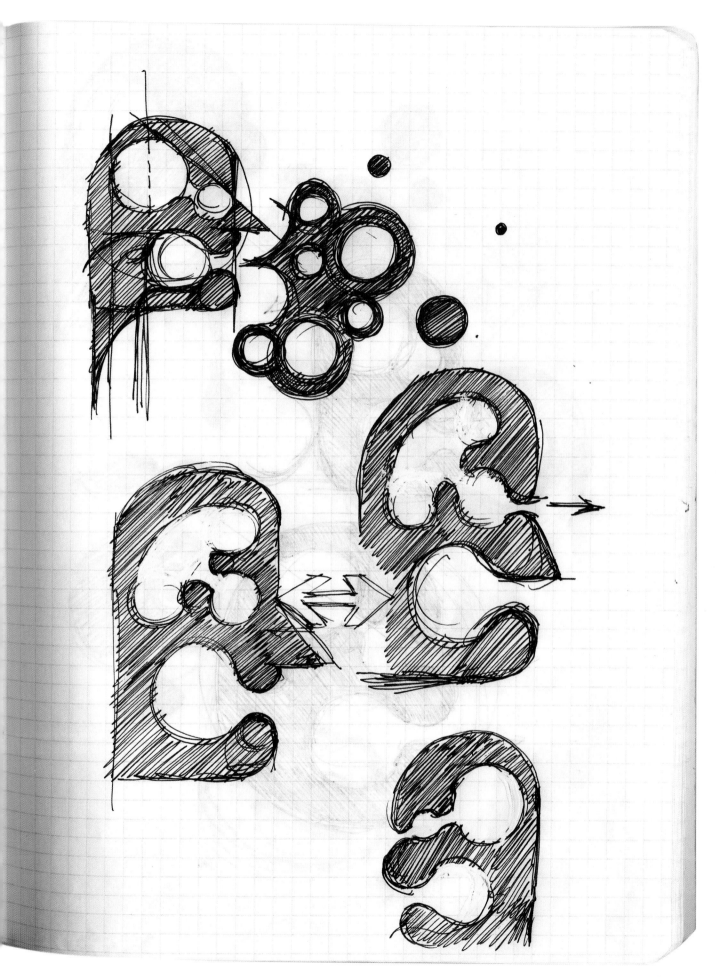

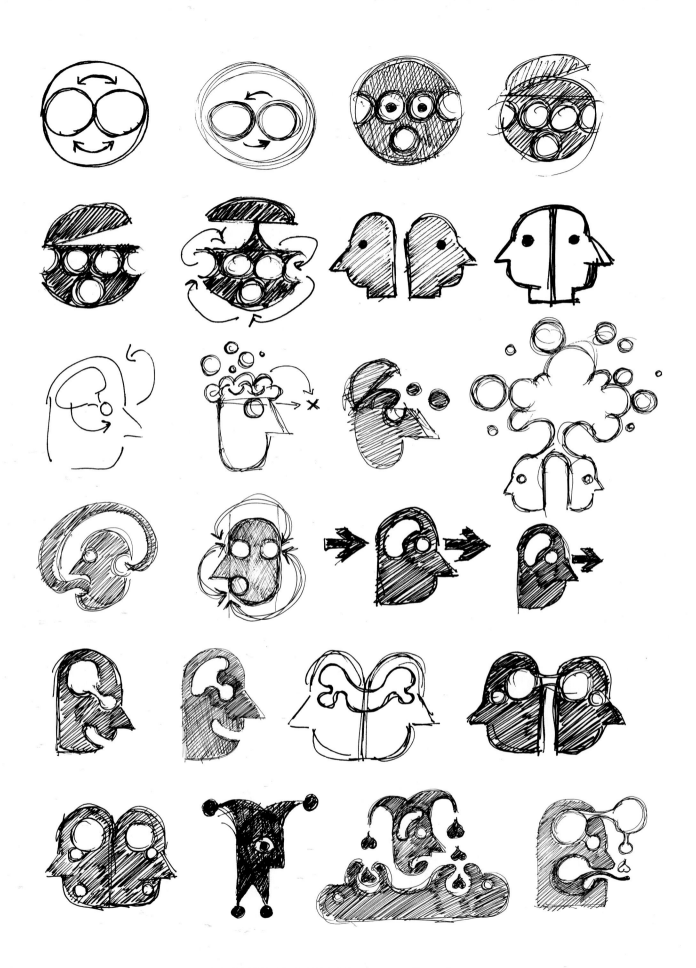

DRAWING PROCESS 2003-2005, ink on paper, dimensions vary

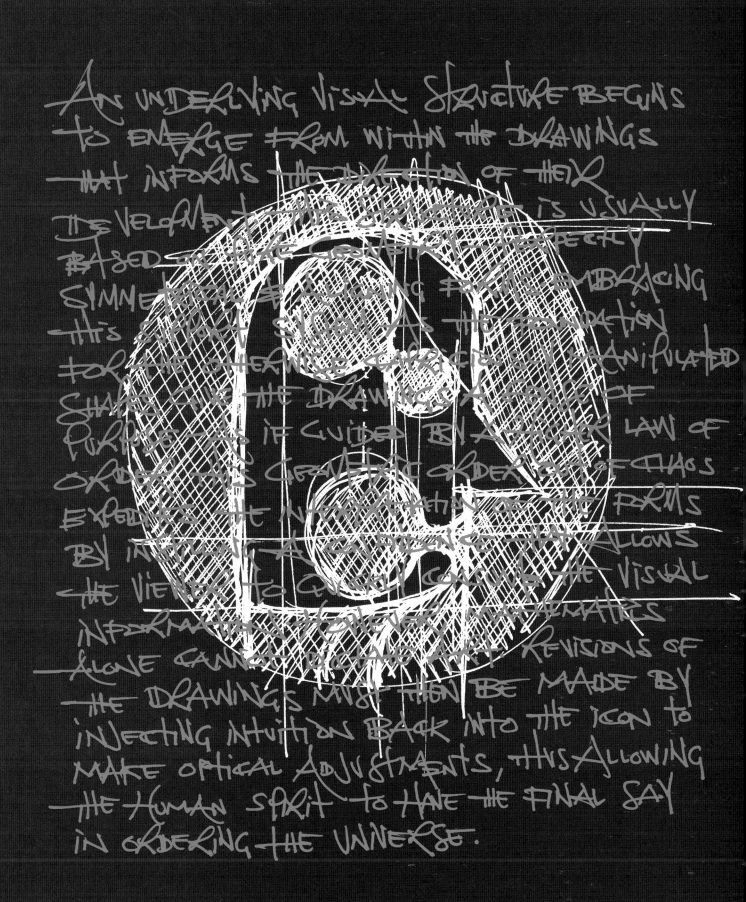

An underlying visual structure begins to emerge from within the drawings that informs the direction of their development... the underlying structure is usually based... the geometric... perfectly symmetrical... embracing this... as the foundation for the otherwise... manipulated shapes... the drawing... purpose... if guided by a higher law of order... the geometric order out of chaos expedites the interpretation of the forms by injecting... a presence that allows the viewer to quickly consume the visual information... digital... mathematics alone cannot produce... revisions of the drawings must then be made by injecting intuition back into the icon to make optical adjustments, thus allowing the human spirit to have the final say in ordering the universe.

DRAWING PROCESS & NOTES 2004–2005, ink on paper, dimensions vary

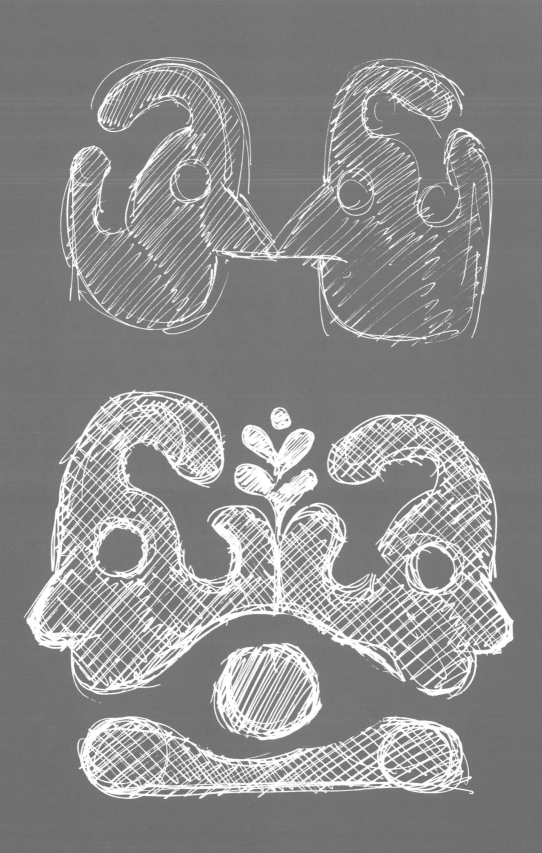

DRAWING PROCESS 2005, ink on paper, dimensions vary

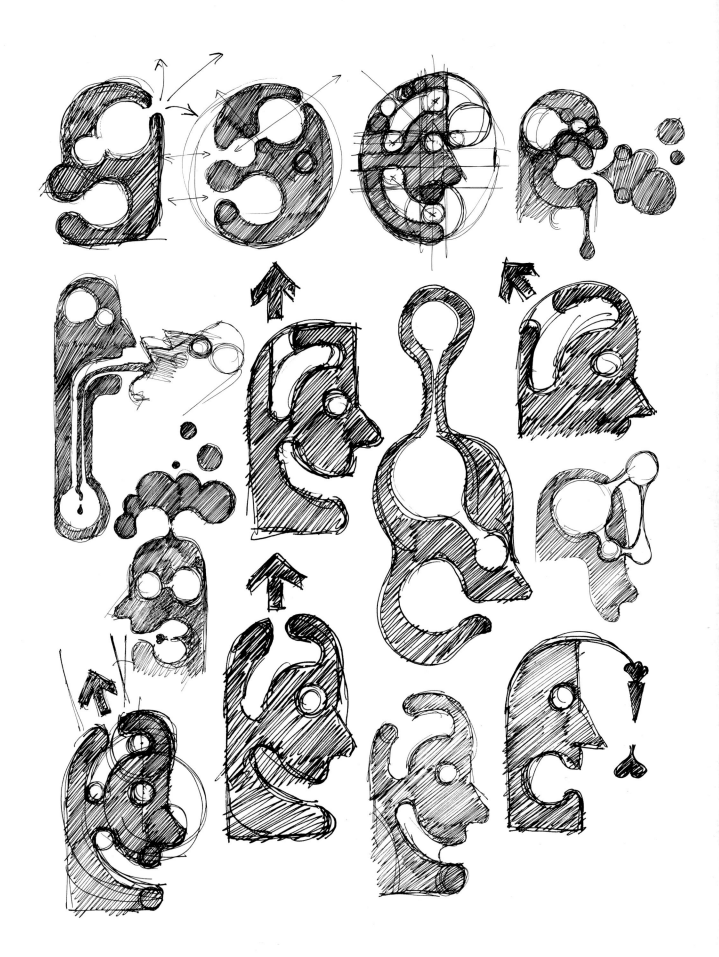

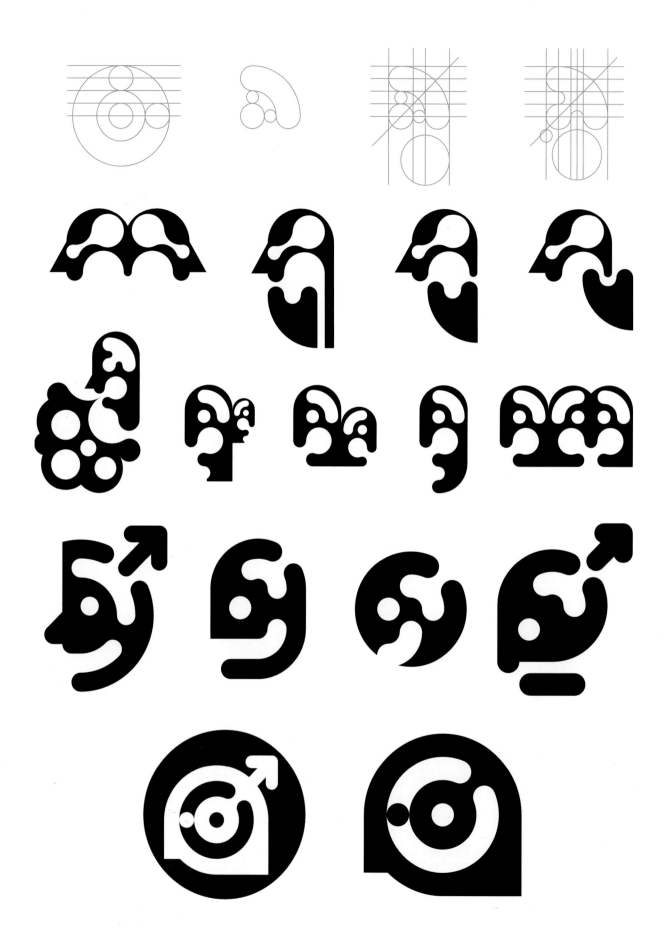

DRAWING PROCESS 2005, vector drawings, digital files

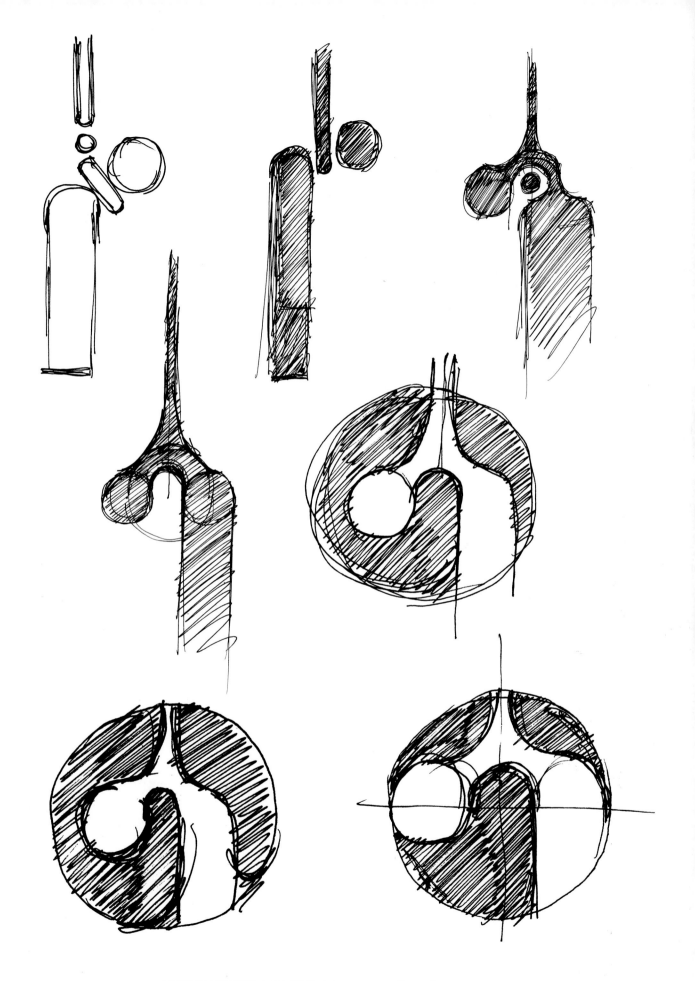

DRAWING PROCESS 2004-2005, ink on paper, dimensions vary

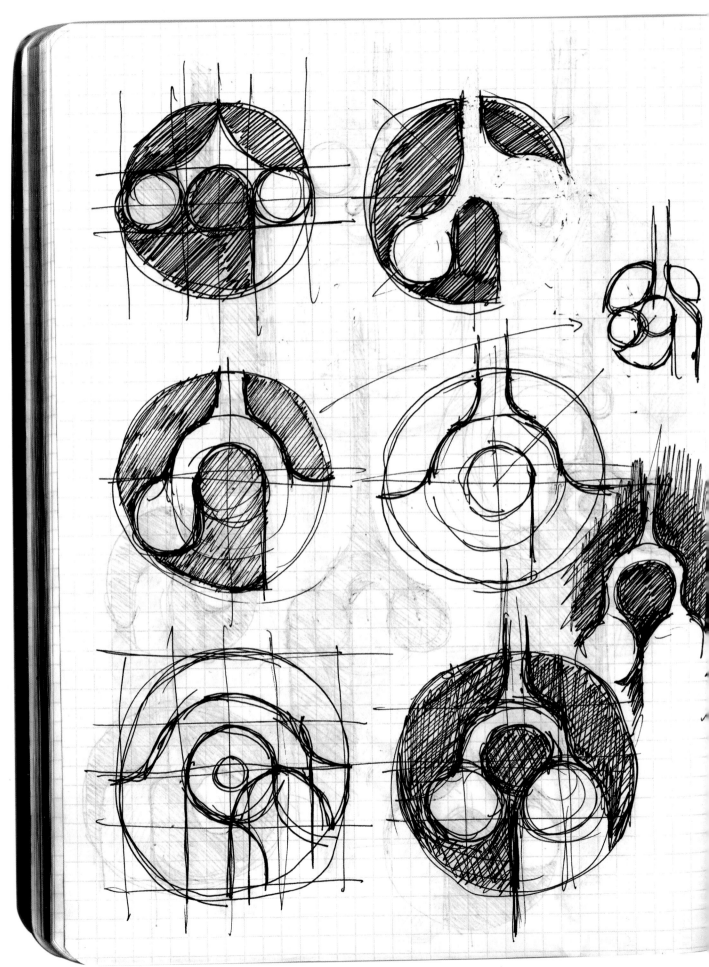

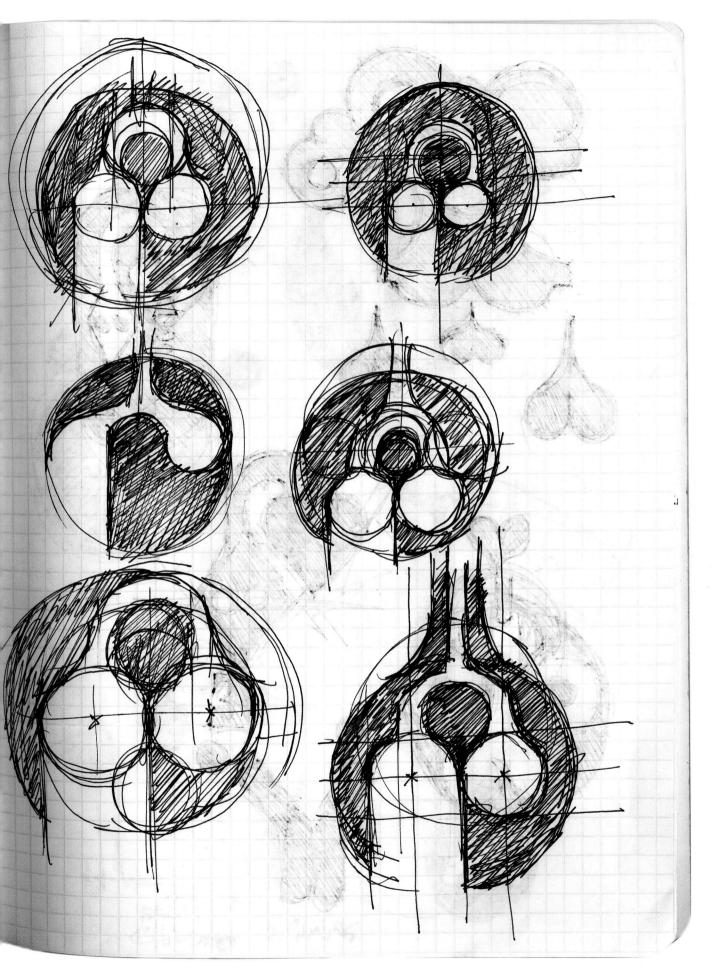

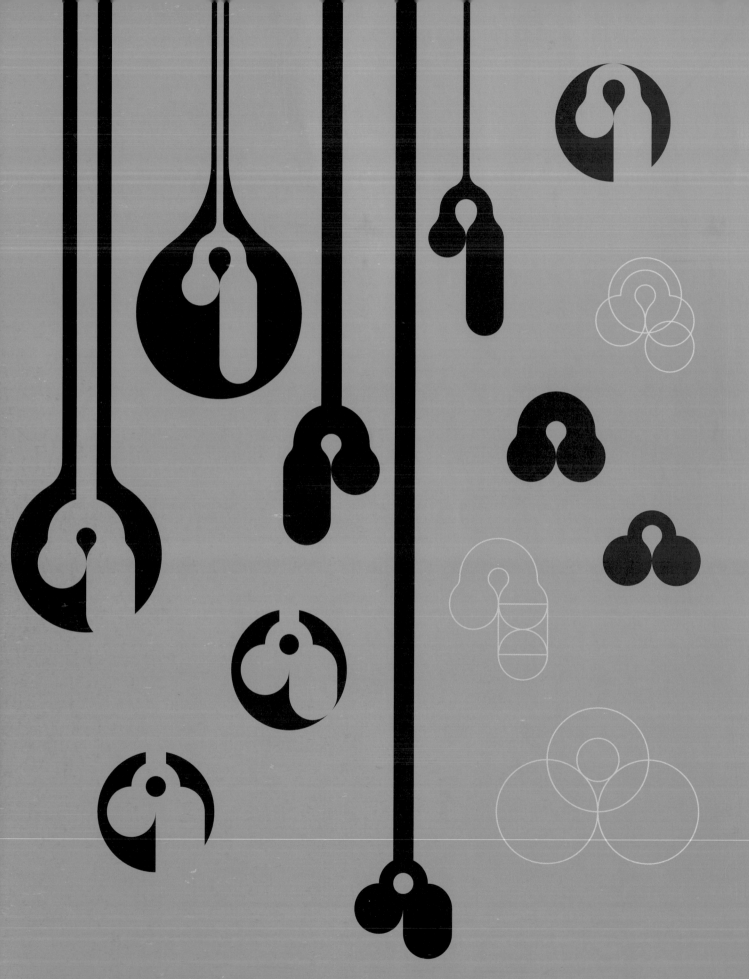

DRAWING PROCESS 2005, vector drawings, digital files

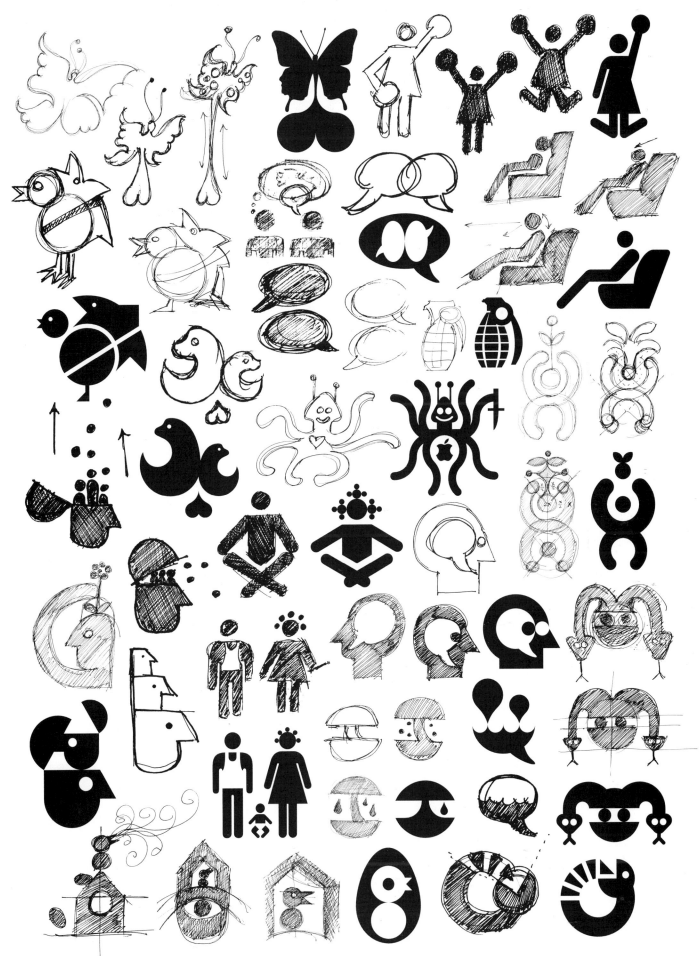

DRAWING PROCESS 1999-2005, ink on paper and vector drawings, dimensions vary

DRAWING PROCESS 2003-2005, ink on paper, dimensions vary
Opposite: **DRAWING PROCESS** 2005, vector drawings, digital file

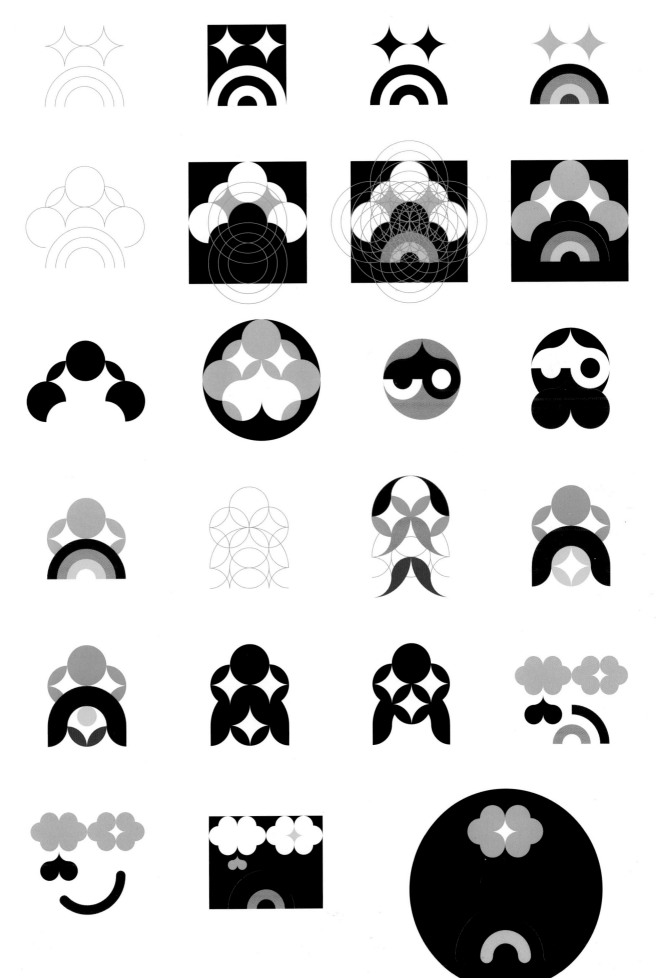

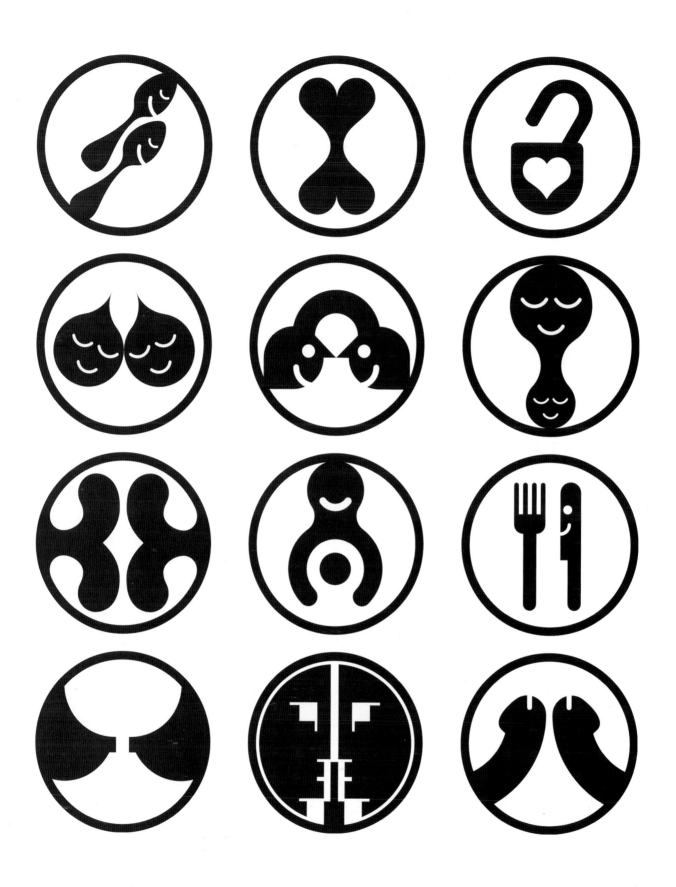

LOVE
2004, vector drawings, digital files

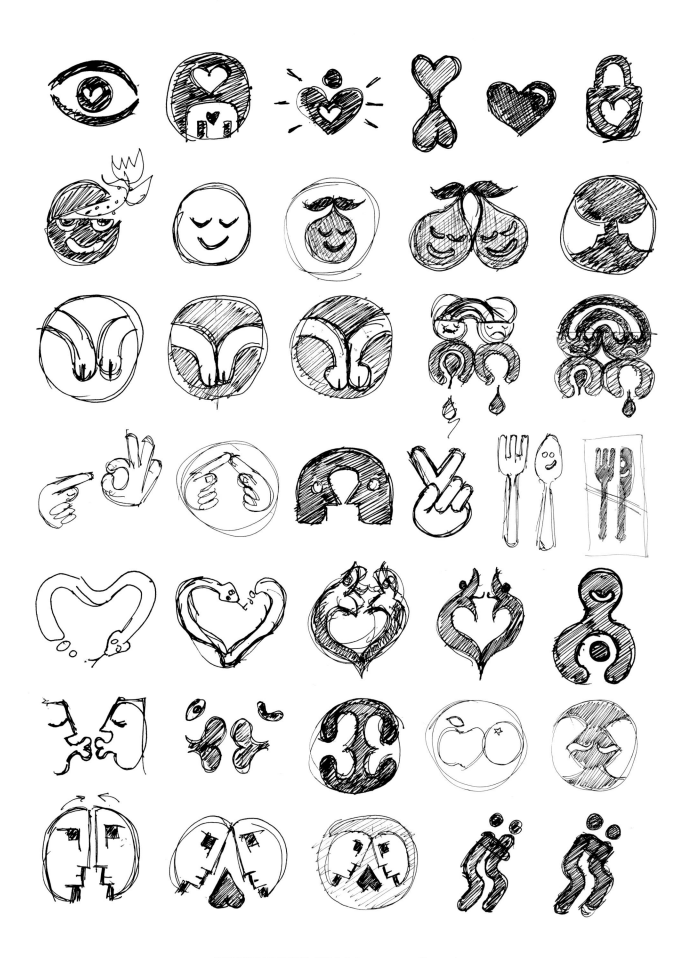

DRAWING PROCESS 2004, ink on paper, dimensions vary

DRAWING PROCESS 2001-2005, ink on paper, dimensions vary

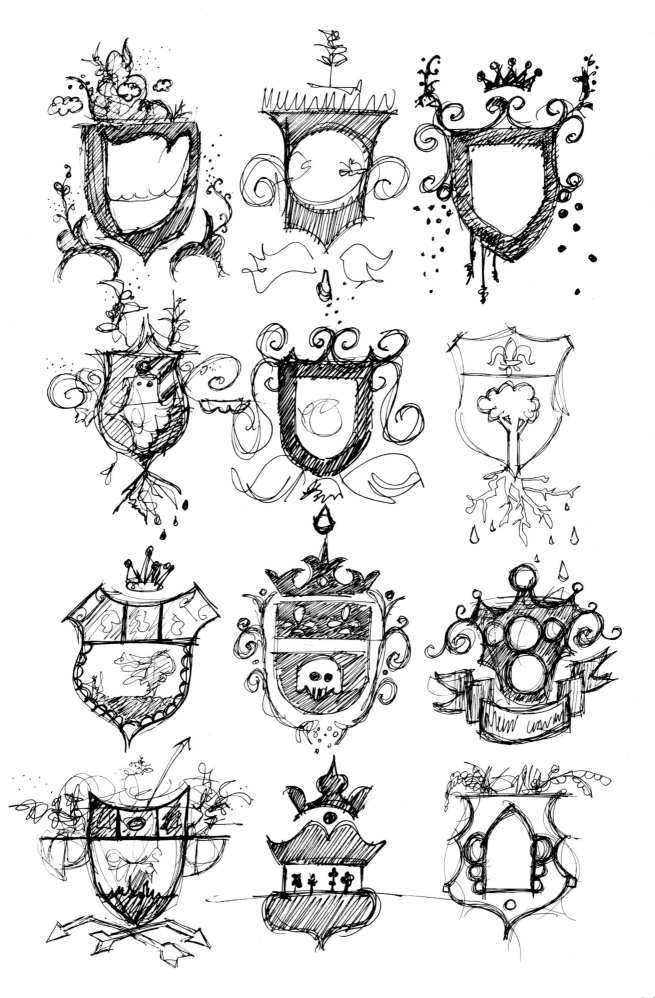

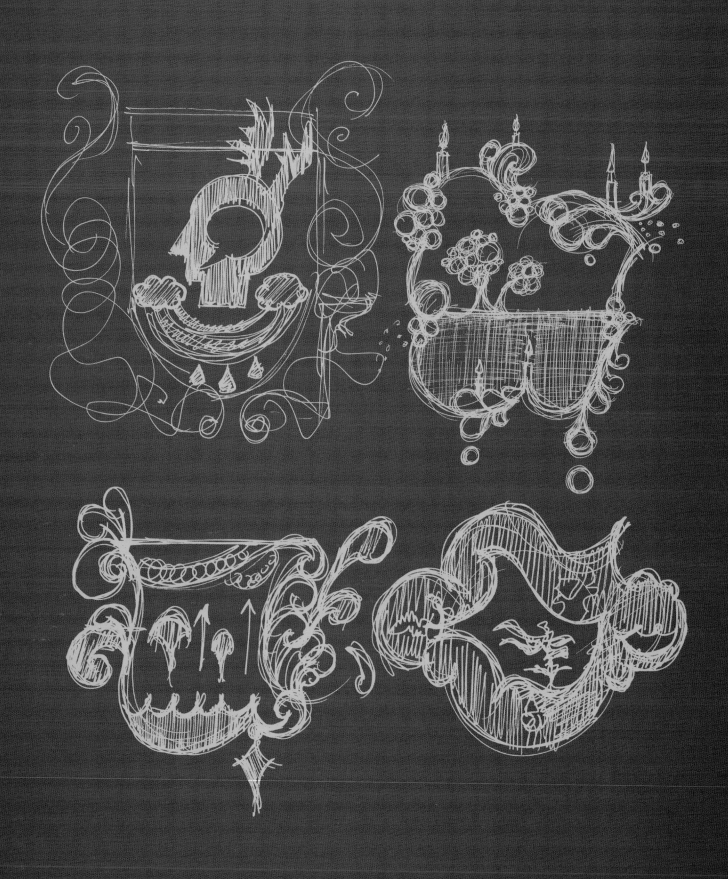

DRAWING PROCESS 2001-2005, ink on paper, dimensions vary

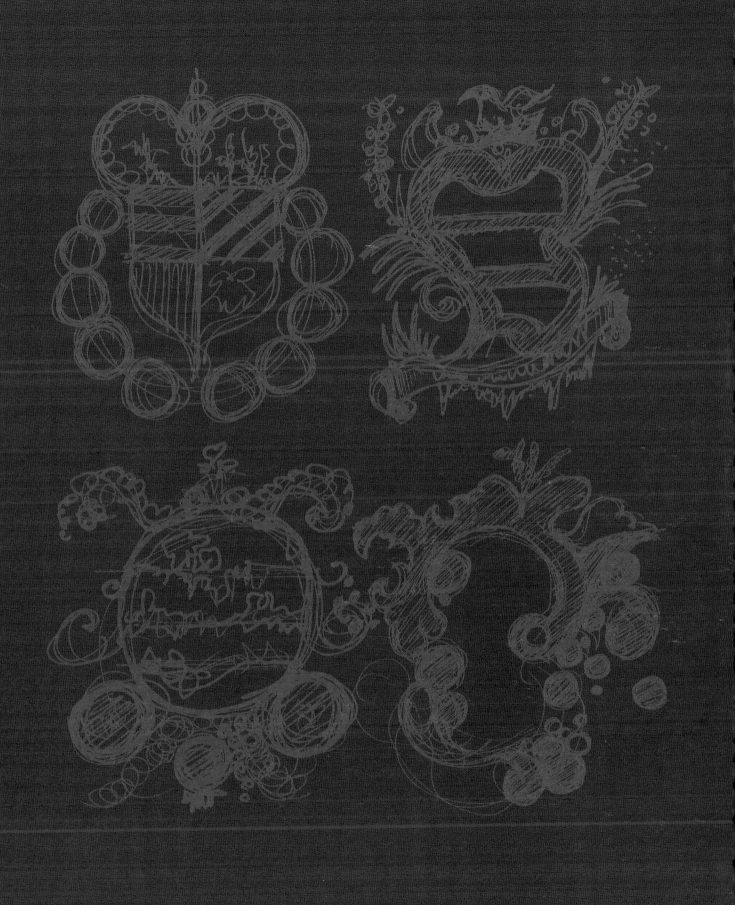

DRAWING PROCESS 2001-2005, ink on paper, dimensions vary

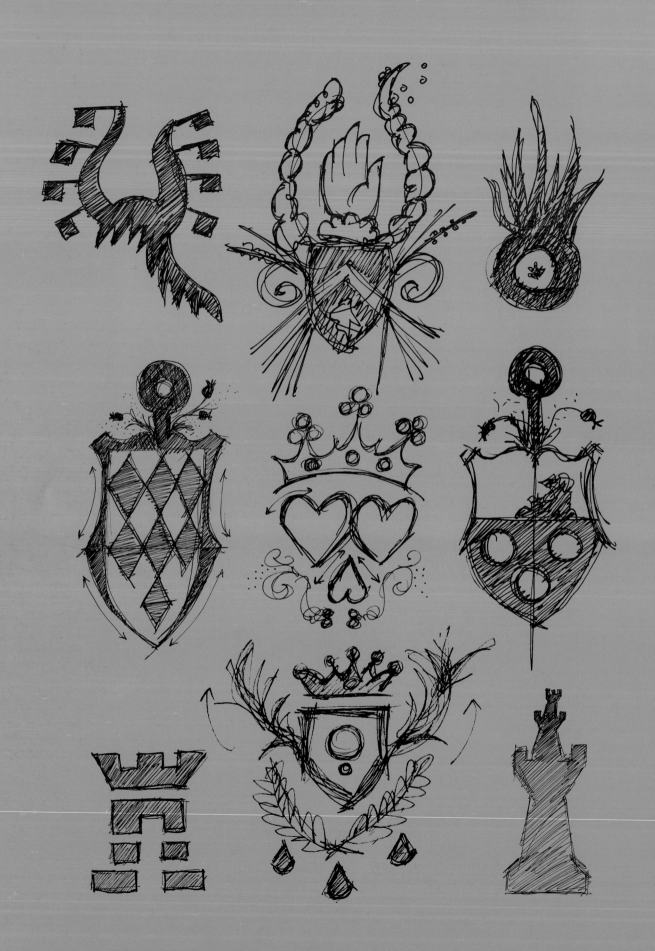

DRAWING PROCESS 2001-2005, ink on paper, dimensions vary

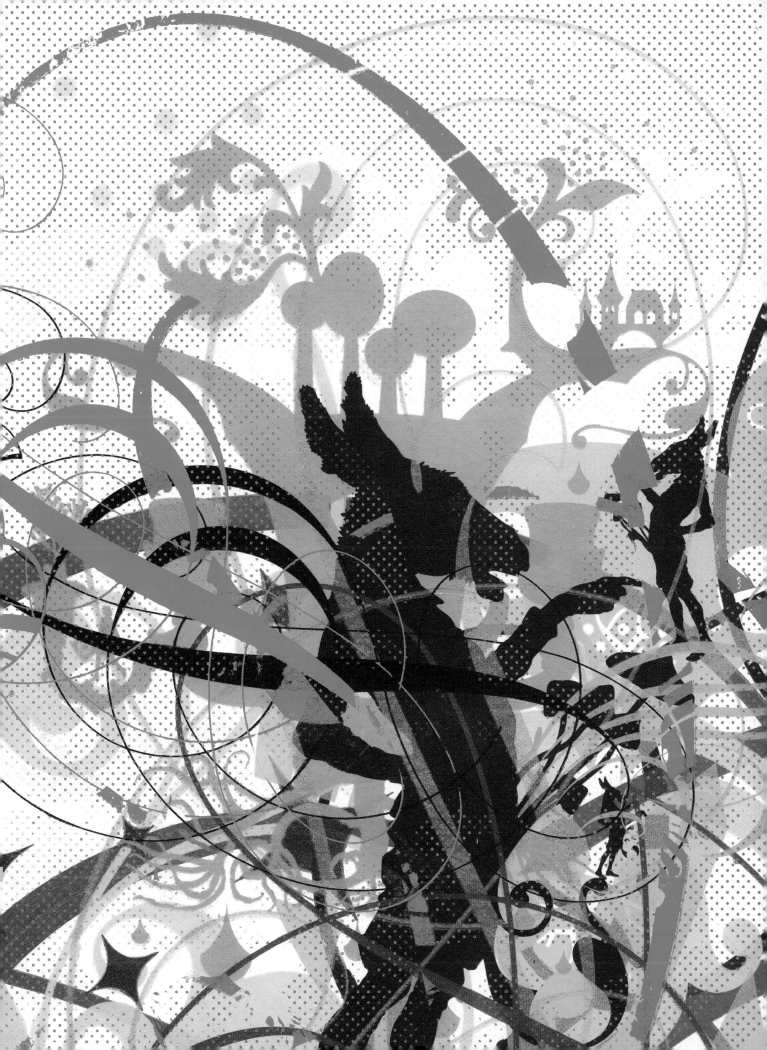

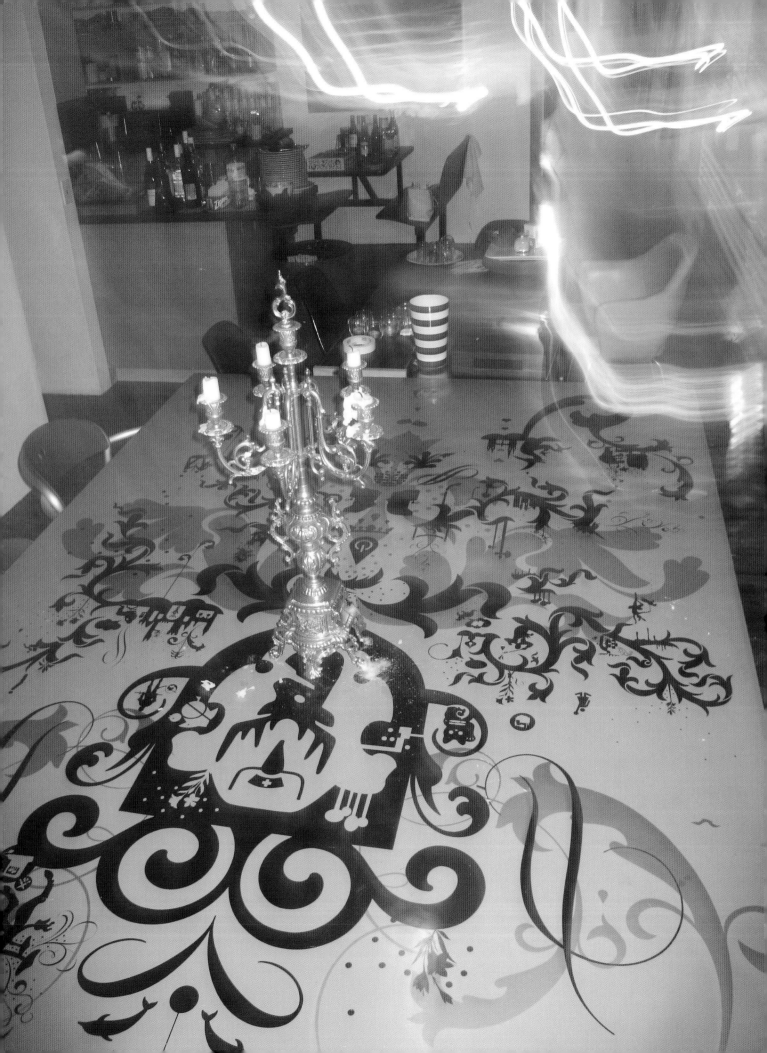

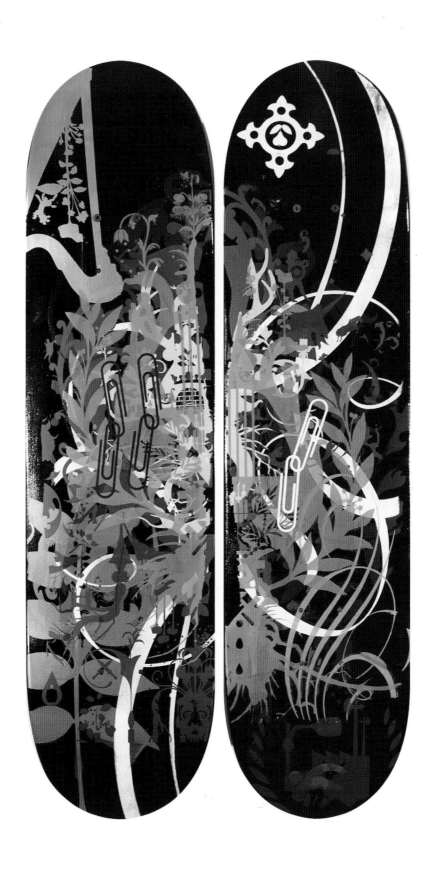

ERE LONG DONE DO DOES DID
2004, oil enamel and silkscreen ink on skateboards, 32 x 8 in. ea.

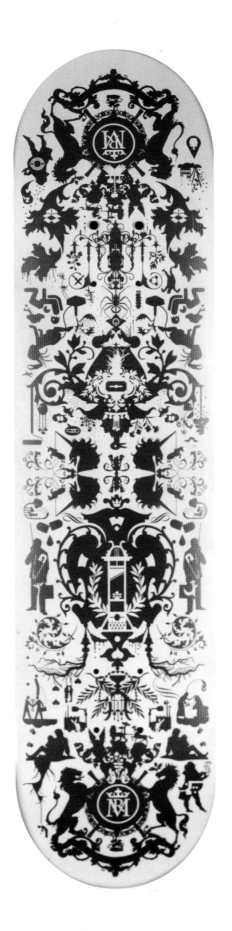

UNTITLED
2003, silkscreen ink on skateboard, 32 x 8 in., open ed.

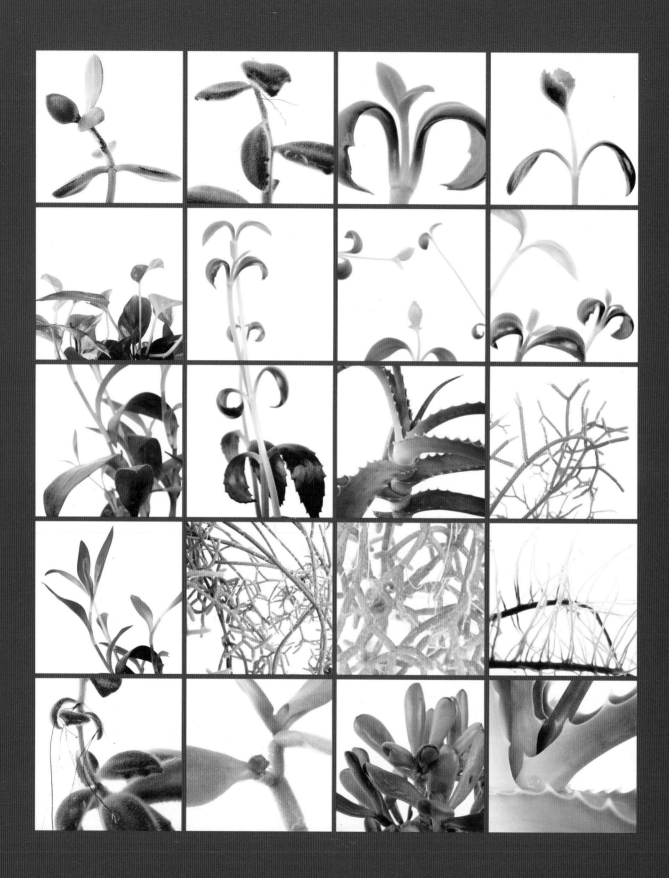

STIMULI (various plants grown in the studio)

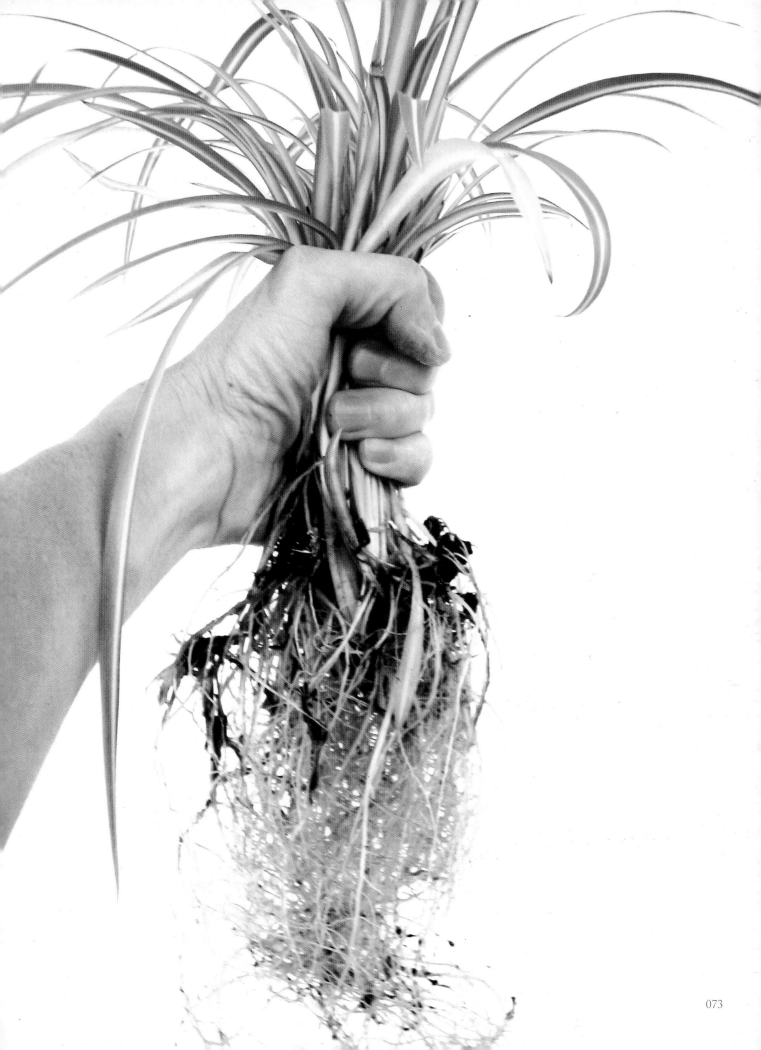

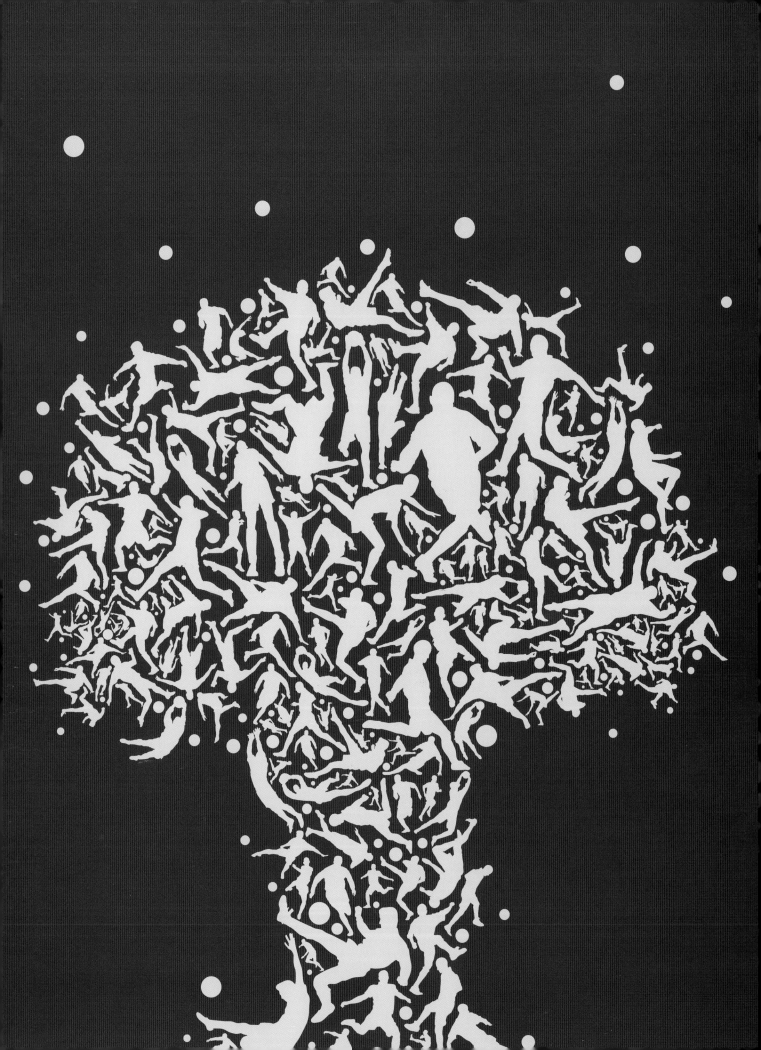

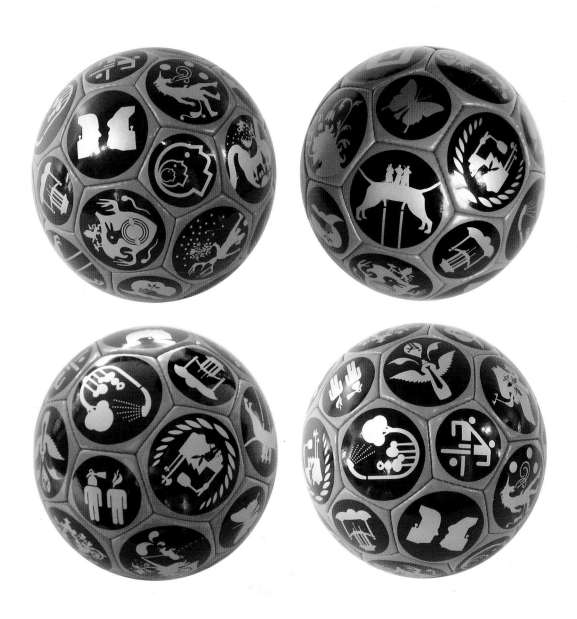

RM SOCCER BALL
2004, size 5 soccer ball, hand-stitched leather icosahedron, 8.25 in. diameter, open ed.

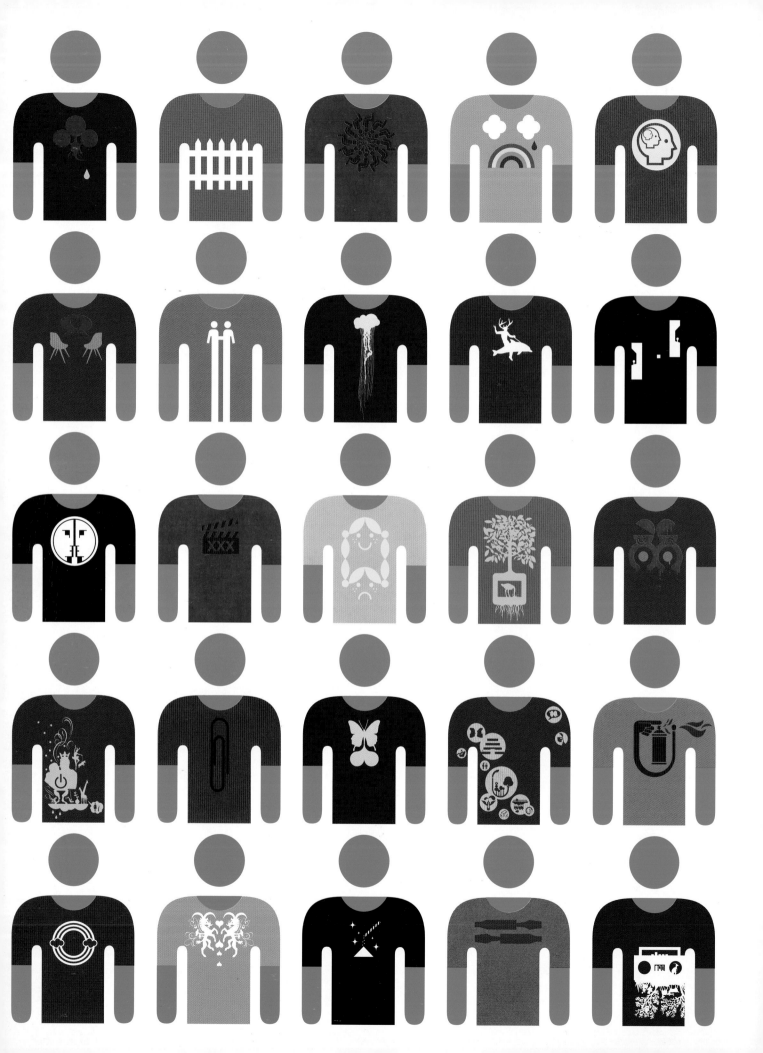

From Low to High and Back Again

Zen and the Art of Being in Consumer Culture

AA Bronson

I first met Ryan McGinness at Printed Matter, the artists' bookstore in New York, in 2003. He was installing his user-friendly cut-vinyl icons on the walls, the furniture, and in unexpected corners throughout the space. I was struck by his open, optimistic presence, his understated generosity, and his appreciation of this opportunity to work in a casual, non-glamorous, but interesting space.

Since then I have come to know Ryan and his work much better. As director of Printed Matter, I have presented an exhibition of Ryan's work, featured his prints, books, and skateboards at the Art Basel Miami Beach art fair, and watched his recent development, especially in the use of silkscreened icons to create dense mandalas of imagery as both paintings and prints.

The aspect of Ryan's work that interests me most is the fluidity with which he moves from medium to medium and context to context. His production of shirts and T-shirts, skateboards, paper cups and plates, and soccer balls, for example, flows effortlessly into his production of wall paintings (that sometimes take the form of retail-store decoration), prints, and

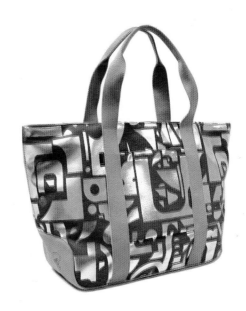

PARTS OF PART OF EVERYTHING 2001, metallic foil on canvas, 12 x 20 x 8 in., ed. of 80

paintings. He does not appear to distinguish between high and low culture. Rather, his approach is a process that has its roots in a small-scale artisan's workshop and a very particular mode of distribution. Ryan comes of a generation that has grown up in an environment largely formed by the language of marketing and branding. He understands these concepts implicitly and he accepts them as givens, as part of life and living and working today.

My own generation—and in particular my own work as part of the artists' group General Idea—was dedicated to a sort of analysis and even inhabitation of mass

culture and a critique of consumerism. In a sense, we were complicit with consumerism: while our work could be read as a critique of consumer culture it was also a simulacrum of it, and our products—which ran the gamut from publications to cocktail glasses to silk scarves and flags—were at once collectible and critical of that collectibility.

Ryan doesn't question consumer culture; it is the very air he breathes, the current in which he swims. He accepts consumer culture in a way that my generation could not, in a way that strikes me as almost Buddhist. Like a sort of urban planner planting flowering trees on city streets, he infiltrates the consumer environment with his low-run productions of optimistic and attractive products, using corporate-like icons that speak to an easier way of being in the world.

Ryan's method grows primarily out of small-scale silkscreen. He produces iconic images that he builds in groups and layers to create an interconnected vision of the universe: people, plants, lifestyle objects—representing music (a boombox) or sports or even war—join together to form a vast spiraling iconography, a sort of grammar of contemporary urban life, one very conscious of both globalism and the vanishing environment.

The support on which Ryan builds his works is variable—including clothing, objects, canvas, paper, or on the walls themselves. The images are readily applied and layered by hand using small silkscreens that allow for infinite variation. Sometimes the images are transposed

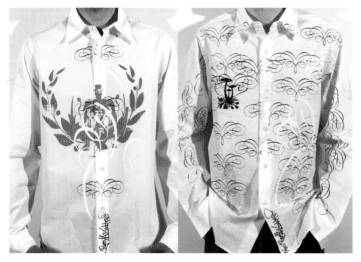

EVOLUTION IS THE THEORY OF EVERYTHING 2001, ceramic mugs, 3.5 x 4.5 x 3 in., published by Parco Gallery, ed. of 100 each
UNTITLED 2004, unique prints on agnès b. shirts, ed. of 50

into cut vinyl, essentially a variant on the silkscreen medium, another form of stencil carrying its own aesthetic and purpose. Most recently, he has been spraying his large-scale canvases with car enamel, a suitable background to his medium: car enamel reminds us of the fusion in his work of the languages of commercial production, design, marketing, and art.

Distribution is another aspect of Ryan's work. I have focused on the subjects of distribution and of audience all my adult life. The distribution system implicit in the art world, with its culture of galleries, art magazines, museums, biennials, and art fairs—not to mention the cultivation of celebrity—is one that has received much attention in the last few years, although there is much room still for investigation.

I want to draw attention to the limited small-scale production of so-called designer fashion. Starting in the early 1980s, fashion designers began focusing on small-scale production of individualized clothing, often employing the techniques and crafts previously reserved for couture that were dying away. Through a system somewhat parallel to the art world's—a network of small boutiques, fashion magazines, fashion television, and celebrity branding—they successfully created a system that penetrates the world of consumer culture globally. In fact, designers now create products for mainstream culture as well: note Todd Oldham's products for the budget chain Target. And Hussein Chalaya, in a remarkable and noteworthy crossover, produced a video installation for the Turkish Pavilion in this year's Venice Biennale.

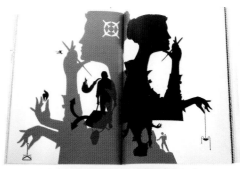

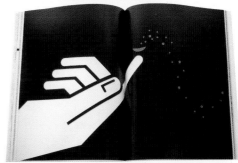

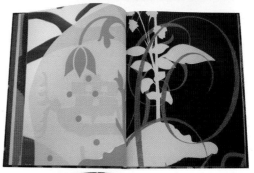

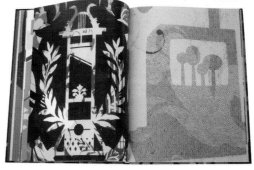

PIECEOFMIND 2001, book, 11 x 8.5 in., 2C, 112 pp., published by Colette, ed. 1,000
PROJECT RAINBOW 2003, book, 11 x 8.5 in., 4C, 112 pp., published by Gingko Press, ed. 2,500

When I first visited the studio of Ryan McGinness I was struck by its similarities to the working environments of the Belgian designer Martin Margiela: the stripped down aesthetic, white walls, the lack of any artwork other than that being produced here. The studio was clearly a small-production atelier, in which the current family of icons and their corresponding silkscreens could be applied to any number of products: clothing, skateboards, prints, and large-scale paintings all appeared in simultaneous production using one integrated process.

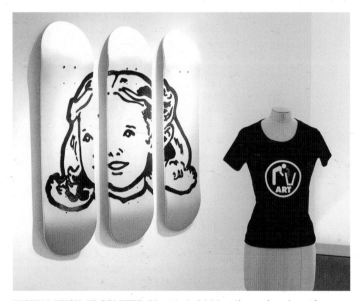

INSTALLATION AT COLETTE: Untitled, 2000, oil on skateboards, 32 x 8 in. ea.; **VOMIT ART** 1998, silkscreen ink on small t-shirt

Ryan talked about his forays into licensing and his dissatisfaction with the loss of control it involves. Products were produced that he had not finally approved, in quantities that he could not confirm. He has returned now to the relative safety of the atelier model, which gives him the pleasure of direct contact with his own limited productions while retaining control of what goes out into the world. He works as artists always have—in his studio—but in the context of today's consumer culture: he might produce a line of shirts one day for a company in Japan; a group of skateboards for an American firm in Cincinnati; a line of paintings for a French art gallery in Paris; and so on.

I was speaking today with a younger artist about the ways in which the boundaries between art, design, and culture in general have shifted. This very horizontal way of thinking and working has shifted the notion of how art moves through the culture. Distribution, which used to be so firmly in the hands of commercial galleries, has opened up, and artists are increasingly able to run their studios in a new way. Ryan McGinness spins his web, producing books, objects, clothing, prints or paintings, with an integrated production and a singularly consistent vision. His way of working and of being in the world seems to me absolutely modern; the Zen, if you will, of how an artist can be in the world today.

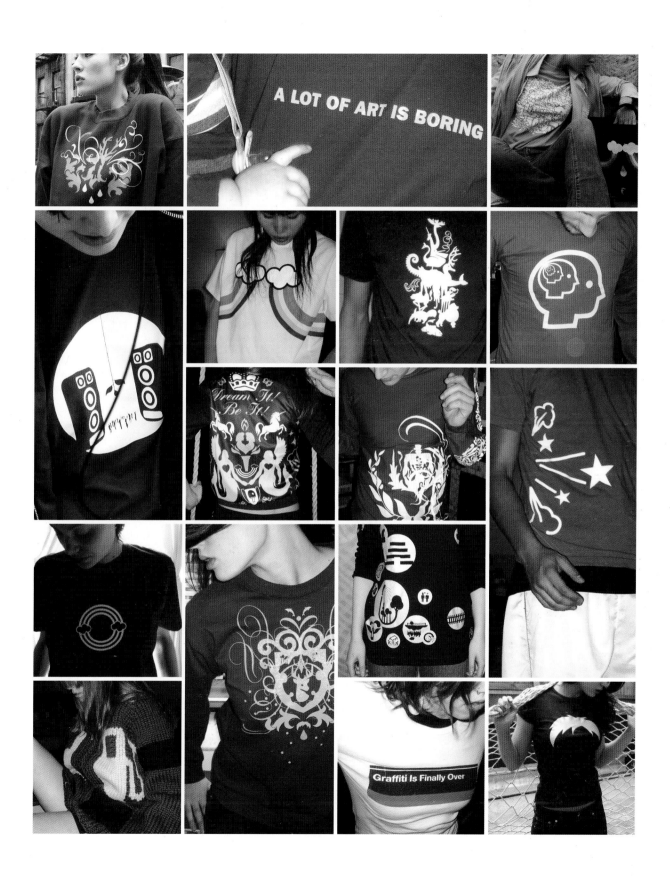

VARIOUS GARMENTS 1998-2004, mixed media, dimensions vary

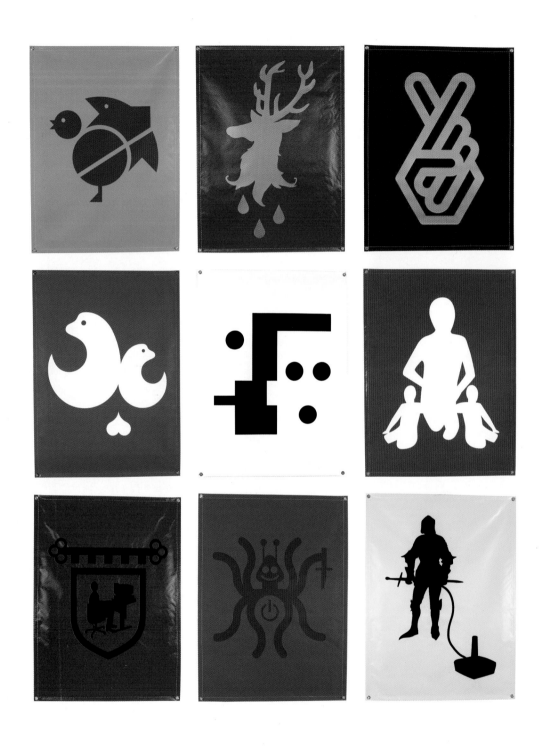

UNTITLED
2002, adhesive vinyl on vinyl banners with grommets, 36 x 24 in. ea.

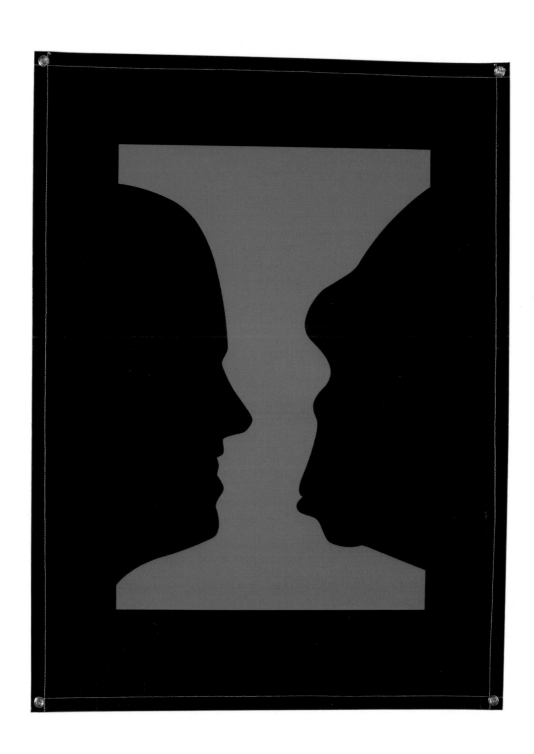

UNTITLED
2002, adhesive vinyl on vinyl banners with grommets, 36 x 24 in.

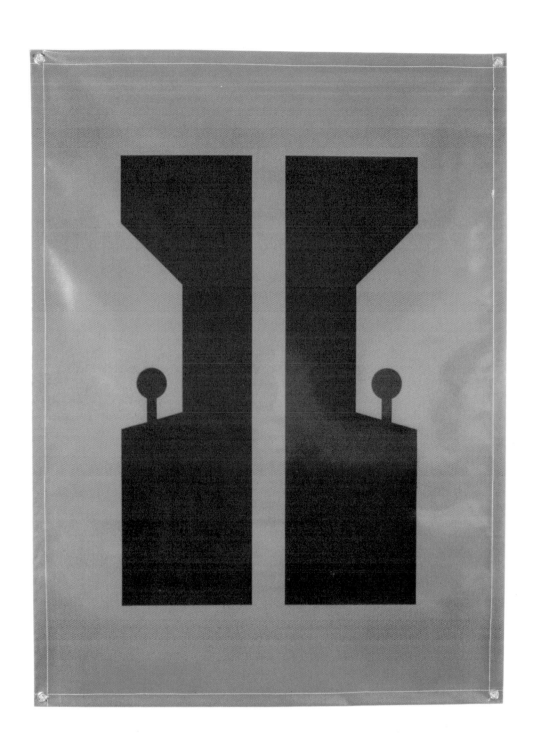

UNTITLED
2002, adhesive vinyl on vinyl banners with grommets, 36 x 24 in.

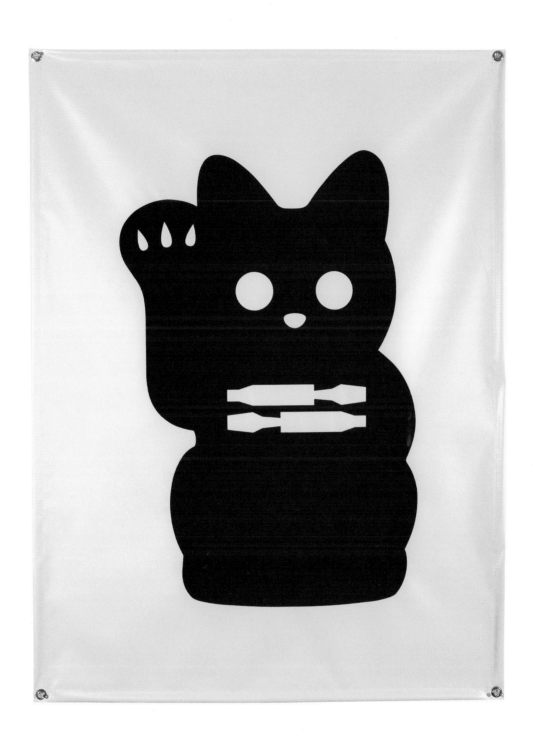

UNTITLED
2002, adhesive vinyl on vinyl banners with grommets, 36 x 24 in.

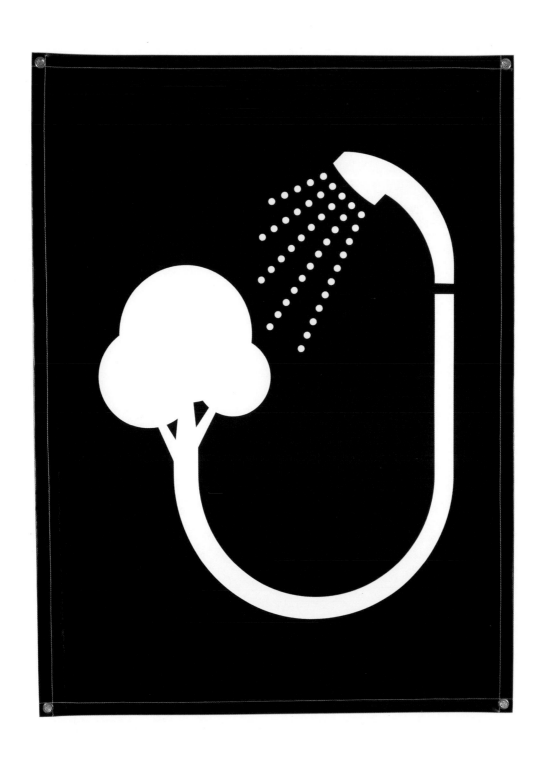

UNTITLED
2002, adhesive vinyl on vinyl banners with grommets, 36 x 24 in.

UNTITLED
2002, adhesive vinyl on vinyl banners with grommets, 36 x 24 in.

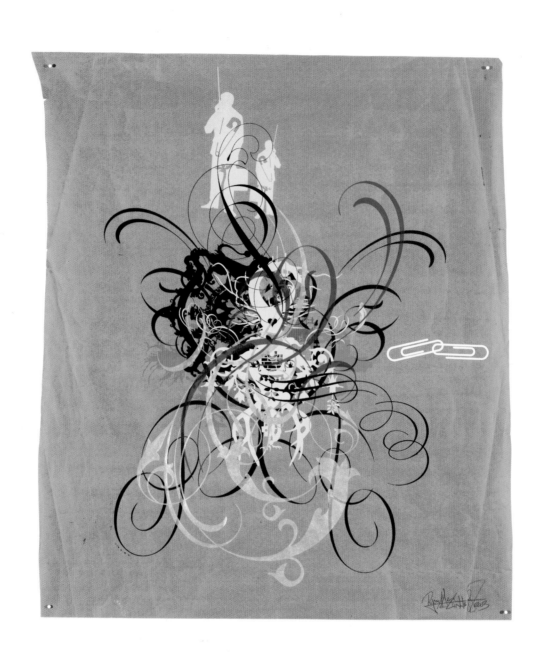

UNTITLED (PROJECT RAINBOW TEST PRINTS)
2003, silkscreen ink on kraft paper, 30 x 26 in.
Opposite: 2003, silkscreen ink on kraft paper, 30 x 23.5 in.

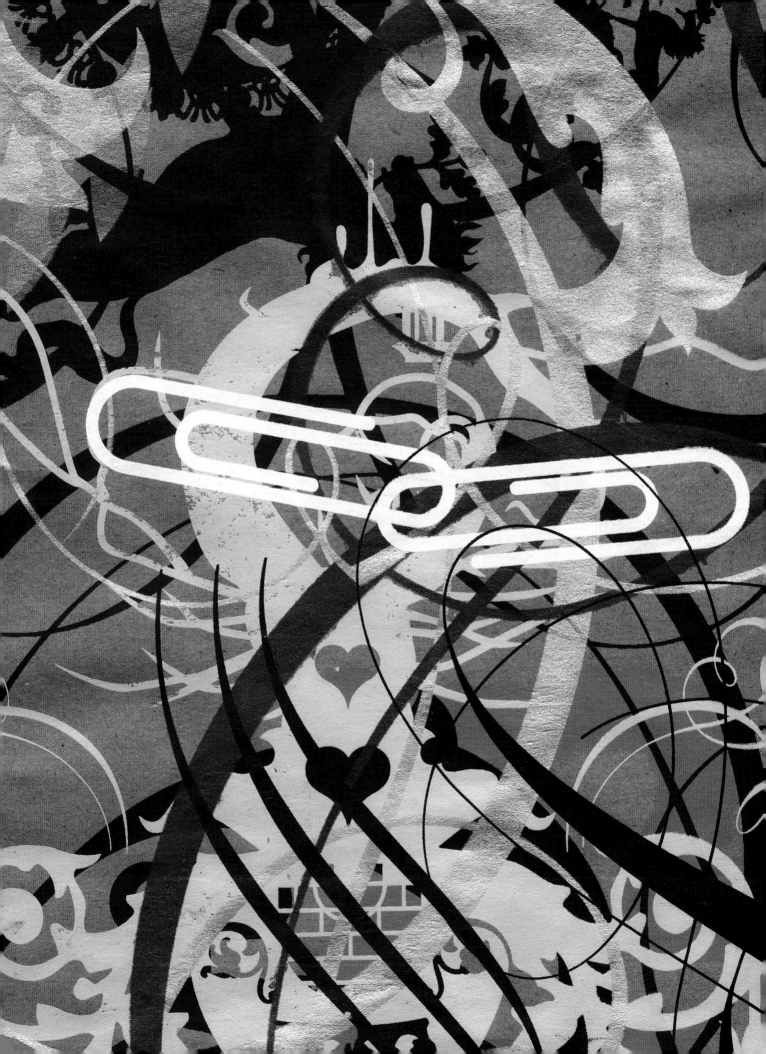

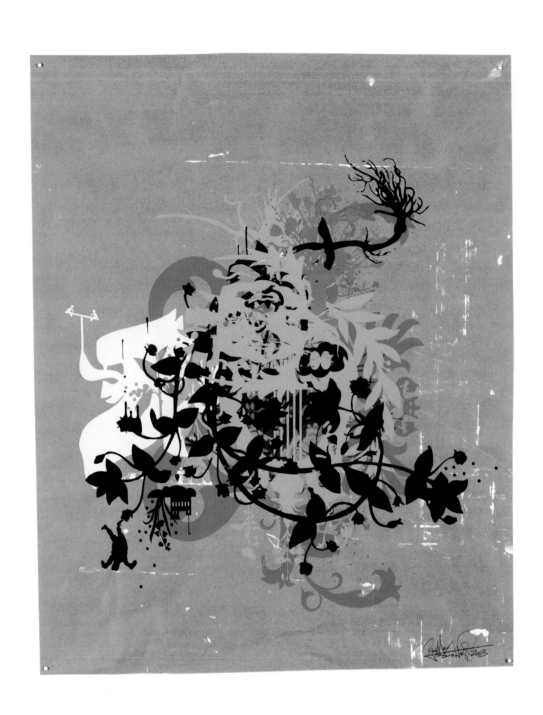

UNTITLED (PROJECT RAINBOW TEST PRINT)
2003, silkscreen ink on kraft paper, 30 x 24 in.

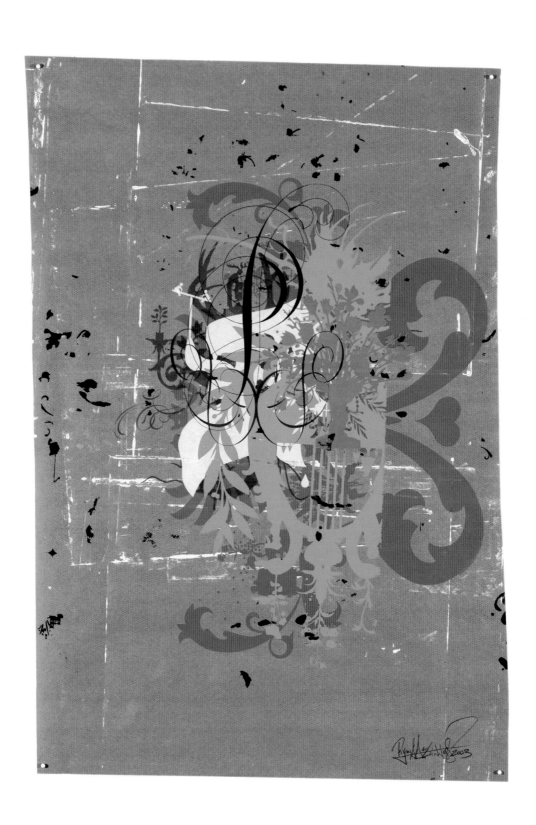

UNTITLED (PROJECT RAINBOW TEST PRINT)
2003, silkscreen ink on kraft paper, 30 x 20 in.

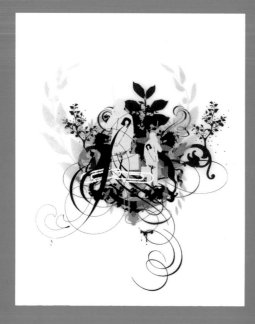

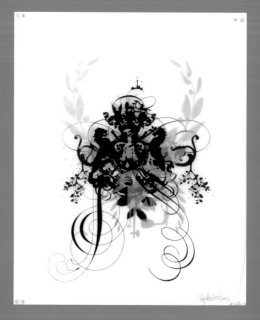

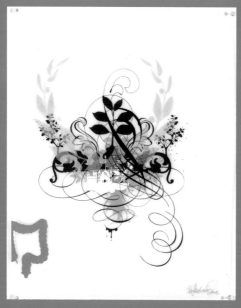

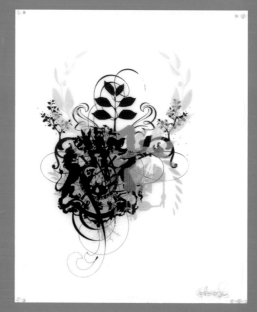

UNTITLED
2003, silkscreen ink on vellum, 24 x 19 in. ea.

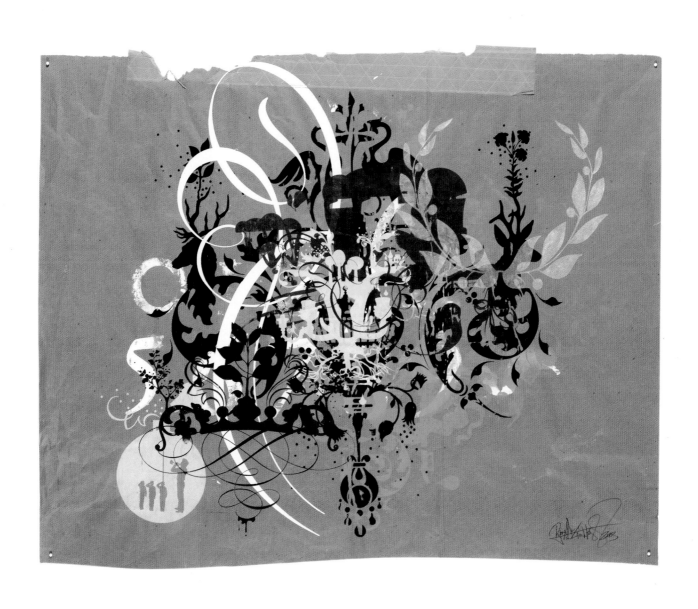

UNTITLED (PROJECT RAINBOW TEST PRINT)
2003, silkscreen ink on kraft paper, 28 x 36 in.

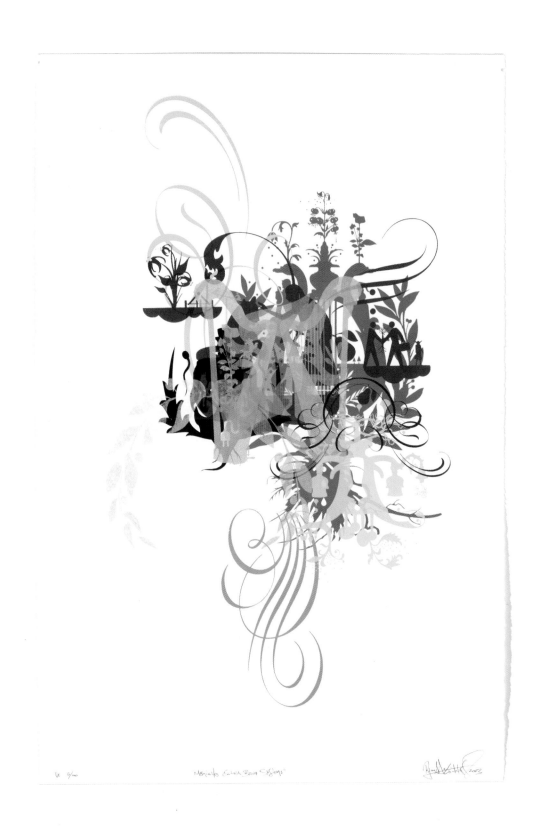

FABRICATED CULTURAL BELIEF SYSTEMS
2003-2004, silkscreen ink on paper, varied ed. of 100, 40 x 27 in. ea.

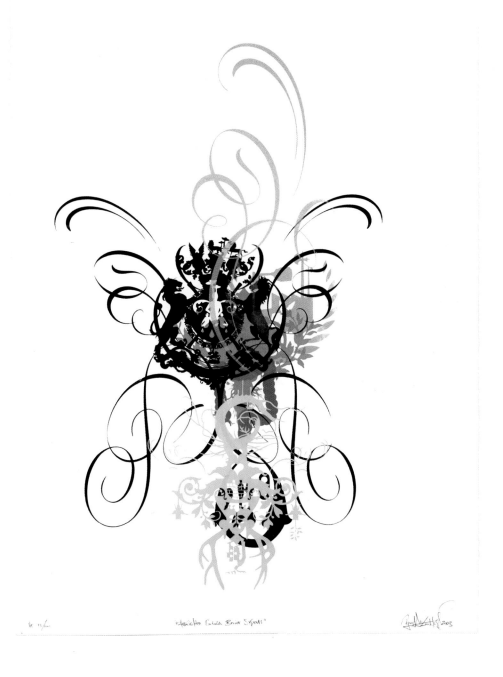

FABRICATED CULTURAL BELIEF SYSTEMS
2003-2004, silkscreen ink on paper, varied ed. of 100, 40 x 27 in. ea.

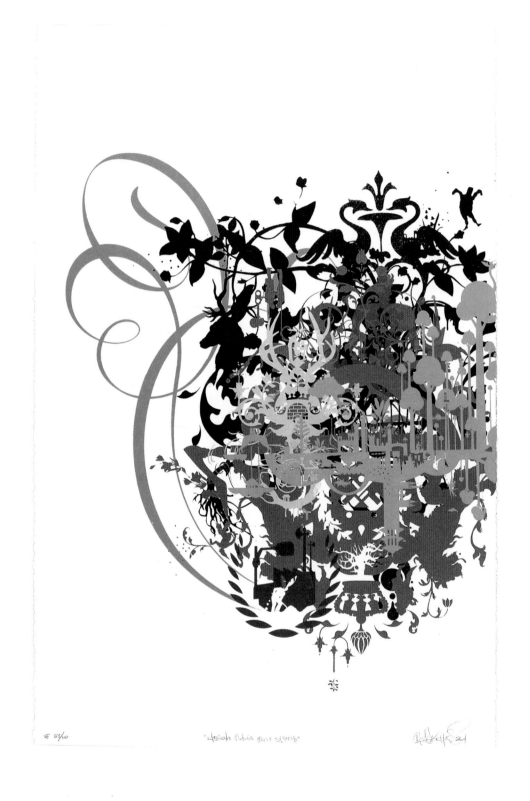

FABRICATED CULTURAL BELIEF SYSTEMS
2003-2004, silkscreen ink on paper, varied ed. of 100, 40 x 27 in. ea.

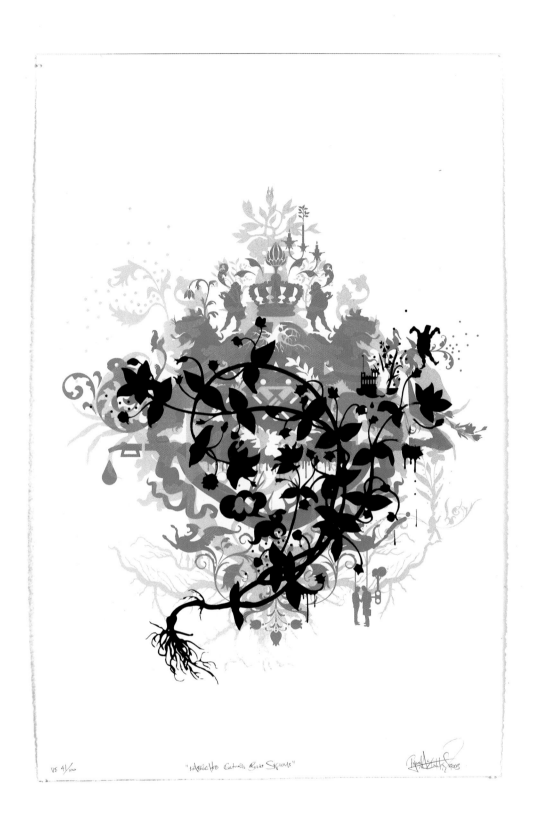

FABRICATED CULTURAL BELIEF SYSTEMS
2003-2004, silkscreen ink on paper, varied ed. of 100, 40 x 27 in. ea.

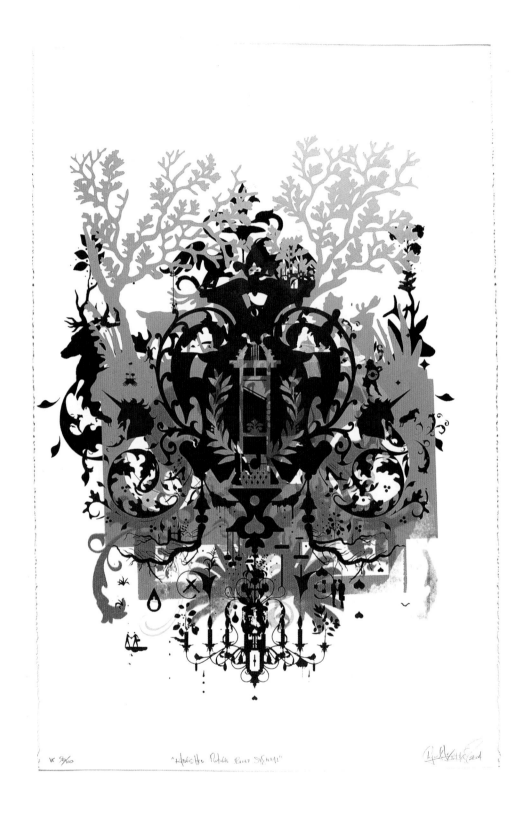

FABRICATED CULTURAL BELIEF SYSTEMS
2003-2004, silkscreen ink on paper, varied ed. of 100, 40 x 27 in. ea.

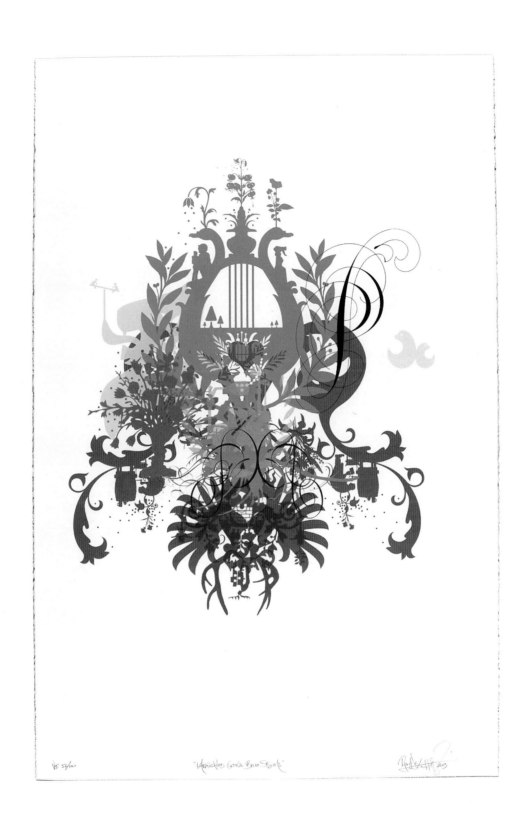

FABRICATED CULTURAL BELIEF SYSTEMS
2003-2004, silkscreen ink on paper, varied ed. of 100, 40 x 27 in. ea.

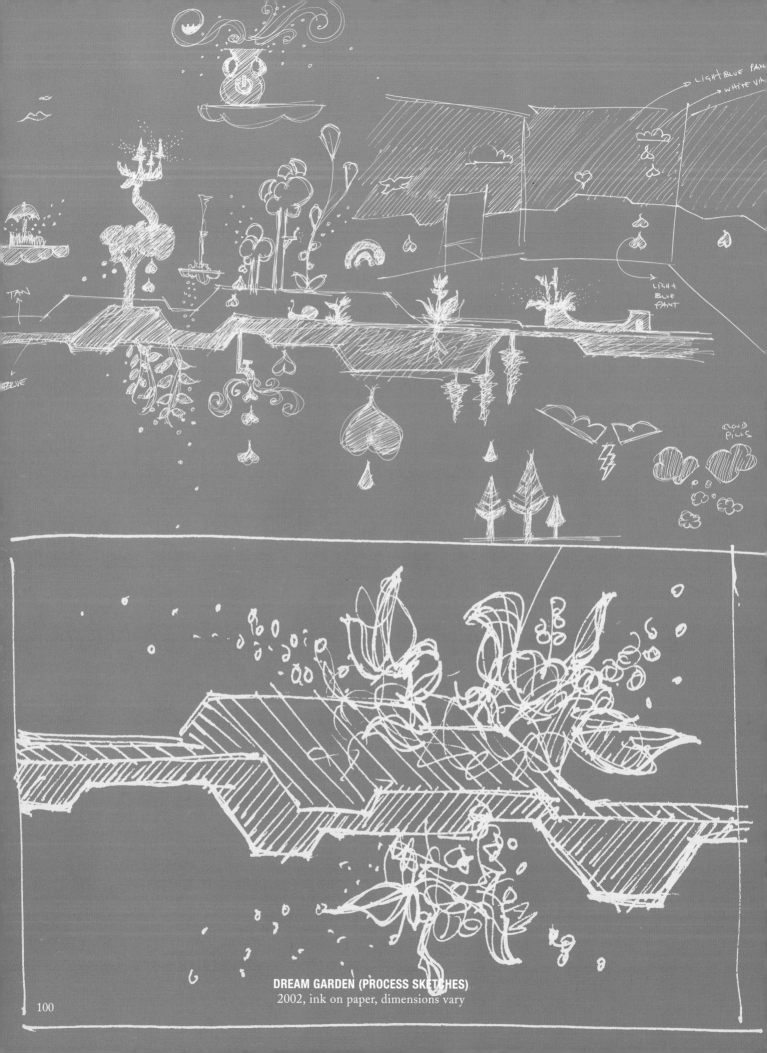

DREAM GARDEN (PROCESS SKETCHES)
2002, ink on paper, dimensions vary

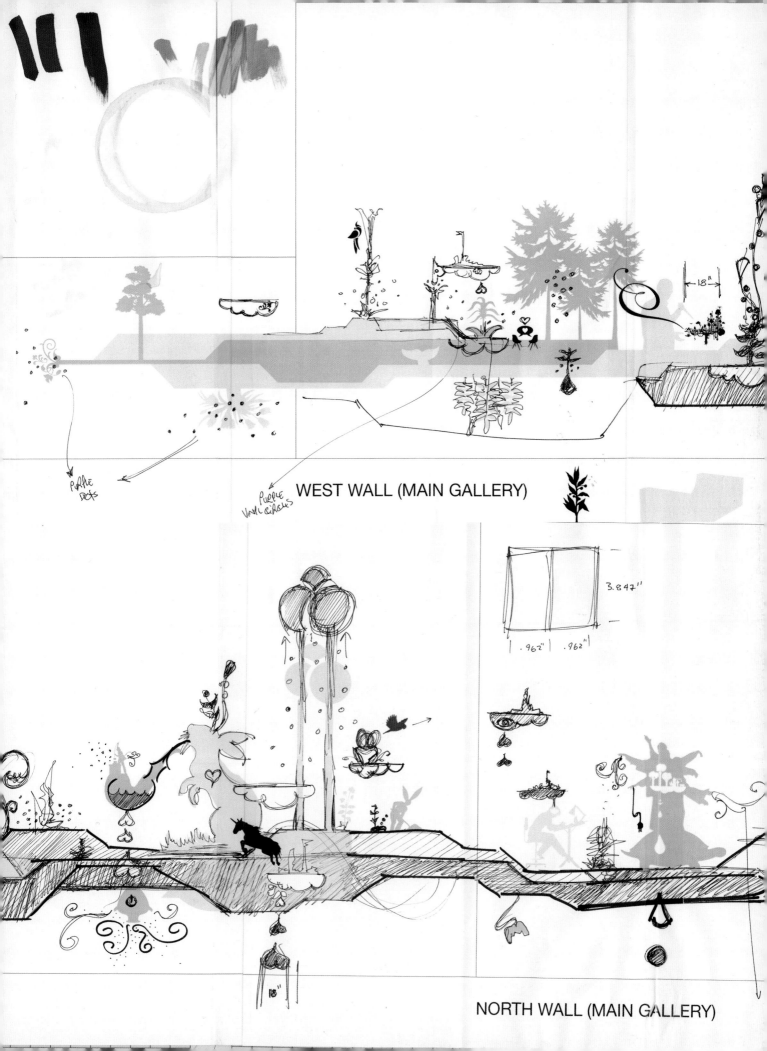

WEST WALL (MAIN GALLERY)

NORTH WALL (MAIN GALLERY)

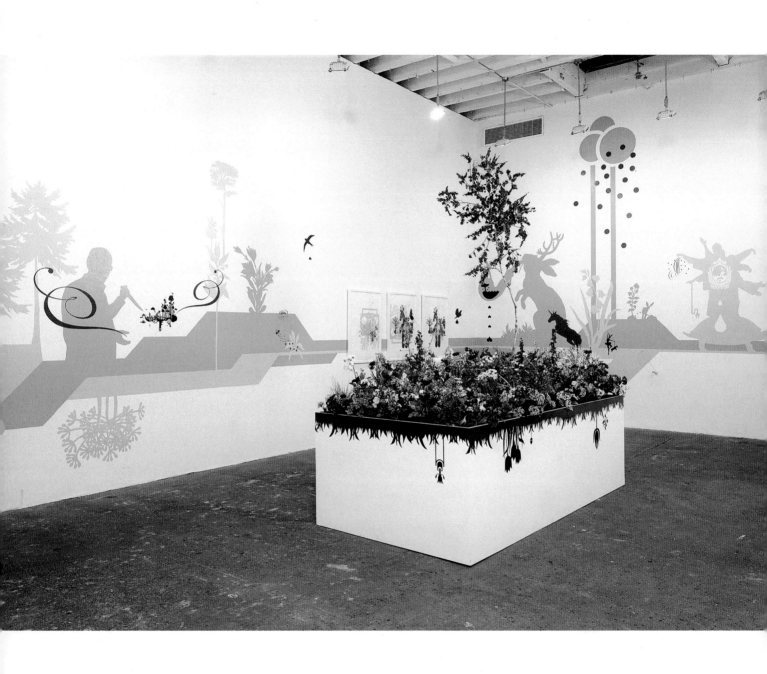

DREAM GARDEN
2002, with Julia Chiang, installation view, Deitch Projects, New York

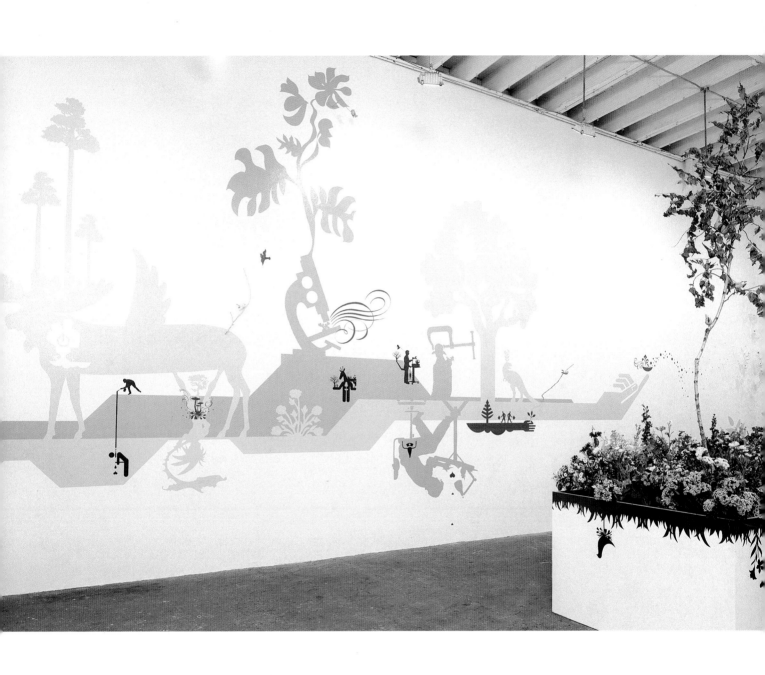

DREAM GARDEN
2002, with Julia Chiang, installation view, Deitch Projects, New York

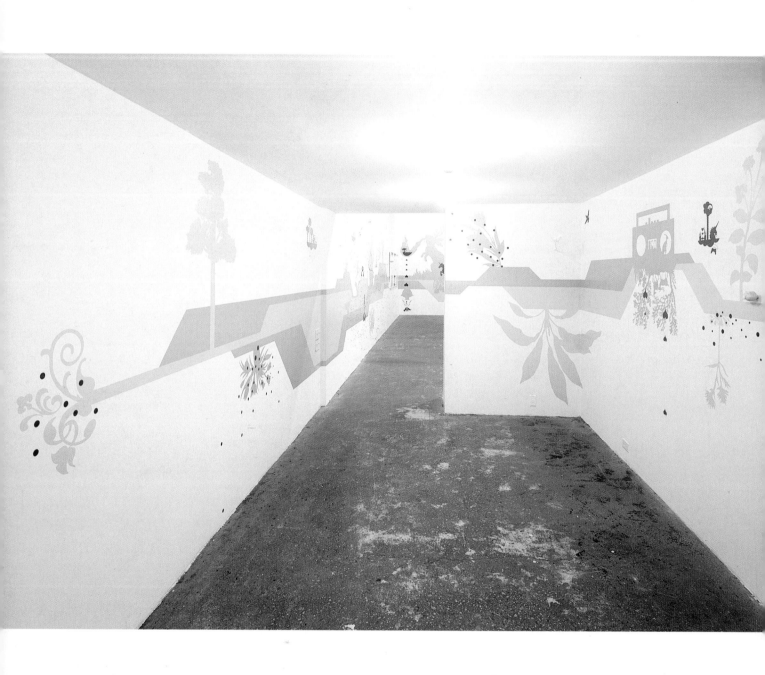

DREAM GARDEN
2002, with Julia Chiang, installation view, Deitch Projects, New York

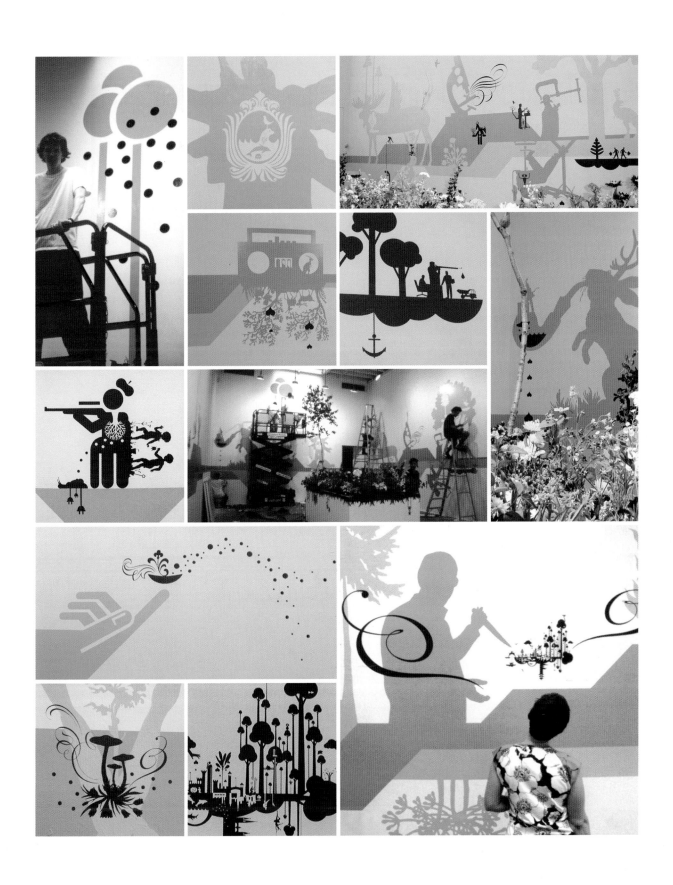

DREAM GARDEN (INSTALLATION PROCESS & DETAILS)
2002, with Julia Chiang, installation view, Deitch Projects, New York

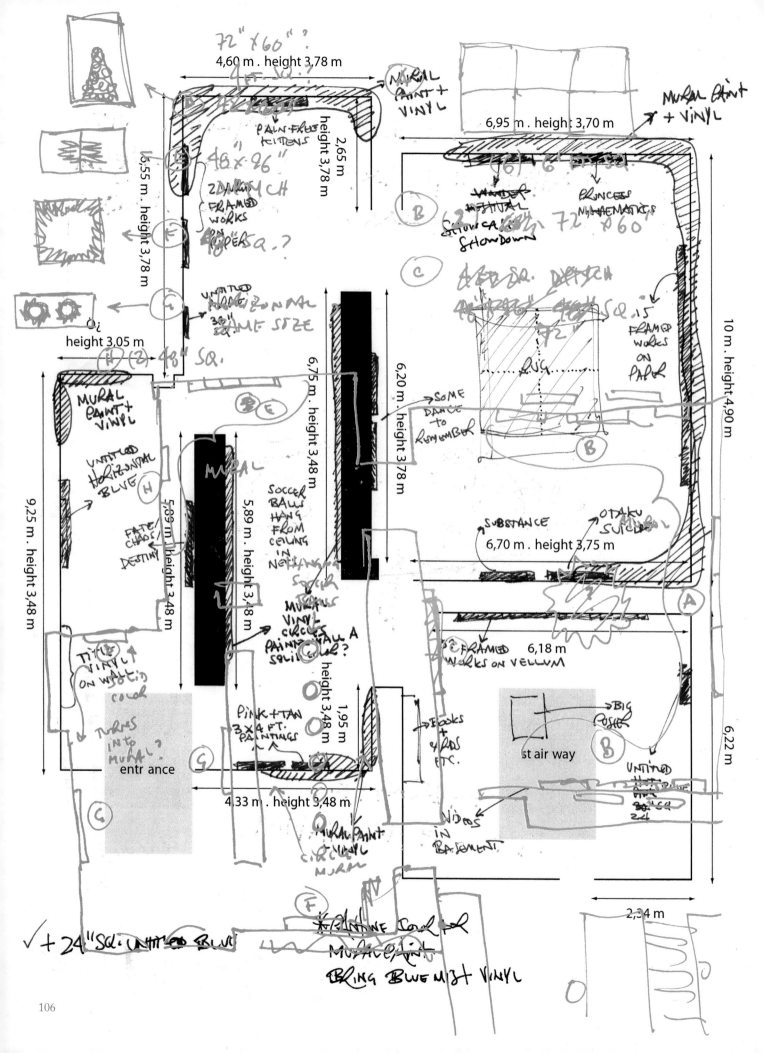

3.48 m.

1.95 m. — 4.33 m.

Ryan McGinness
Multiverse

Galerie du Jour
Entrance, Right

Painting:
Middle Class Fancy, 2003,
oil enamel and silkscreen ink on linen
48 x 36 in. (121.92 x 91.44 cm.)

Painting:
Programmed to Receive, 2003,
oil enamel and silkscreen ink on linen
48 x 36 in. (121.92 x 91.44 cm.)

SCALE:
Each Small Square = 1 CM
Each Large Square = 1 M

Blue Mist Metallic Vinyl

Light Blue Paint (Pantone 277)

Dark Blue Paint (Pantone 295)

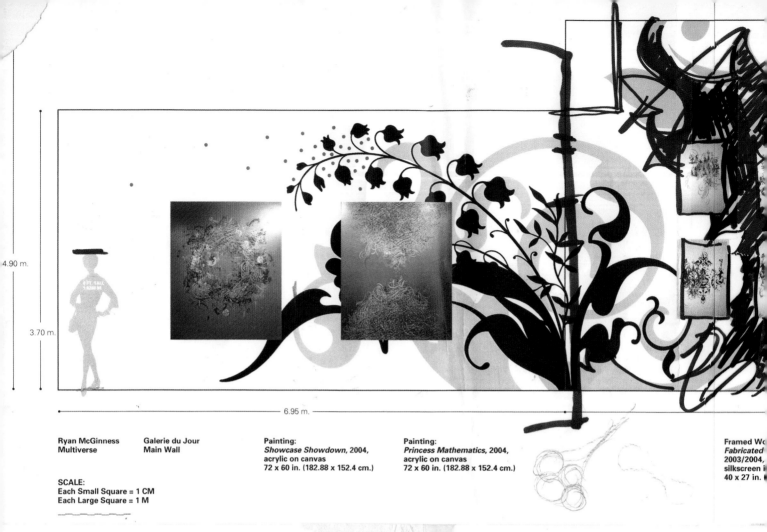

4.90 m.

3.70 m.

6.95 m.

Ryan McGinness
Multiverse

Galerie du Jour
Main Wall

Painting:
Showcase Showdown, 2004,
acrylic on canvas
72 x 60 in. (182.88 x 152.4 cm.)

Painting:
Princess Mathematics, 2004,
acrylic on canvas
72 x 60 in. (182.88 x 152.4 cm.)

Framed Wo
Fabricated
2003/2004,
silkscreen i
40 x 27 in.

SCALE:
Each Small Square = 1 CM
Each Large Square = 1 M

multiverse
Ryan McGinness

48 m.

9.25 m.

2.25 m.

Ryan McGinness
Multiverse

Galerie du Jour
Entrance, Left

Vinyl: 1.75 m. wide

Painting:
Love Singularity, 2004, acrylic on canvas
60 x 72 in. (152.4 x 182.88 cm.)

SCALE:
Each Small Square = 1 CM
Each Large Square = 1 M

Blue Mist Metallic Vinyl

Light Blue Paint (Pantone 277)

Dark Blue Paint (Pantone 295)

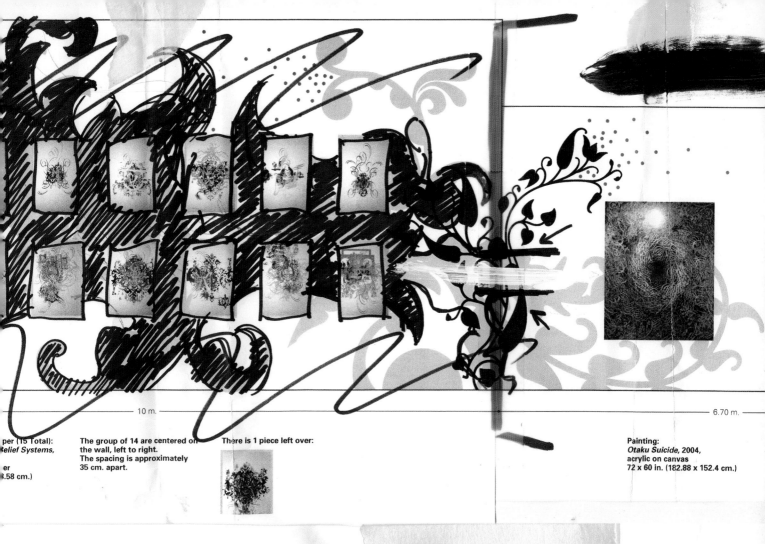

per (15 Total):
Relief Systems,

er
.58 cm.)

The group of 14 are centered on the wall, left to right.
The spacing is approximately 35 cm. apart.

There is 1 piece left over:

Painting:
Otaku Suicide, 2004,
acrylic on canvas
72 x 60 in. (182.88 x 152.4 cm.)

10 m.

6.70 m.

3 m.

COMPOSITE SKETCH STUDY 2005, ink on paper

COMPOSITE SKETCH STUDY 2005, ink on paper

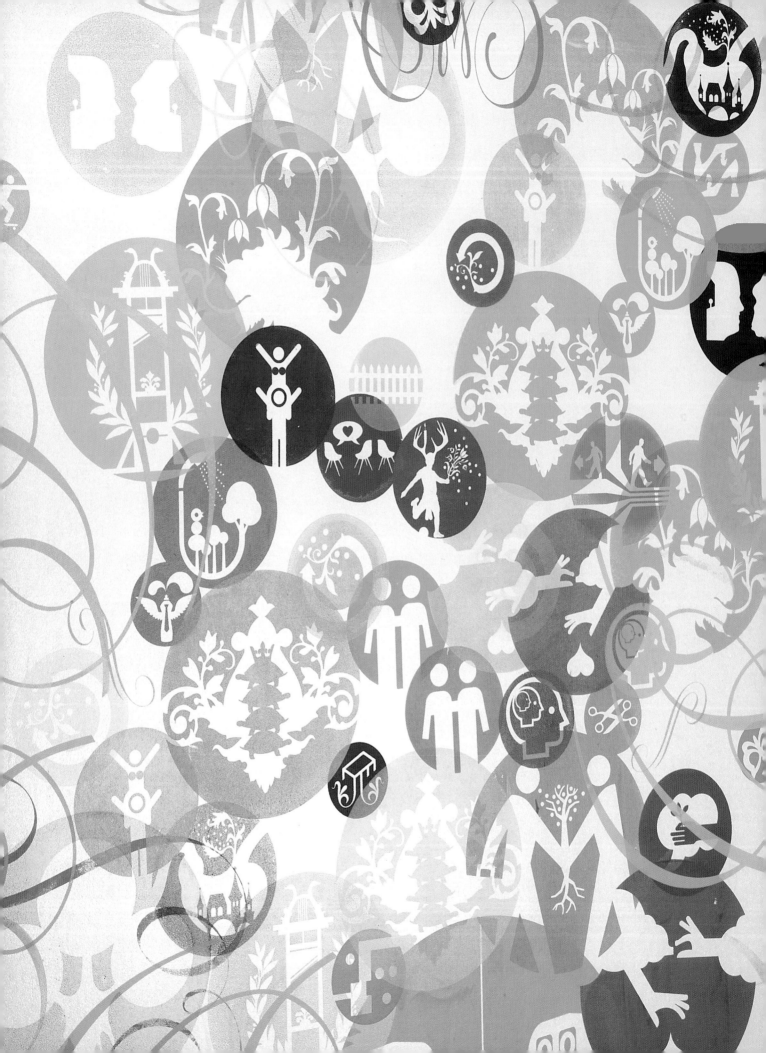

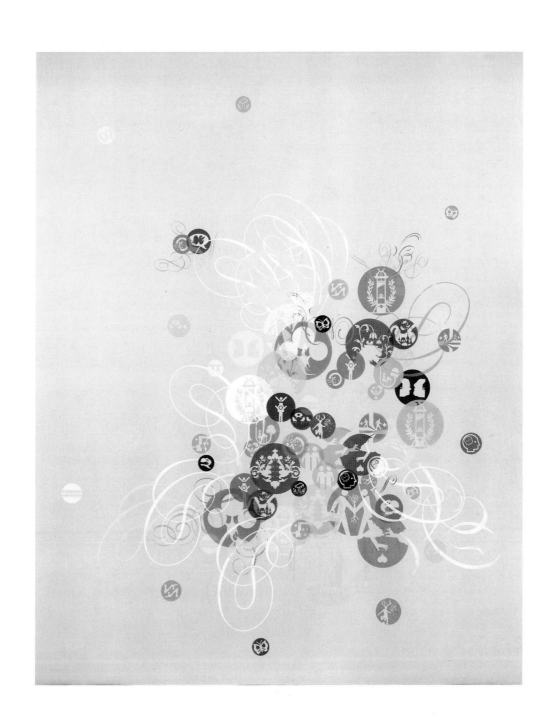

PAIN-FREE KITTENS
2004, acrylic on canvas, 90 x 72 in. (detail on opposite page)

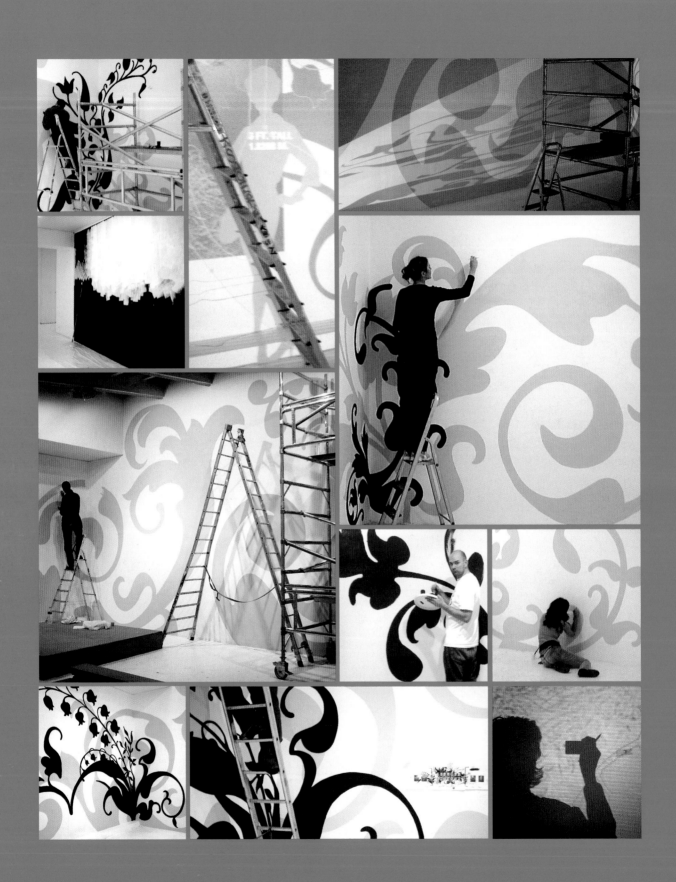

MULTIVERSE (INSTALLATION PROCESS)
2004, installation view, Galerie du Jour, Paris

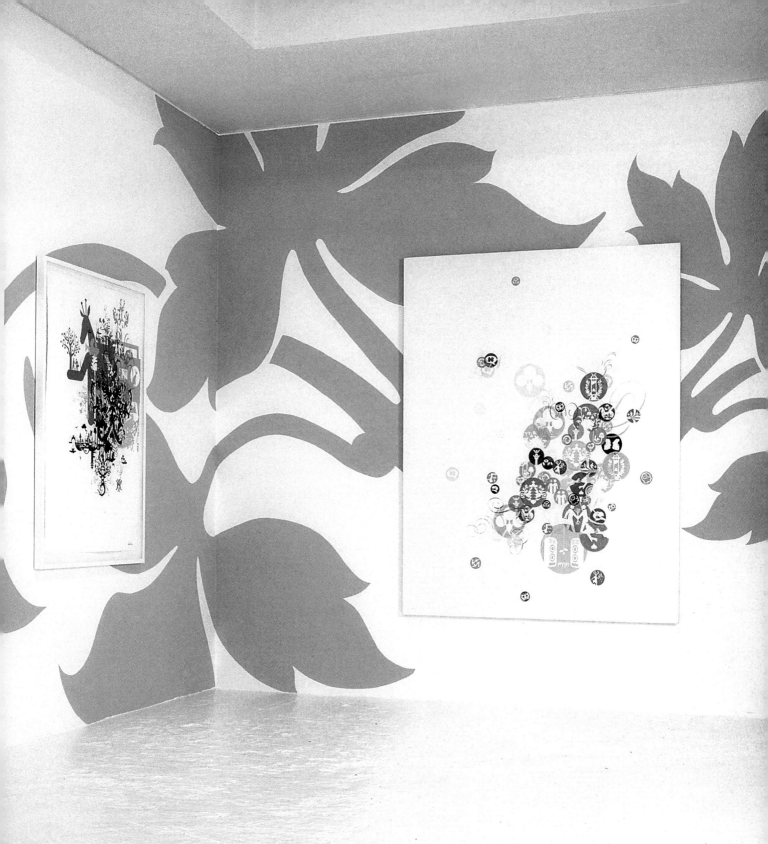

MULTIVERSE
2004, installation view, Galerie du Jour, Paris

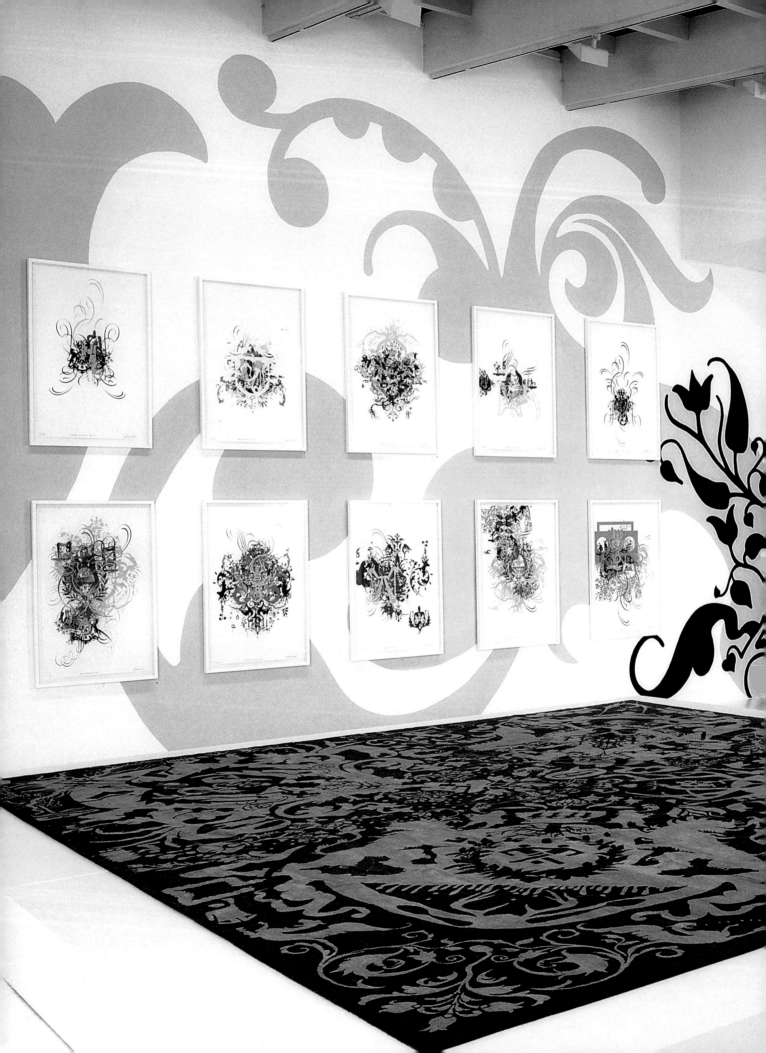

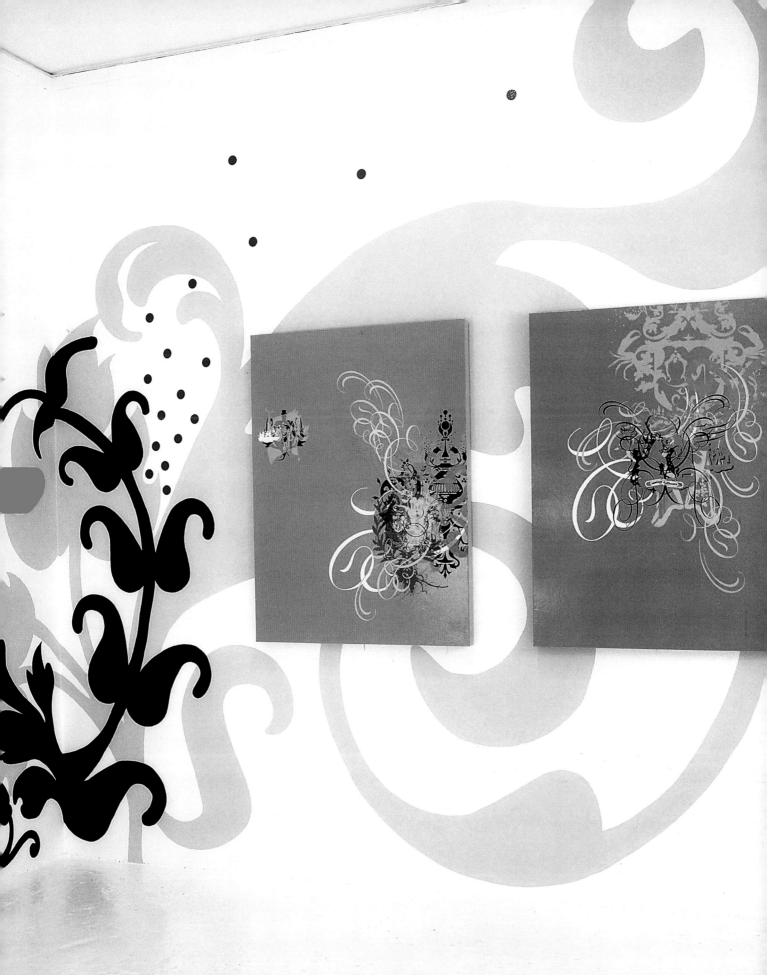

MULTIVERSE
2004, installation view, Galerie du Jour, Paris

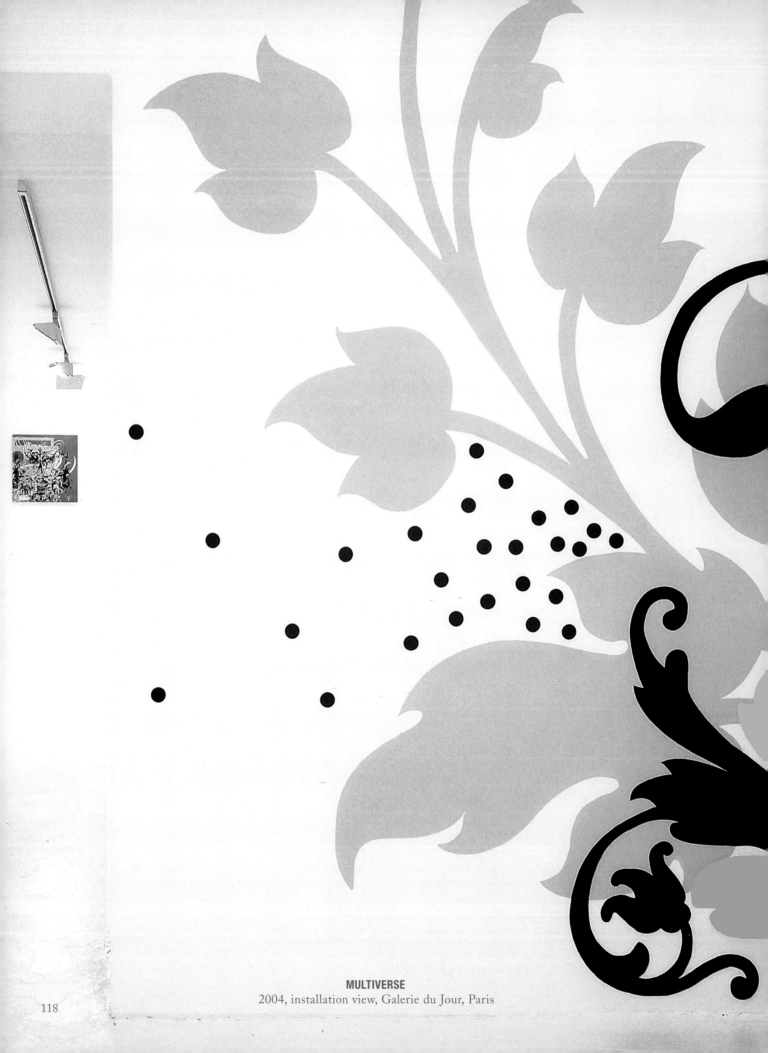

MULTIVERSE
2004, installation view, Galerie du Jour, Paris

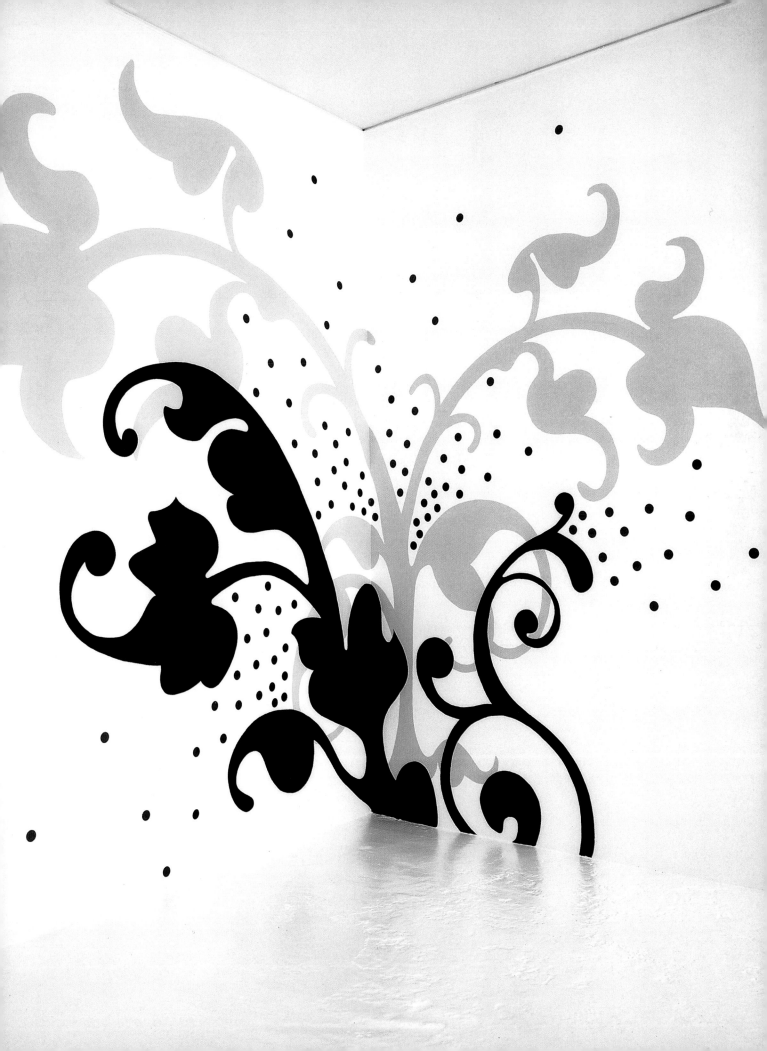

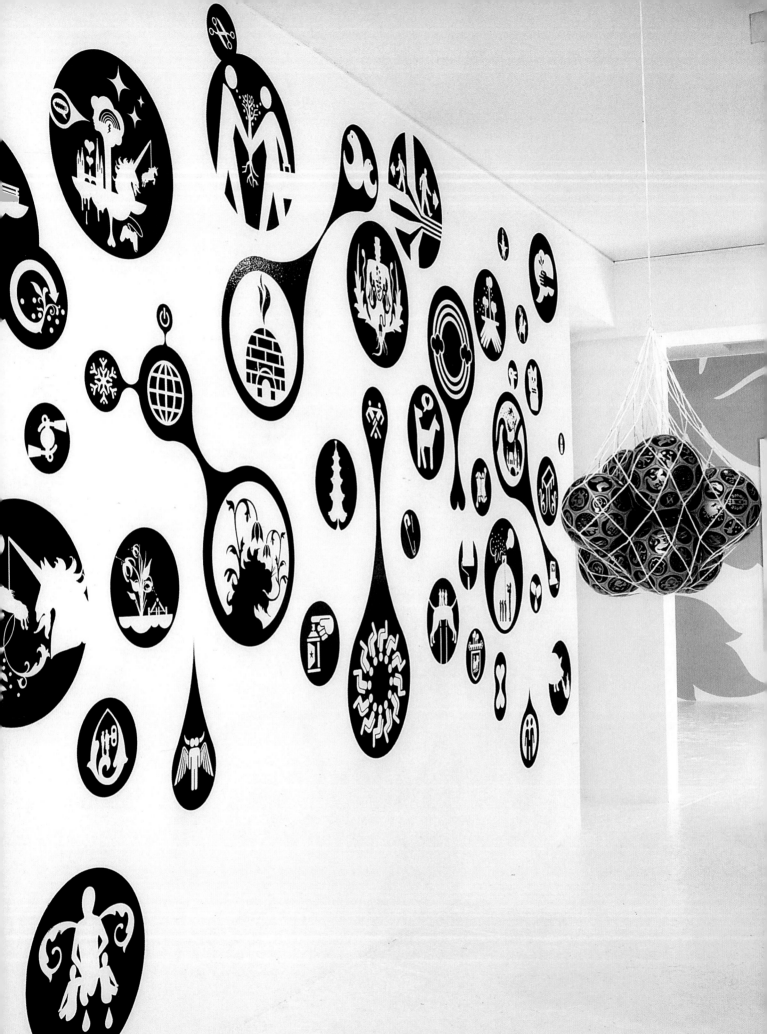

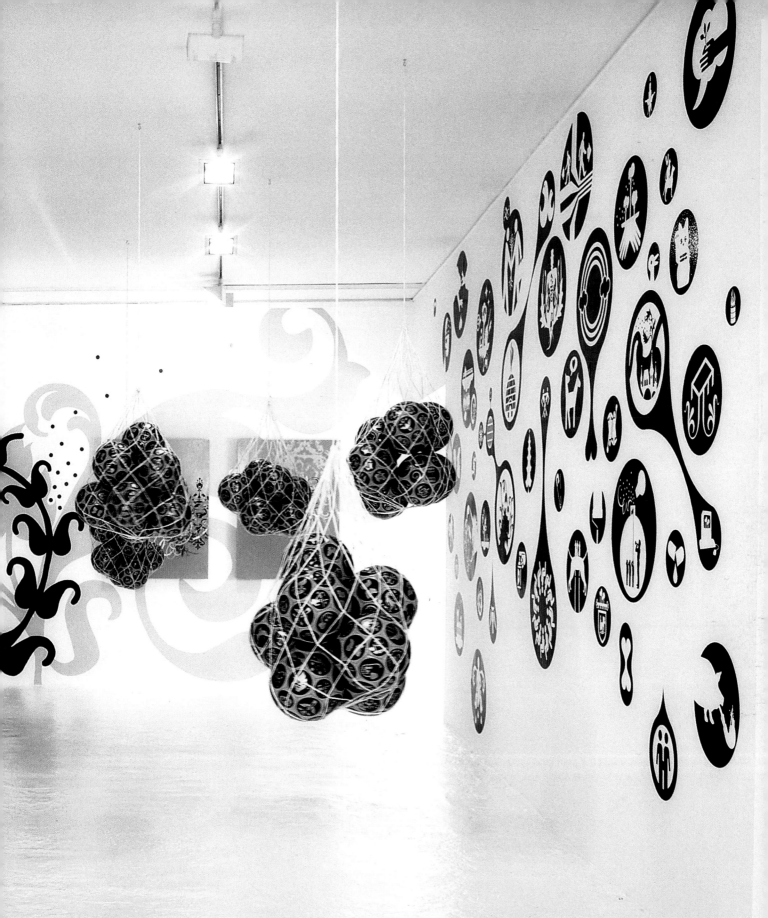

MULTIVERSE
2004, installation view, Galerie du Jour, Paris

COMPOSITE SKETCH STUDY 2005, ink on paper

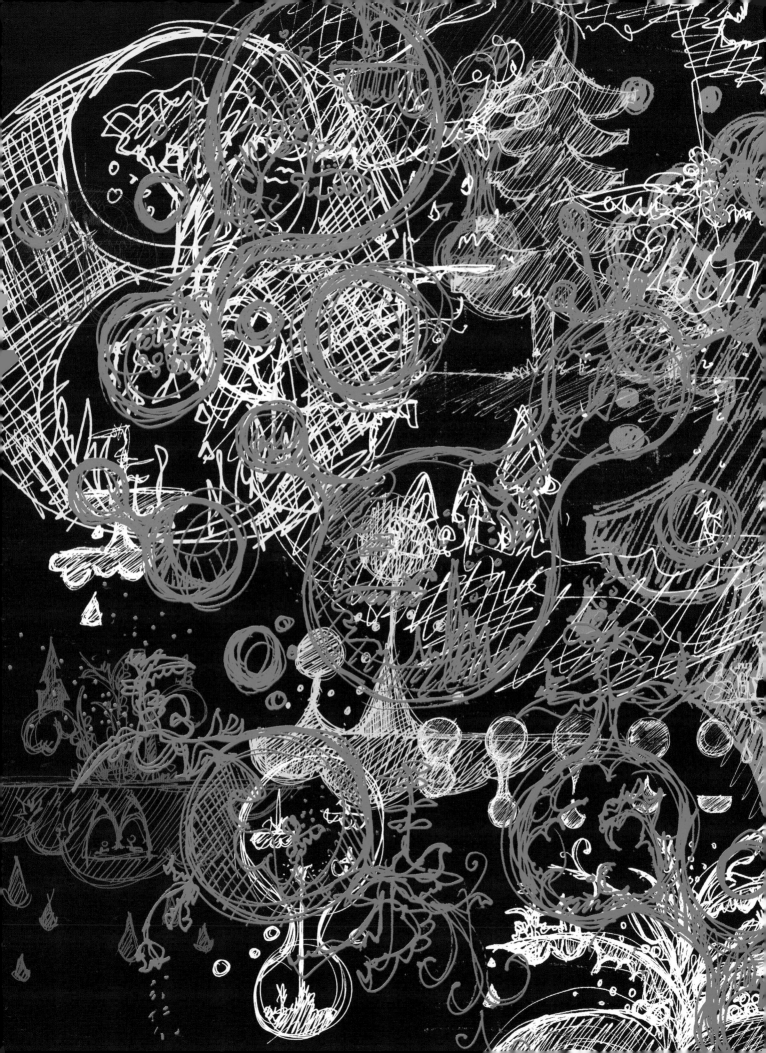

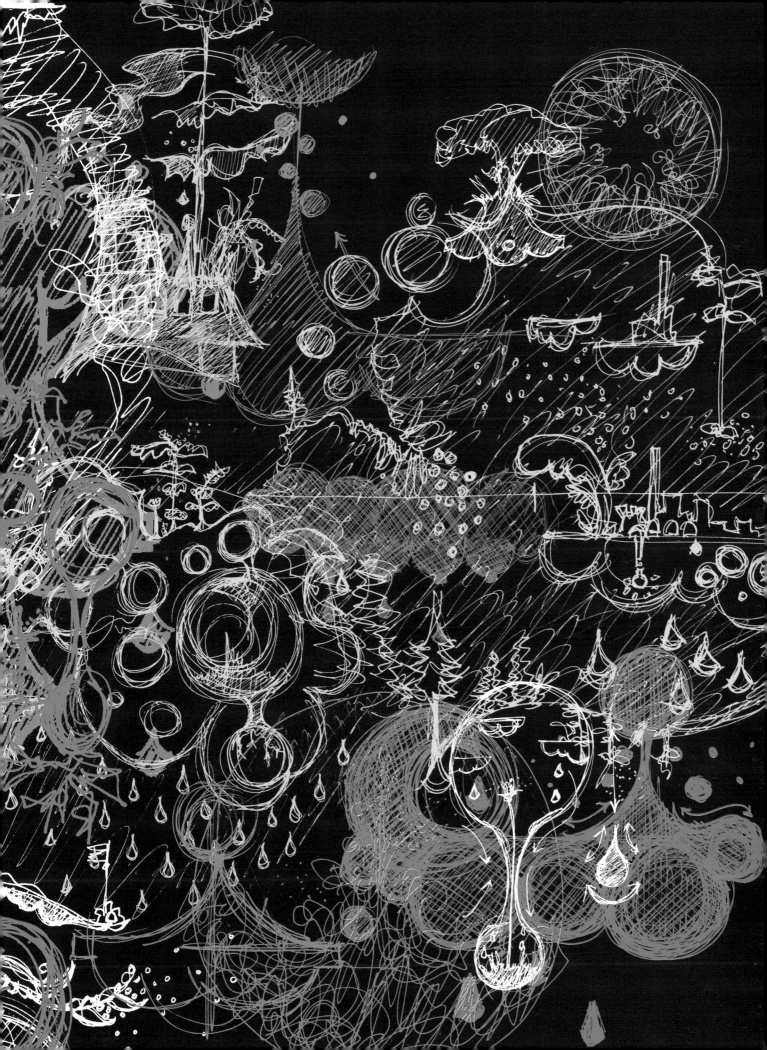

COMPOSITION STUDIES 2001-2005, ink on paper, dimensions vary

COMPOSITION STUDIES 2001-2005, ink on paper, dimensions vary

127

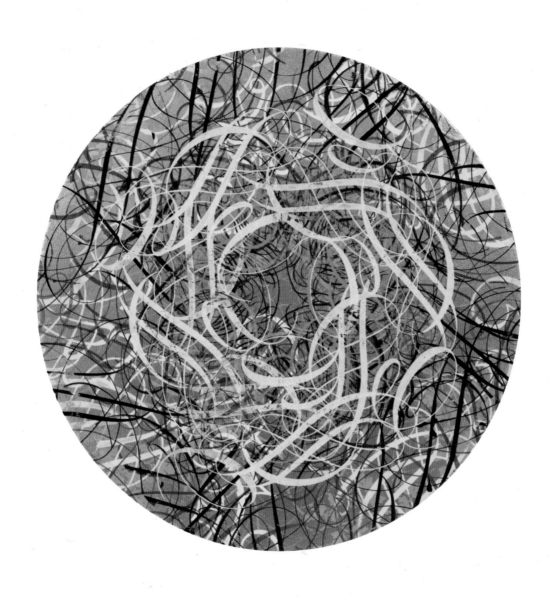

RECORDING LOOP
2005, acrylic on canvas, 30 in. diameter

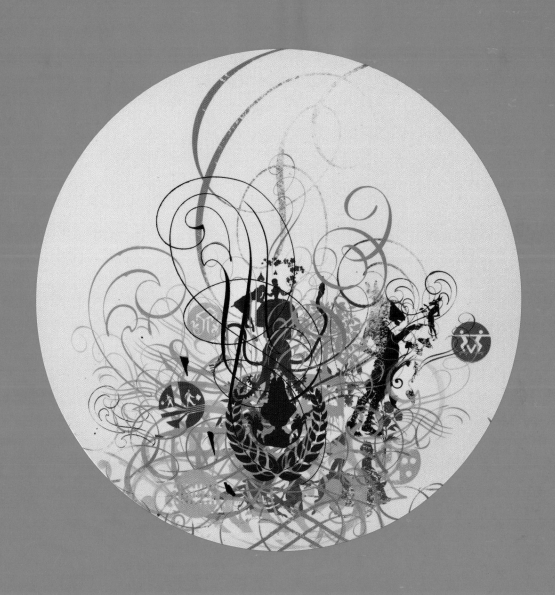

SCRIBBLE & TWEAK
2005, acrylic on canvas, 30 in. diameter

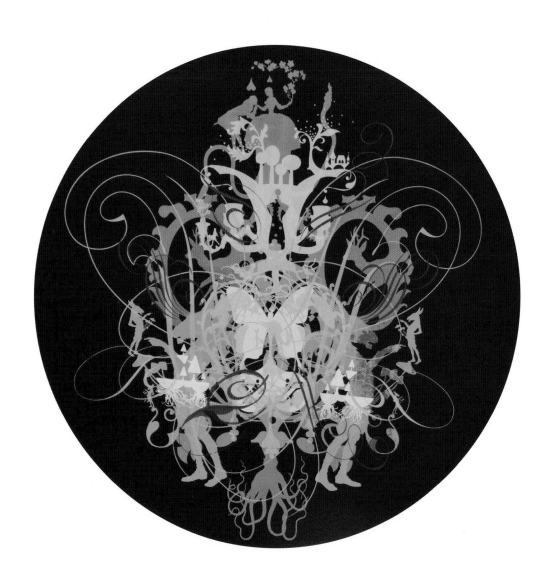

RHYME & REASON
2005, acrylic and urethane alkyd on wood panel, 24 in. diameter

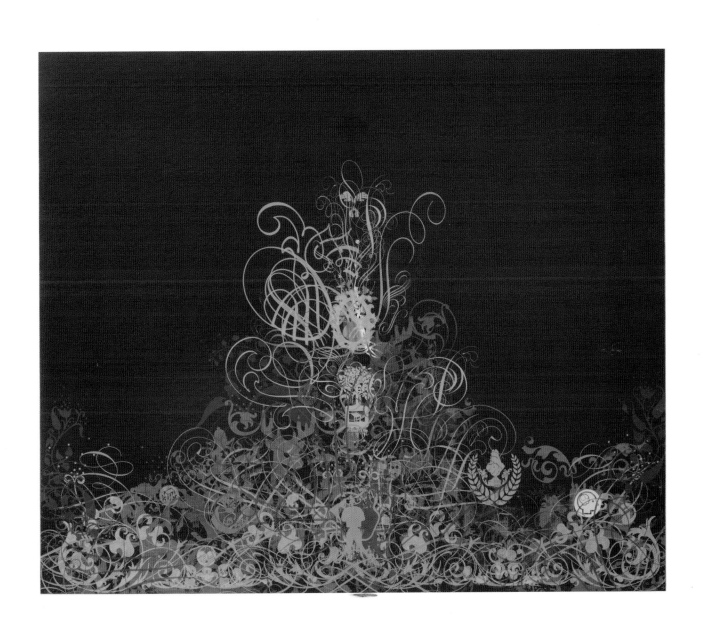

SURRENDER
2005, acrylic on canvas, 60 x 72 in.

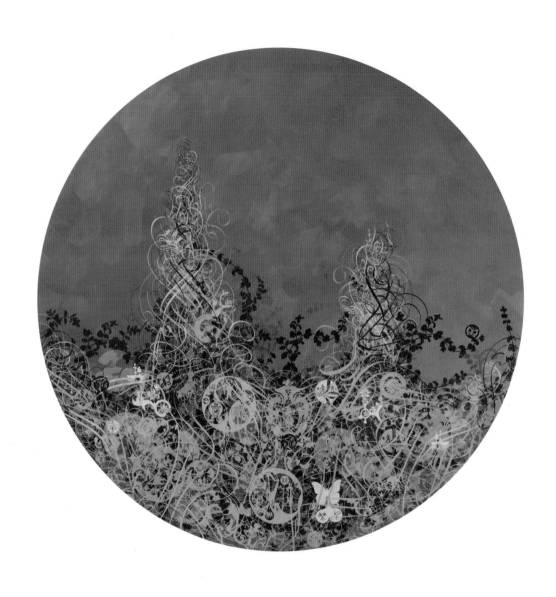

ONCE NONE
2005, acrylic on linen, 72 in. diameter

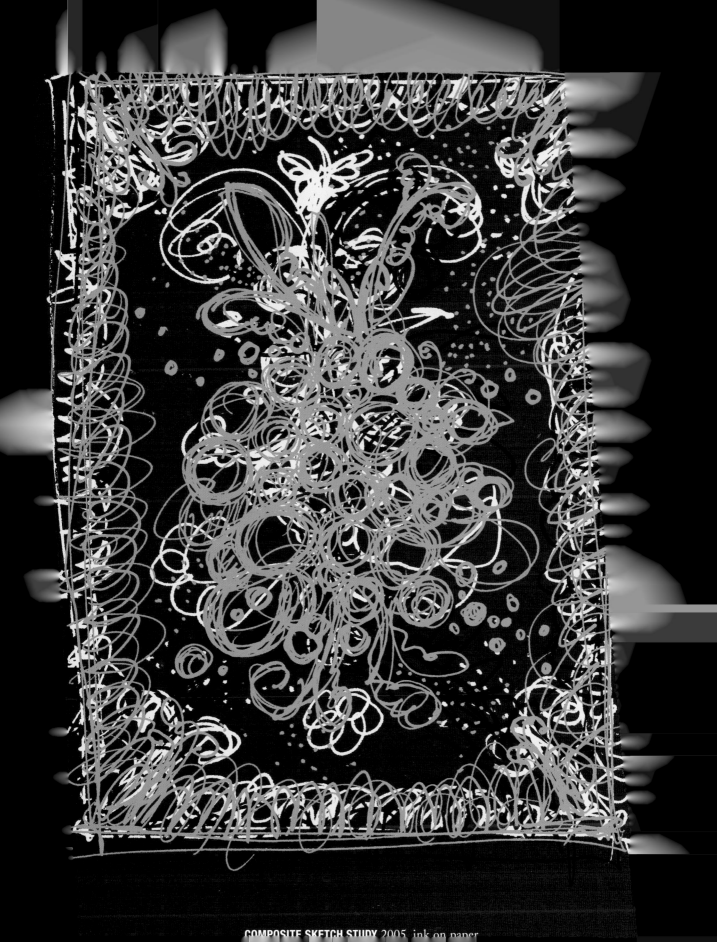

COMPOSITE SKETCH STUDY 2005 ink on paper

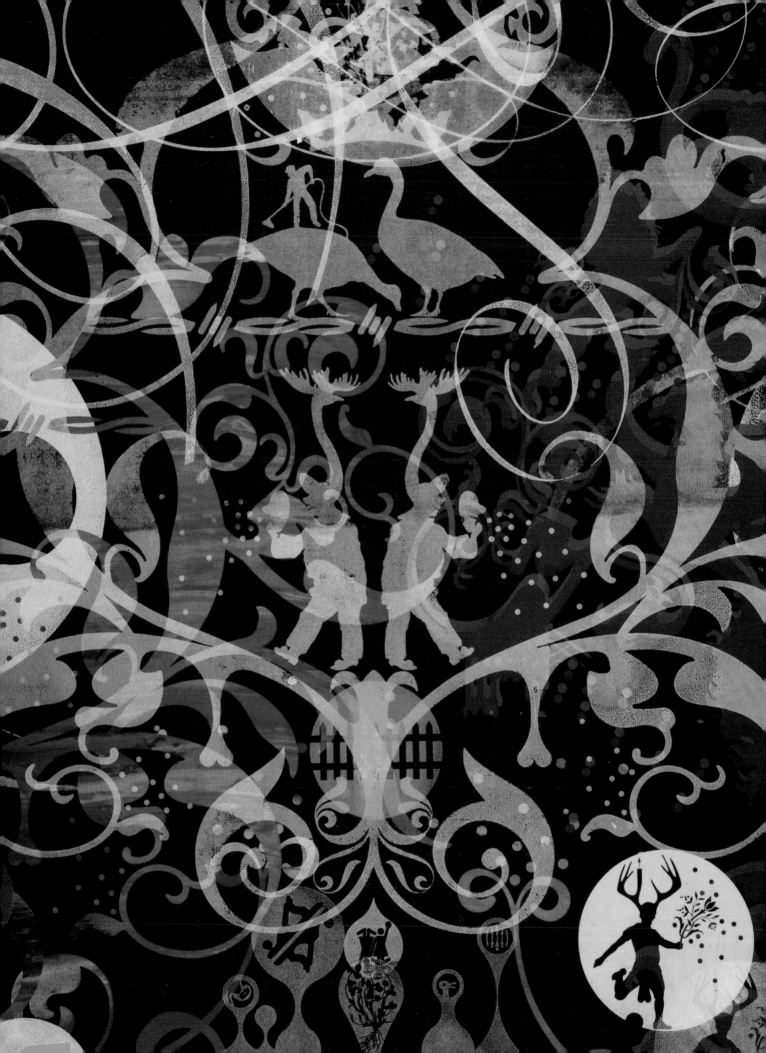

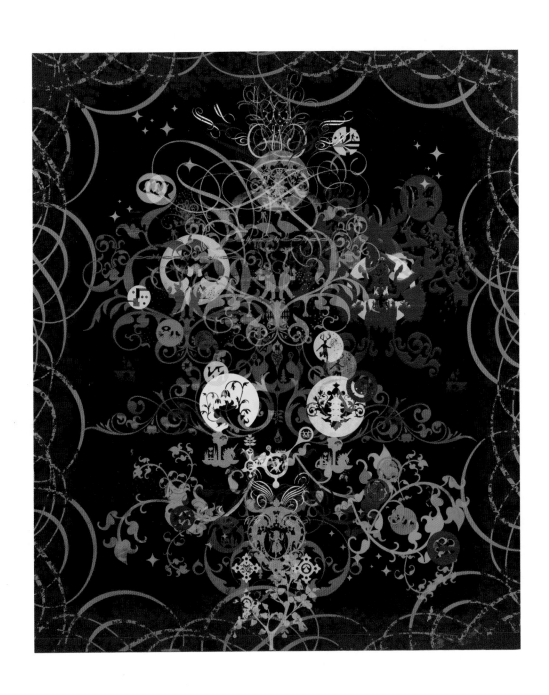

DESTINY VS. AMBITION
2004, acrylic on linen, 72 x 60 in. (detail on opposite page)

EXPOSURE COMPENSATION

HUSTLE MUSCLE

WHO GETS THE LAST LAUGH NOW?

THE TRIUMPH OF TIME

IAN CURTIS
SUBSTANCE

GLORY HOLE

THEY CAME TO SEE WHO CAME

THEY CAME TO SEE WHO CAME

COMPOSITION STUDIES 2000-2005, ink on paper, dimensions vary

COMPOSITION STUDIES 2000-2005, ink on paper, dimensions vary

COMPOSITION STUDIES 2004, ink on paper, dimensions vary

COMPOSITION STUDIES 2004, ink on paper, dimensions vary

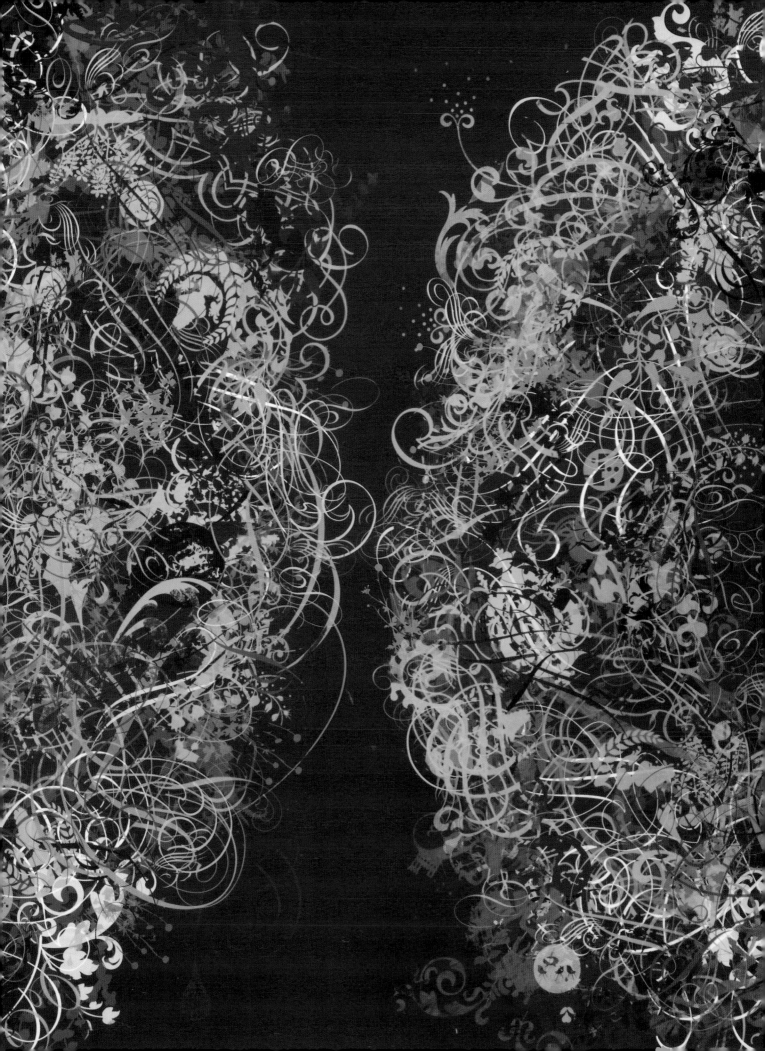

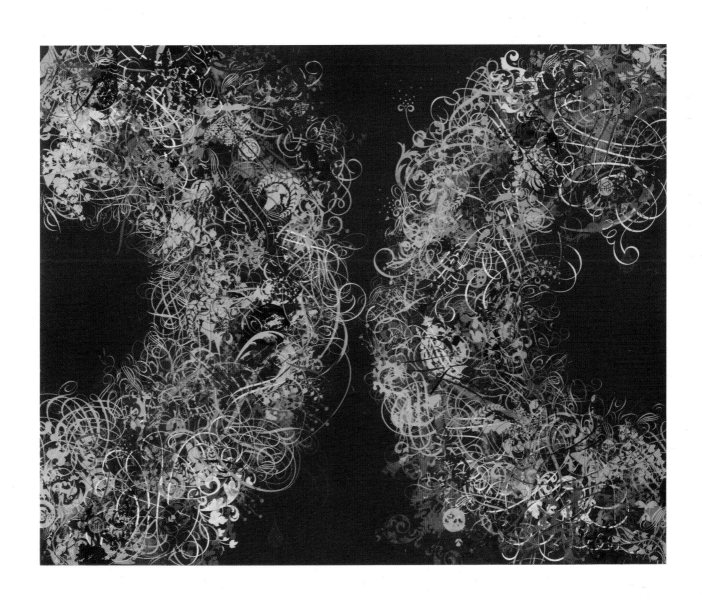

SEMIOTICS VS. METASEMIOTICS
2005, acrylic on canvas, 72 x 90 in. (detail on opposite page)

COMPOSITE SKETCH STUDY 2004, ink on paper

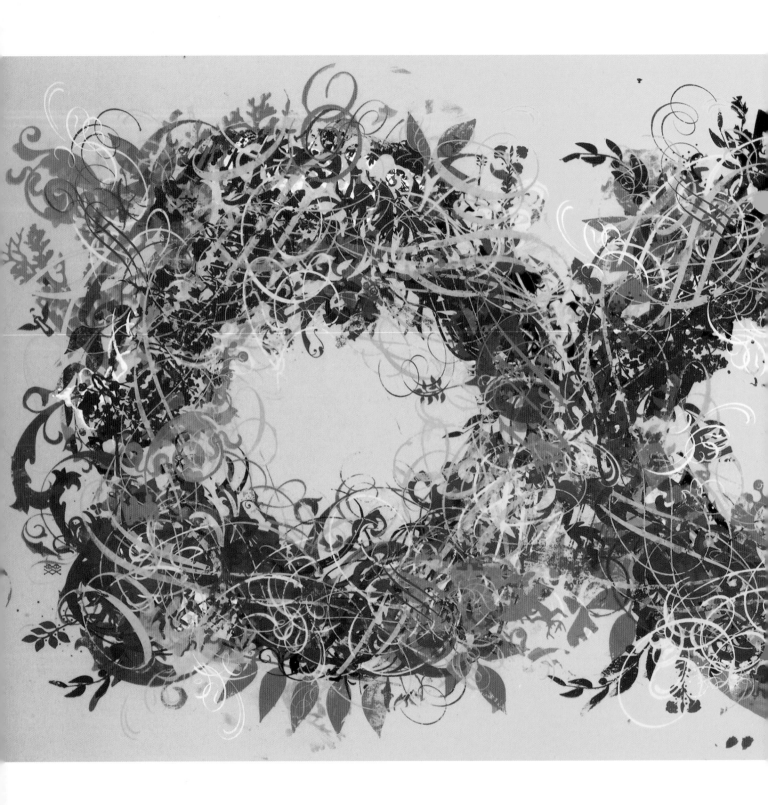

FATE/CHAOS/DESTINY
2004, acrylic on canvas, 42 x 96 in.

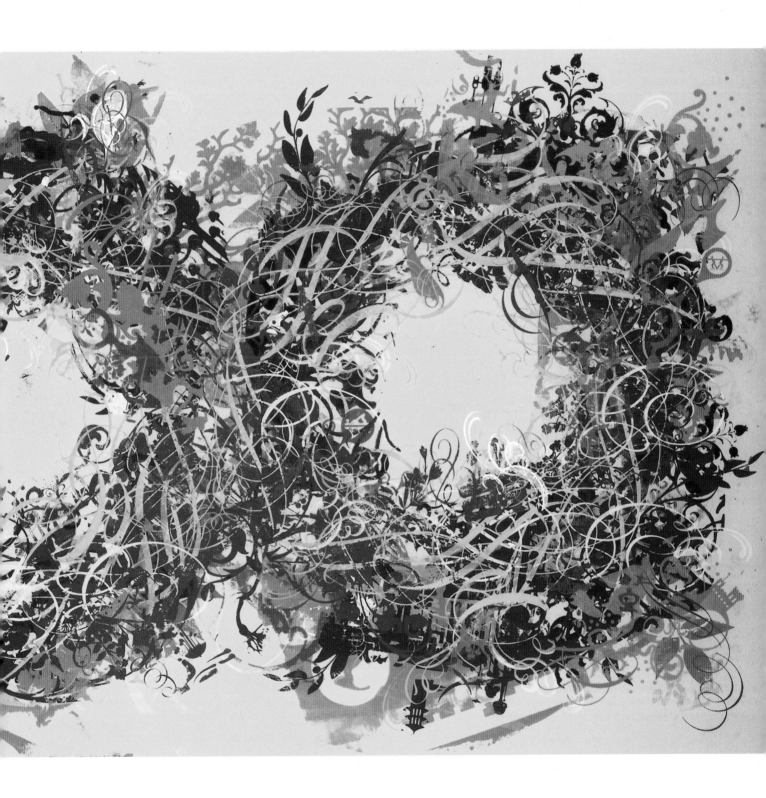

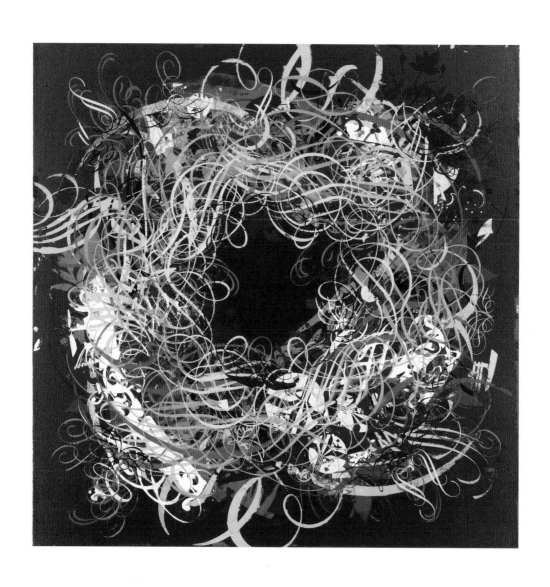

RUDY RAVIOLI
2004, acrylic on canvas, 36 x 36 in.

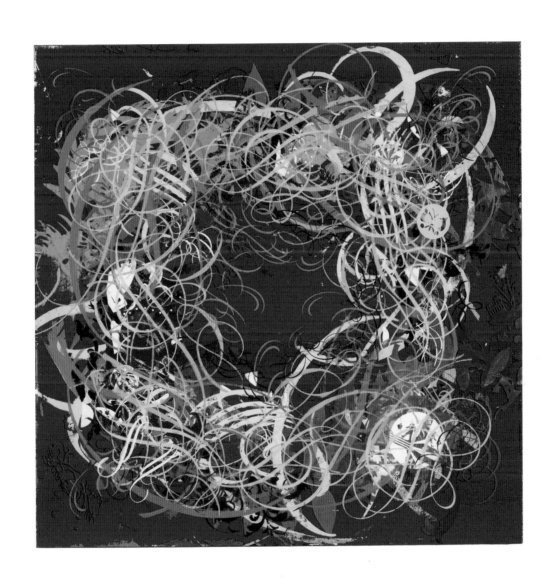

SHUT UP INFINITY
2004, acrylic on canvas, 30 x 30 in.

COMPOSITE SKETCH STUDY 2003, ink on paper

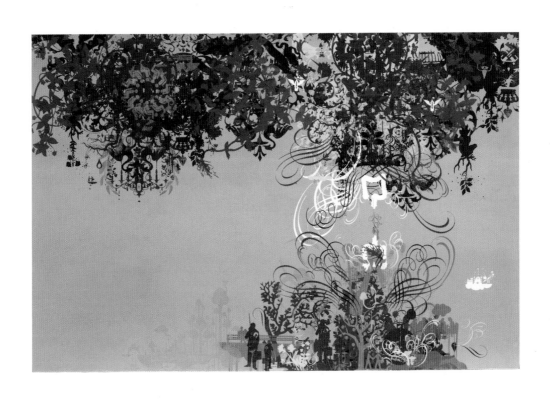

JACK OFF TRADES, MASTER NUN
2004, acrylic on canvas, 48 x 72 in.

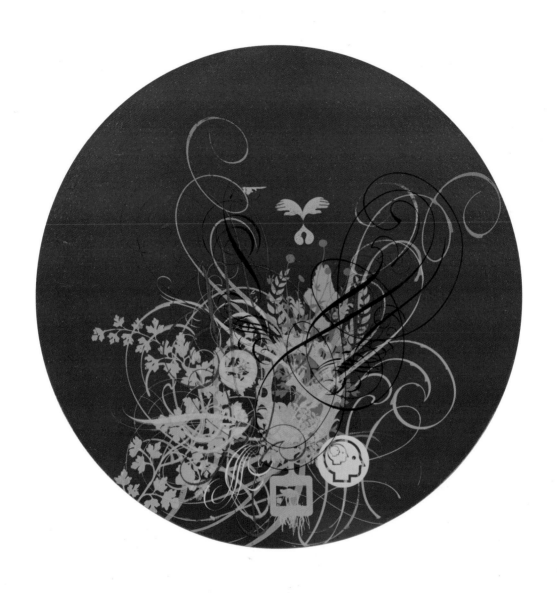

SOCIOFRAUDE
2005, acrylic on canvas, 30 in. diameter

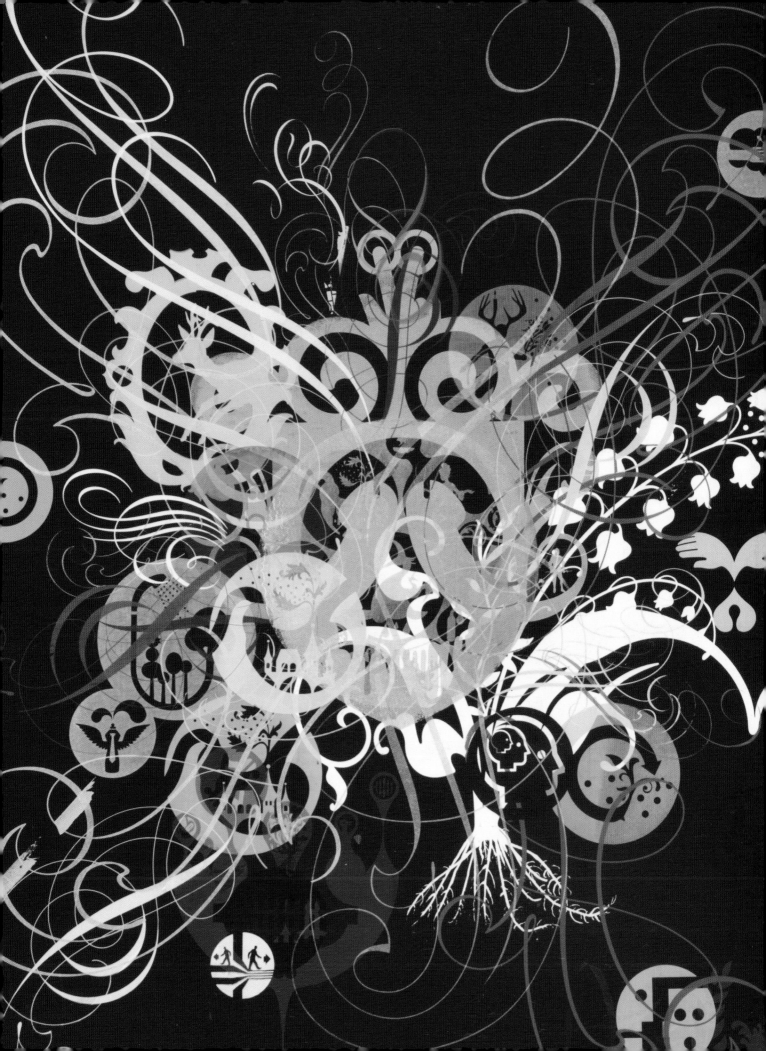

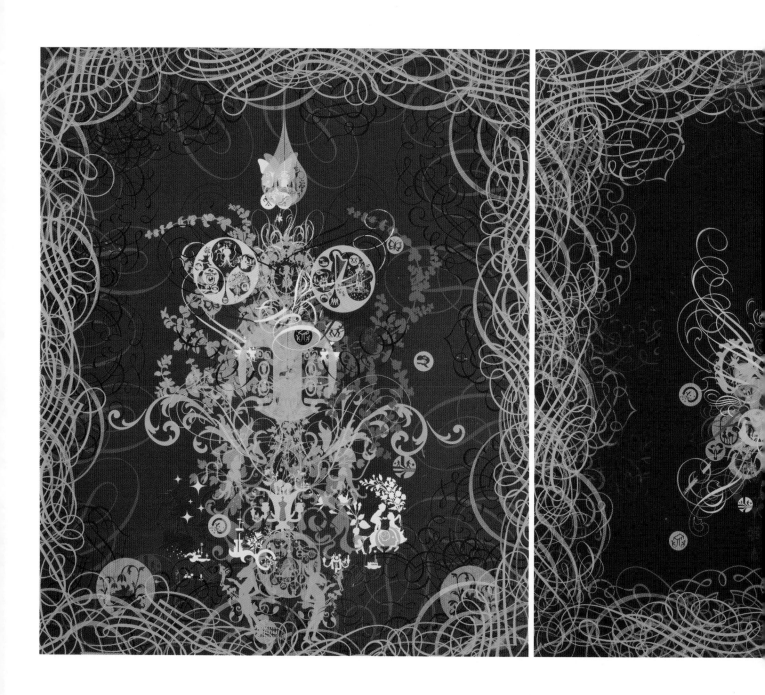

UNDER FIVE CHAIRS, PSYCHIATRISTS WINK
2005, acrylic on canvas, 72 x 180 in. (detail on previous page)

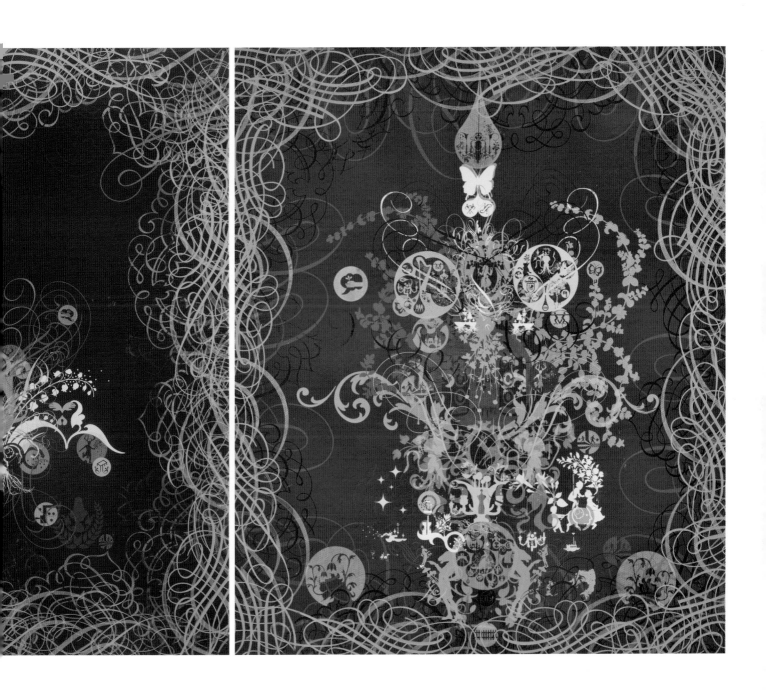

COMPOSITION STUDIES 2002–2004, ink on paper, dimensions vary

COMPOSITION STUDIES 2002–2004, ink on paper, dimensions vary

COMPOSITION STUDIES 2004, ink on paper, dimensions vary

COMPOSITION STUDIES 2004, ink on paper, dimensions vary

COMPOSITION STUDIES 2002-2004, ink on paper, dimensions vary

COMPOSITION STUDIES 2003-2004, ink on paper, dimensions vary

COMPOSITION STUDY 2004, ink on paper

COMPOSITION STUDY 2004, ink on paper

COMPOSITE SKETCH STUDY 2004, ink on paper

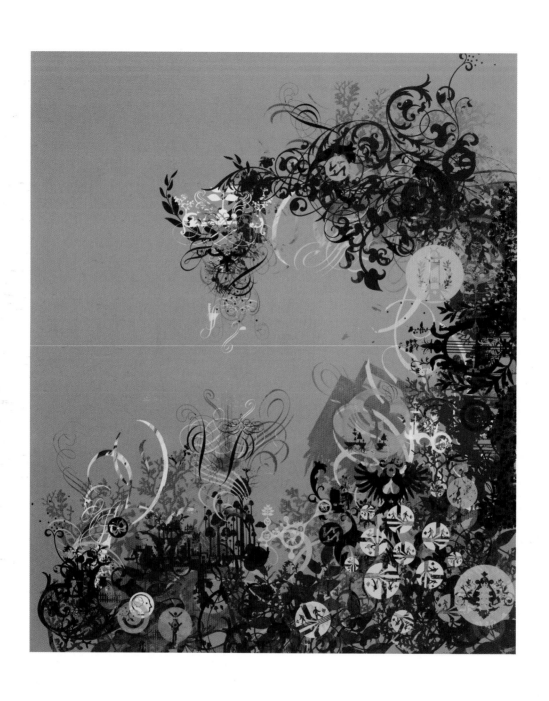

THEY CAME TO SEE WHO CAME
2004, acrylic on canvas, 72 x 60 in.

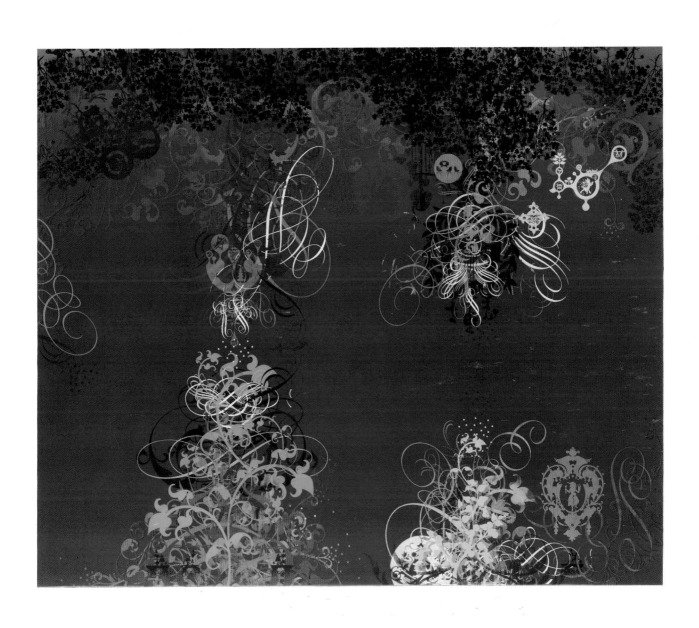

LOVE SINGULARITY
2004, acrylic on canvas, 60 x 72 in.

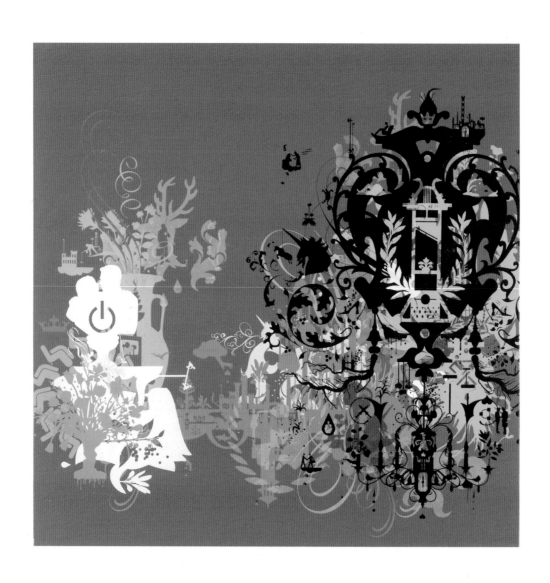

UNTITLED
2002, oil and silkscreen ink on wood panel, 30 x 30 in.

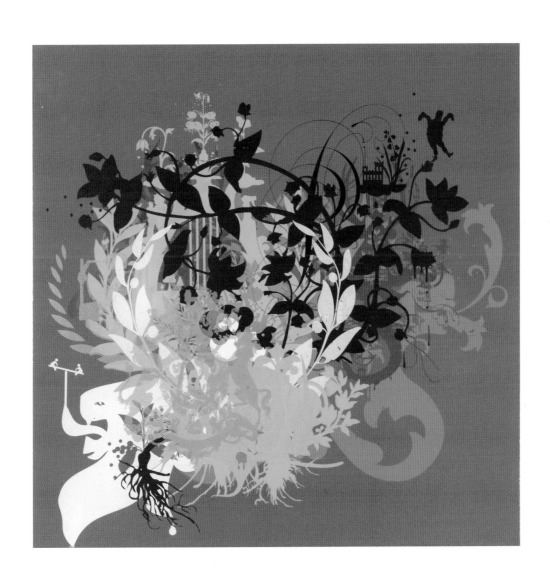

UNTITLED
2003, oil and silkscreen ink on canvas, 24 x 24 in.

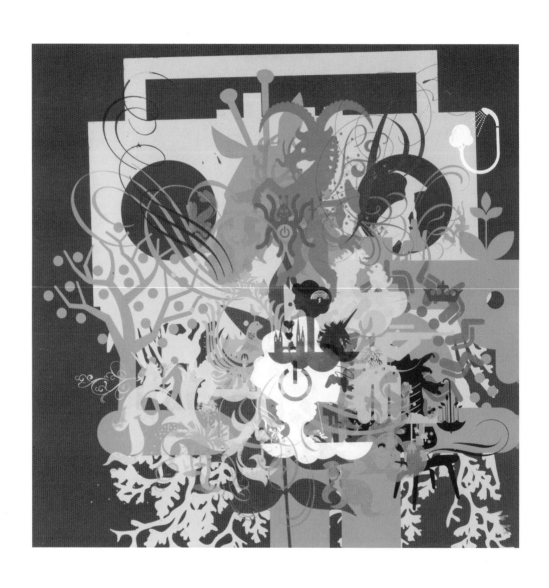

UNTITLED
2002, oil and silkscreen ink on wood panel, 24 x 24 in.

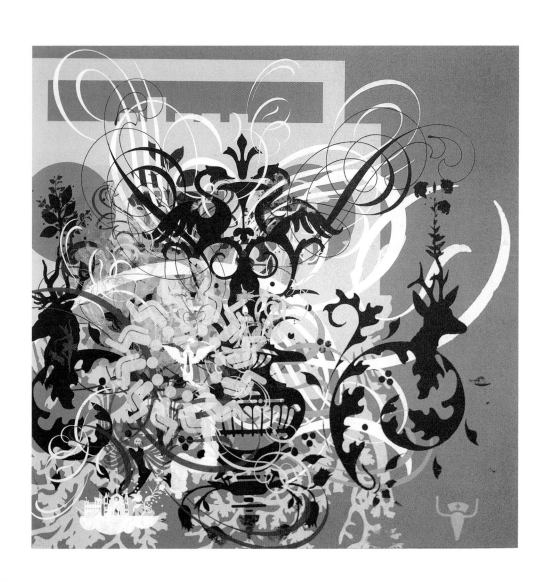

UNTITLED
2004, acrylic on wood panel, 24 x 24 in.

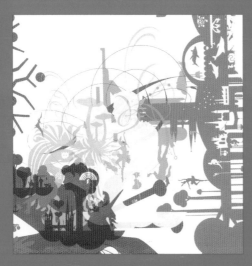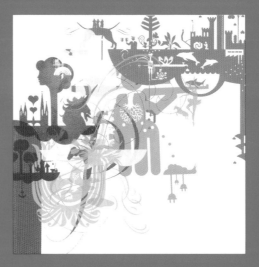

UNTITLED (THIS DREAM IS SO LIFE-LIKE SERIES)
2002, oil enamel and silkscreen ink on wood panels, 12 x 12 in. ea.

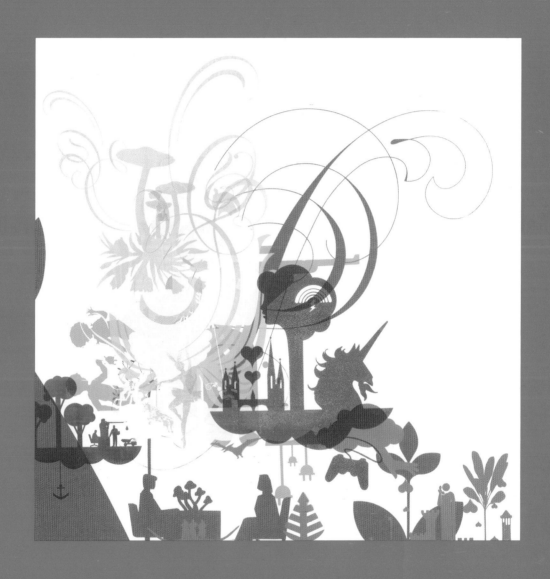

UNTITLED (THIS DREAM IS SO LIFE-LIKE SERIES)
2002, oil enamel and silkscreen ink on wood panel, 12 x 12 in.

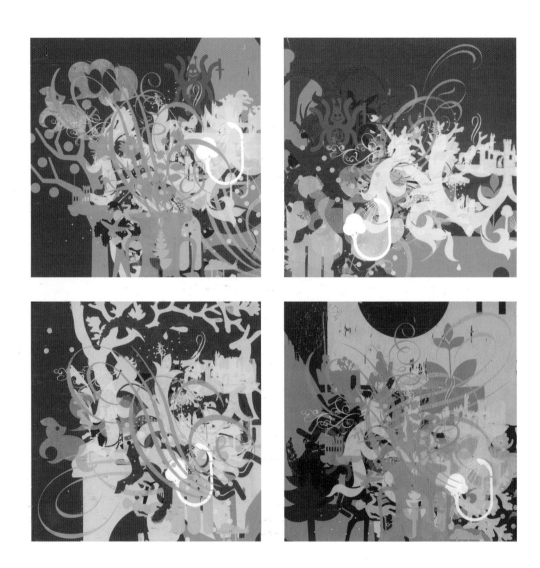

UNTITLED (THIS DREAM IS SO LIFE-LIKE SERIES)
2002, oil enamel and silkscreen ink on wood panels, 12 x 12 in. ea.

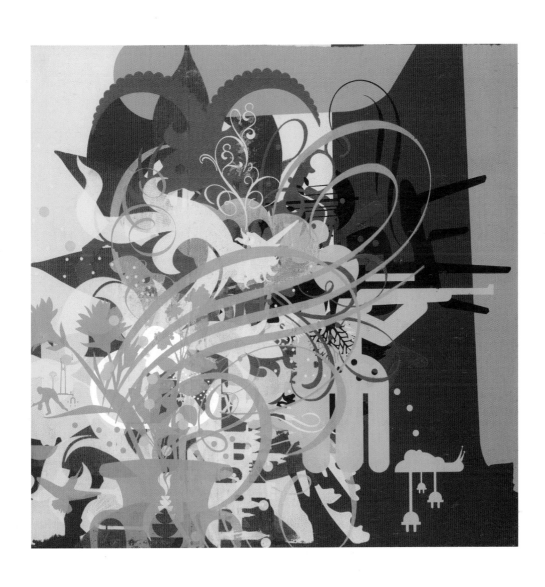

UNTITLED (THIS DREAM IS SO LIFE-LIKE SERIES)
2002, oil enamel and silkscreen ink on wood panel, 12 x 12 in.

UNTITLED
2003, oil enamel and silkscreen ink on wood panels, 24 x 48 in.

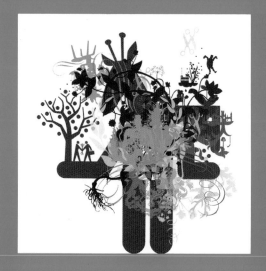

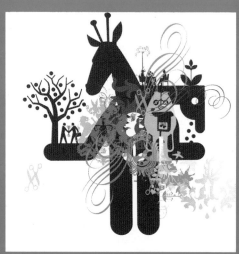

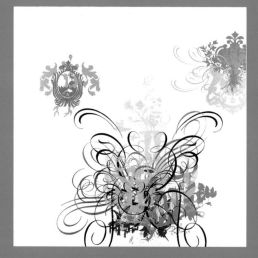

UNTITLED (PROJECT RAINBOW SERIES)
2003, oil enamel and silkscreen ink on wood panels, 30 x 30 in. ea.

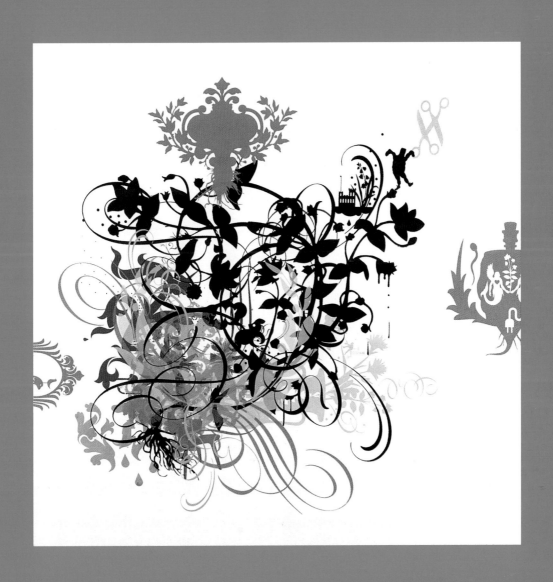

UNTITLED (PROJECT RAINBOW SERIES)
2003, oil enamel and silkscreen ink on wood panel, 30 x 30 in.

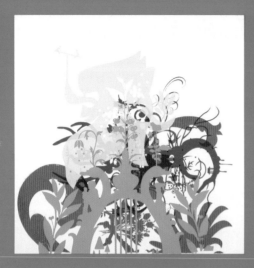
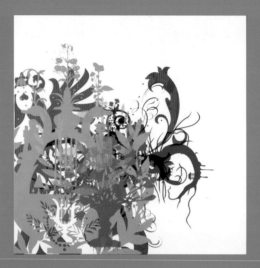
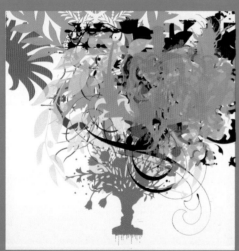
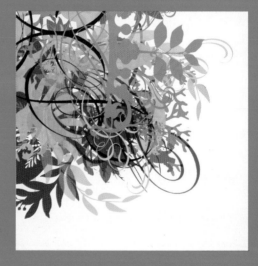

UNTITLED (PROJECT RAINBOW SERIES)
2003, oil enamel and silkscreen ink on wood panels, 15 x 15 in. ea.

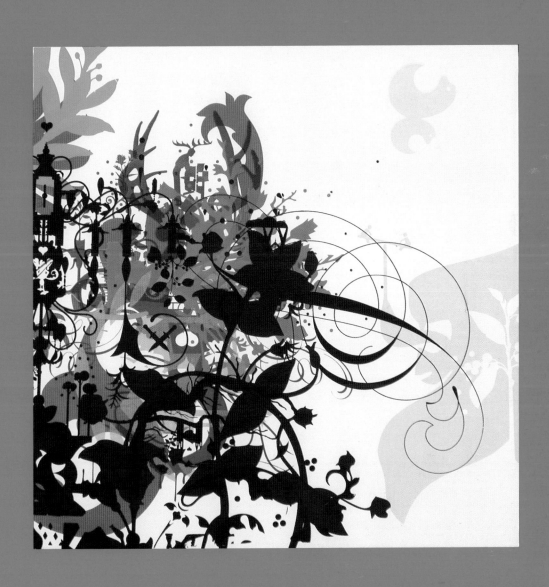

UNTITLED (PROJECT RAINBOW SERIES)
2003, oil enamel and silkscreen ink on wood panel, 15 x 15 in.

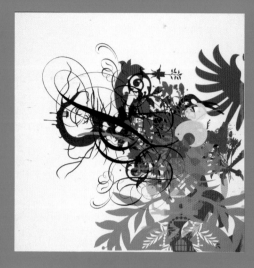
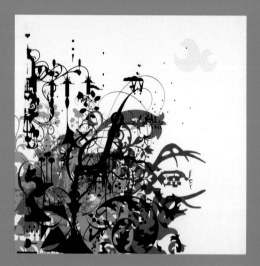
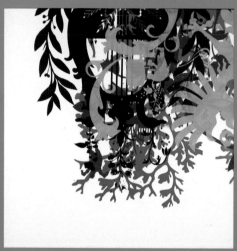
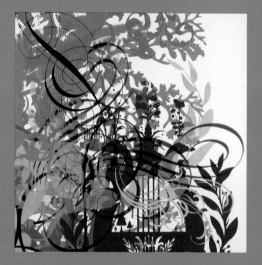

UNTITLED (PROJECT RAINBOW SERIES)
2003, oil enamel and silkscreen ink on wood panels, 15 x 15 in. ea.

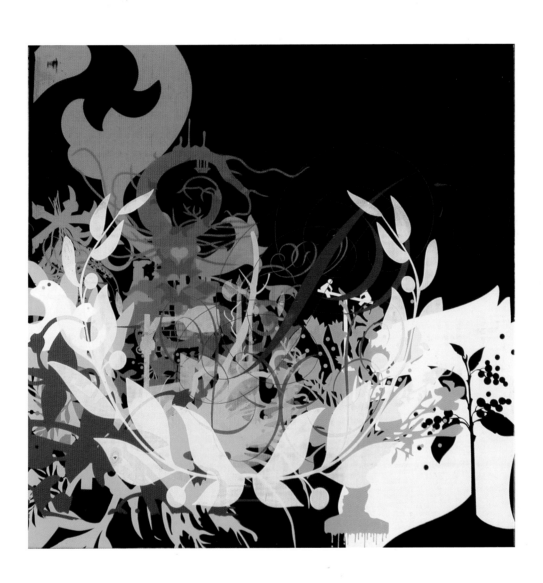

UNTITLED (PROJECT RAINBOW SERIES)
2003, oil enamel and silkscreen ink on wood panel, 15 x 15 in.

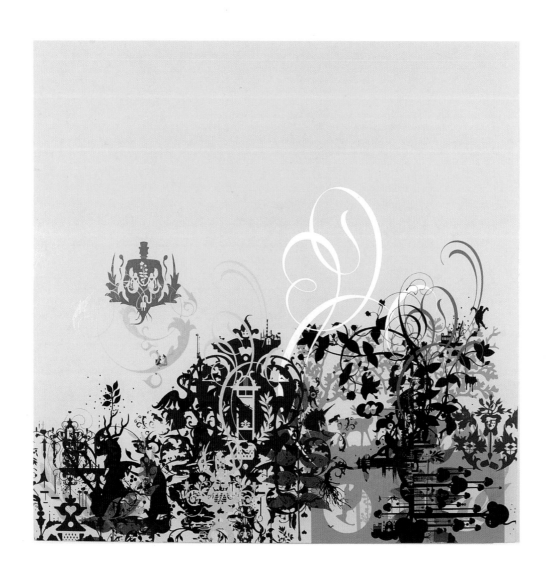

CELEBRITY TROJAN HORSE
2004, oil enamel and silkscreen ink on linen, 48 x 48 in.

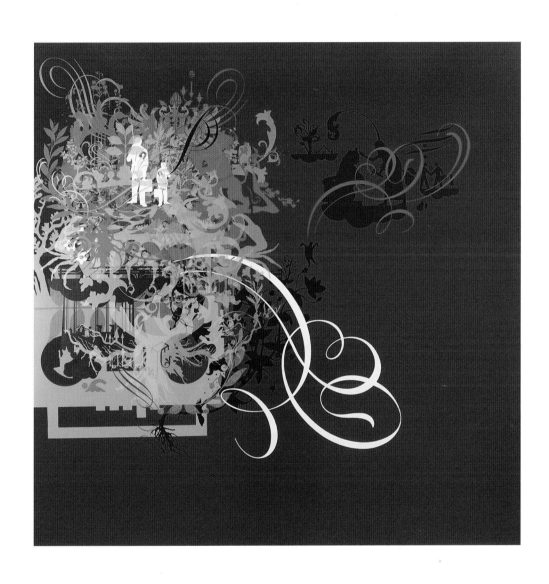

A HUNGRY MAN HAS NO CONSCIENCE
2004, oil enamel and silkscreen ink on linen, 48 x 48 in.

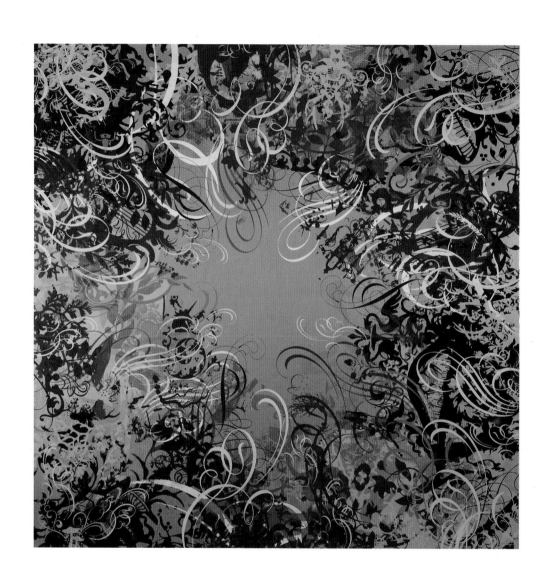

CRITIQUE OF PURE REASON
2004, acrylic on linen, 48 x 48 in.

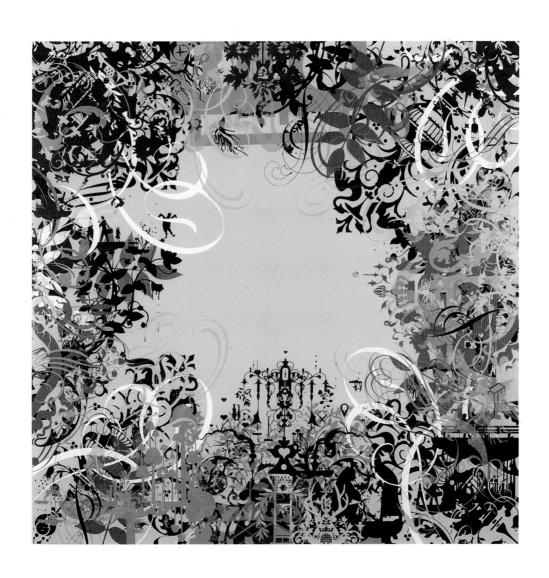

BILDERBERGERS BONES BRIGADE
2004, oil enamel and silkscreen ink on linen, 48 x 48 in.

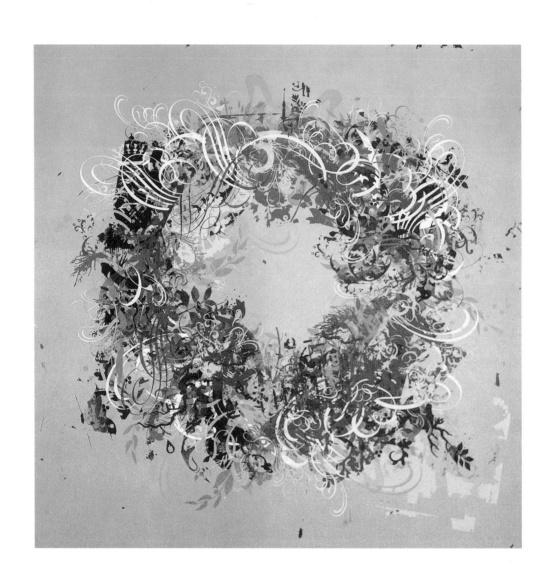

GLORY HOLE
2004, acrylic on linen, 48 x 48 in.

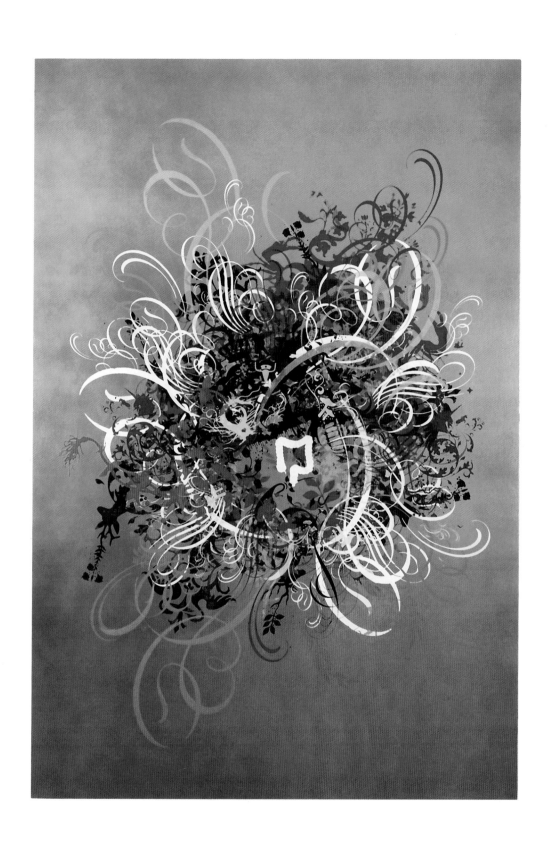

FILLER BETWEEN FEEDINGS
2004, acrylic on linen, 72 x 48 in.

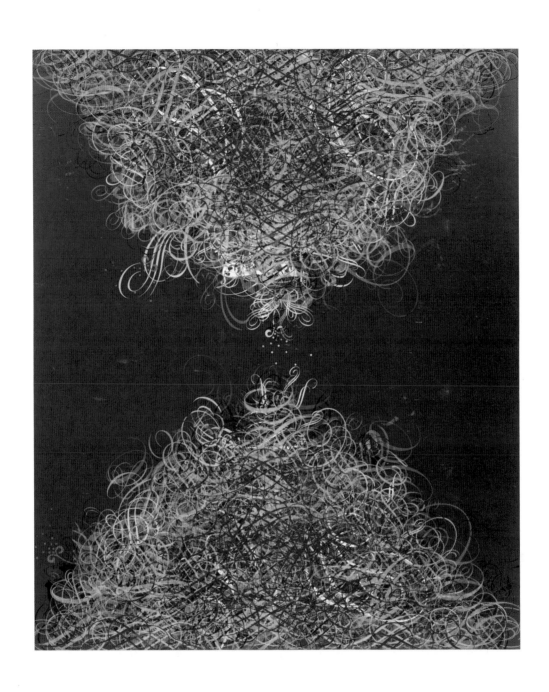

PRINCESS MATHEMATICS
2004, oil enamel and silkscreen ink on linen, 72 x 60 in.

UNTITLED (PROJECT RAINBOW SERIES)
2003, latex and silkscreen ink on wood panels, 15 x 15 in. ea.

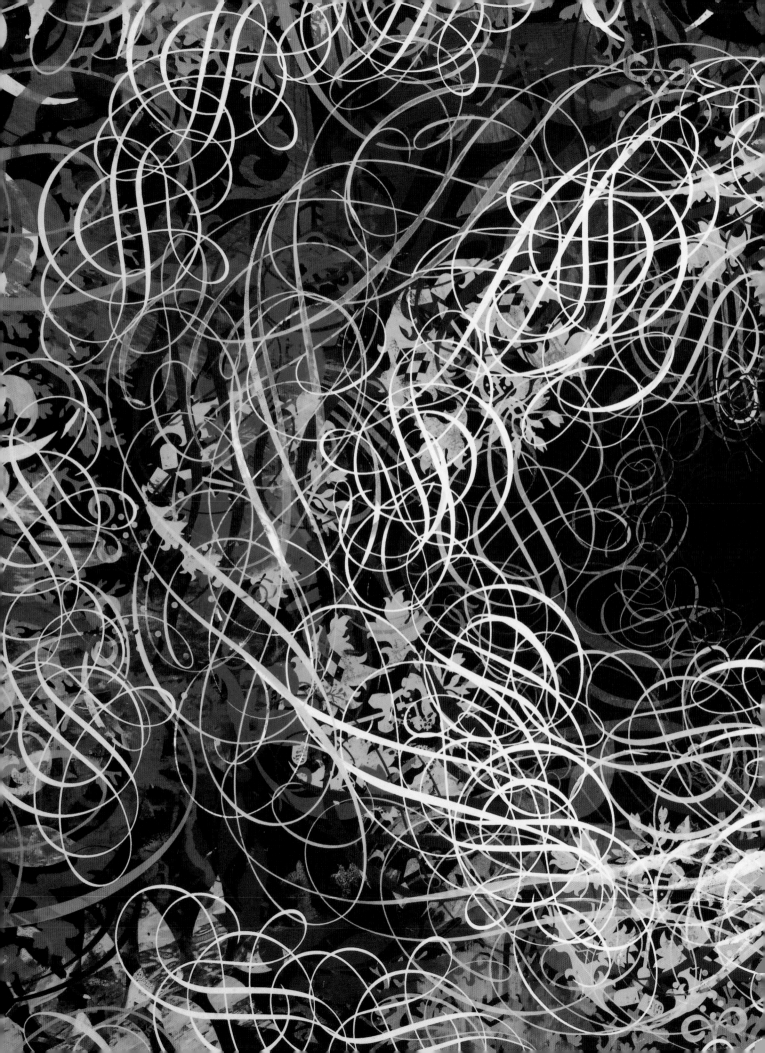

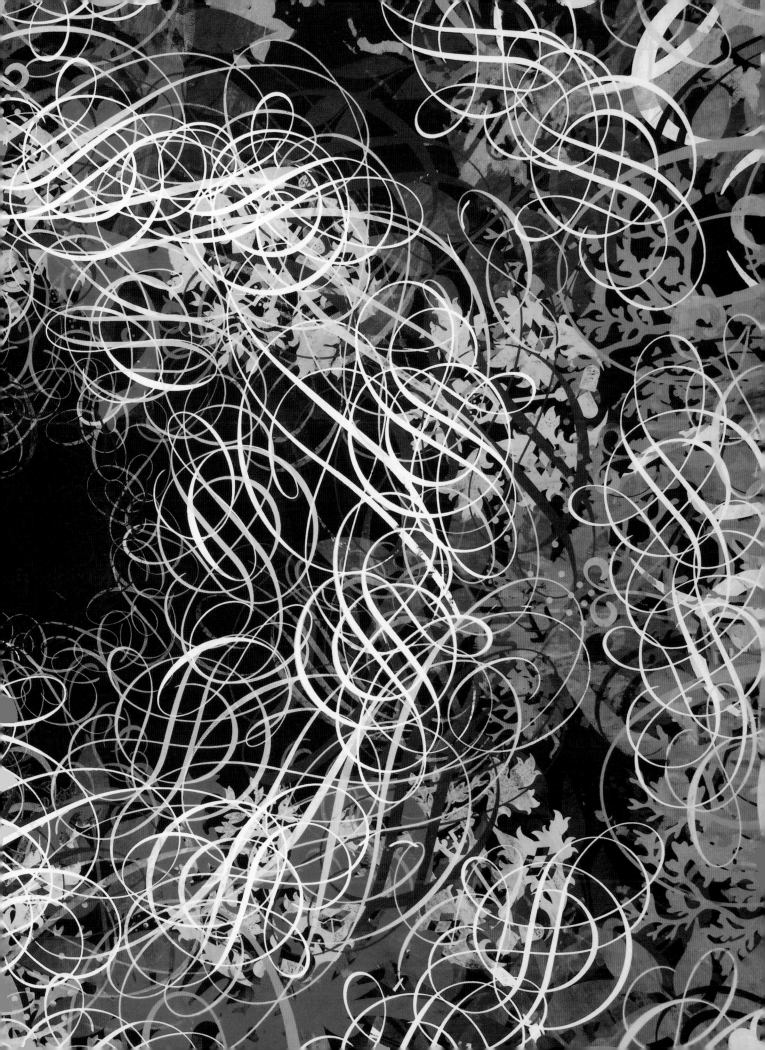

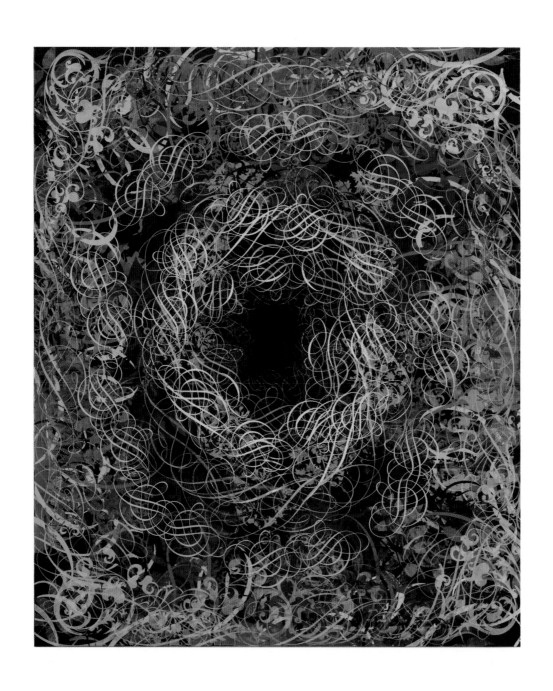

OTAKU SUICIDE
2004, acrylic on canvas, 72 x 60 in. (detail on previous spread)

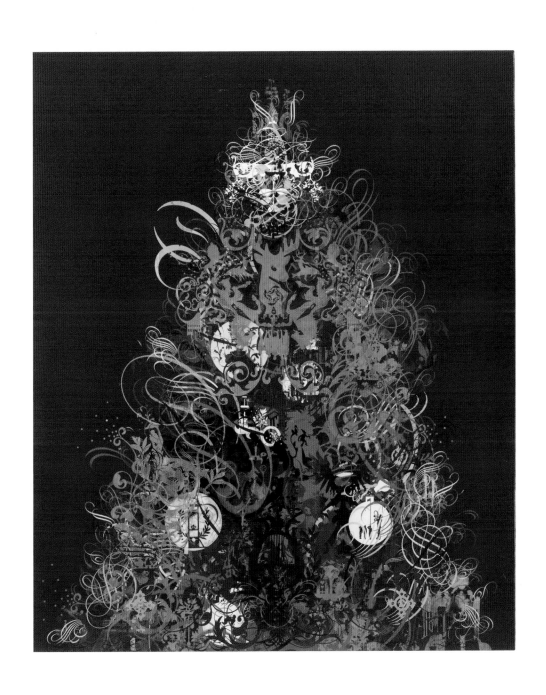

SUBSTANCE
2004, acrylic on canvas, 72 x 60 in.

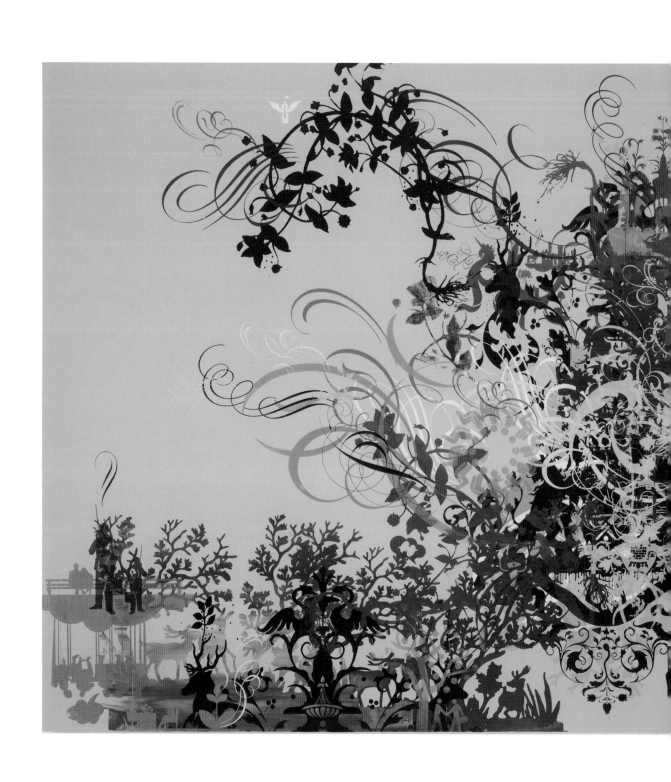

SOME DANCE TO REMEMBER / SOME DANCE TO FORGET
2004, acrylic on linen, 48 x 96 in.

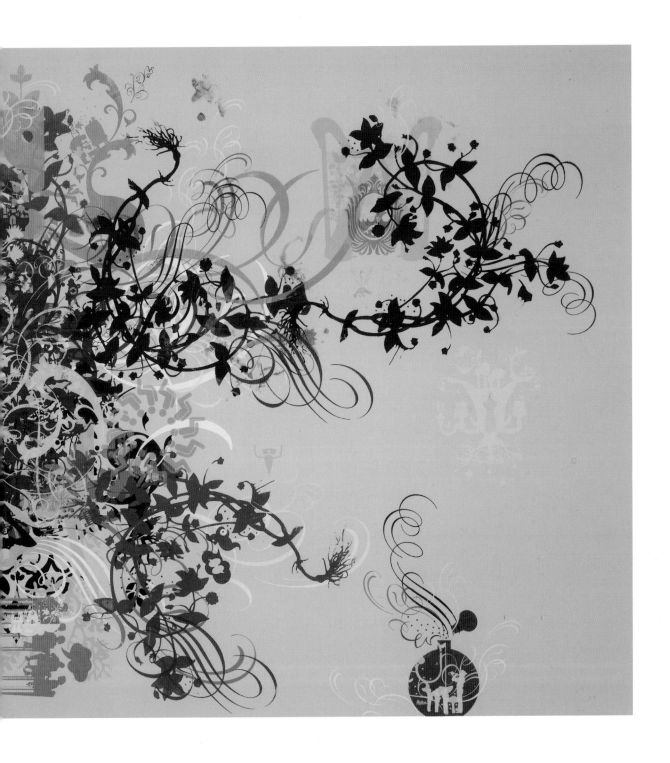

PAINTING PROCESS 2004, Ryan McGinness Studios, Inc., New York

Hybrid States

The Migration of Content and Context in Ryan McGinness' Art

Carlo McCormick

In a gallery, in a store, on the page, or on a wall, or for that matter upon pretty much any item of manufacture one can imagine, it is not so much a question of any single site Ryan McGinness may occupy as an artist but the sight lines between all his myriad contexts. If we have to situate his art, it would be somewhere in-between: neither here nor there but perversely and pervasively everywhere. Operating on the mutual understanding that the multiplication of images and emblems has both diminished meaning and accelerated understanding, Ryan McGinness articulates the multilateral as the compensation of difference. That is, for all that we may gather from an "installationview," as an extended oeuvre what we're really talking about is an instillation purview. A matter of semantics perhaps, but pictographically this kind of parsing is just what Ryan's art relishes. It is more about instillation than the mere placement of an installation, as McGinness likes to intro-

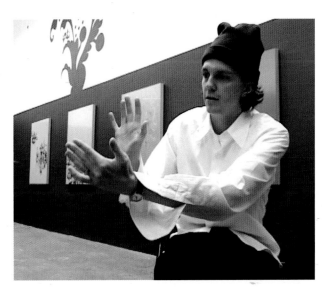

METROPOLIS Spanish TV Program, 2003, Ryan McGinness at *Worlds within Worlds* Exhibition, Deitch Projects, New York, Directed by Monica Blas

duce—or implant—his ideas and methodologies gradually. Indeed, if no single view is satisfactory, we need a purview that encompasses not merely a range and scope, but the manifold degrees to which he addresses function, power, comprehension, and experience.

At the nexus of fulfillment and desire, McGinness's super-saturated pictograms speak directly to the systematic efficacy and incipient self-nullification of our communications age. His art is surely seductive, but it is likewise remarkably self-referential to the manipulative means by which we are taught to want. This is design in the most fundamental sense of the term, but it is design without designation.

On first impression of McGinness's early work, I can quite distinctly recall the reaction that this was just bad clip art. For those of us not too savvy, a younger generation was coming up with a very articulate map of how signs functioned—born, it seems now in retrospect, as if the anatomy of cultural consciousness had grown an extra vertebrae—in ways that were applicable to both fine art and commerce. No matter how many bridges had already been built and crossed, that drive to now marry this sacrosanct separation between church and state was unfathomable still. Of course, the formative work represented in *Flatnessisgod* holds up quite well over time, its prescience an exponential measure of its continued relevance. What is proffered in these pages, however, is the unmistakable evidence of just how much more sophisticated McGinness has become in his visual strategies.

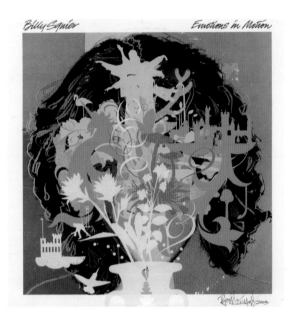

EMOTIONS IN MOTION 2003, silkscreen ink over Andy Warhol-designed Billy Squier album cover

A simultaneous confluence and diversification of methodologies, the art of Ryan McGinness is predicated on its utility. Toward that modernist equation of form following function, McGinness inserts a more radical quotient where form and function are in subservient correspondence to an imperative of adaptability. Hybridity is everywhere in the process and effect of McGinness's art, be it form, venue, or the dynamics of representation. We might easily call this democratic work by sheer virtue of its accessibility and affordability, but it is more than that—the inclusivity and malleability McGinness embraces in his studio/laboratory, crossbreeding product, design, and fine art, is a direct affront to the autocracy of any individuated domain. McGinness has a wonderful way of coloring outside the lines with an intellectual precision and engineered exactitude. The results are meant to be confusing—a maze of signs that perpetually cannibalize themselves and lead us to infotainment cul-de-sacs as if they were grand vistas—but unlike so many who speak to this contemporary confusion, McGinness is eminently cognizant every step of the way. Where others are so easily subsumed by the maelstrom of mass communication, this great communicator finds the repose by which to enjoy the overlay. Whether he's working with merchandizing, paintings, or even directly on dollar bills, McGinness makes opaque the aesthetics of

commerce. For him, anything that can be bought or sold, that is an object of desire, or more discretely the immaterial wrapper by which we package the expectation of desire, is of a singular currency. This multi-denominational currency is the flow that carries the entire oeuvre, the electricity that illuminates our waking dreams.

Just as we can now see exactly what types of expressions were emblematic of the culture wars, it is probable that the work of Ryan McGinness will be quite legible in due course as the kind of art pushing against the embattled boundaries of our current fight over artists' properties. Authorship and ownership are hypothetical values that he has little interest in making concrete, but would rather contort into convoluted riddles of identity. His art is his signature, his signature his art, both bearing a distinct trademark yet born of our latent file-sharing tendencies toward a new public domain paradigm. Yes, it's ultimately about property, but it only arrives at its estate as a matter of trespass. Everything is for sale except the artist himself, and it all comes with an unmistakably perilous caveat emptor. This is truly art in the age of pluralism, meanings assembled in the cross-firing synapses of mass mediation. There is an internal logic, a psychology that invokes the self without accessing it, and a quantifiably conceptual bent to his work as a multifaceted project that gives it all a dimensionality and depth, but it is all rendered as pure surface. Surface for McGinness is not merely the tasty icing by which he makes confection of our chaos; it is the veritable skin of content—the definition of whatever vessel or vehicle it may coat. He plays with the allusion (not illusion) of space as a tapestry of interconnectivity laid out in the digital bytes

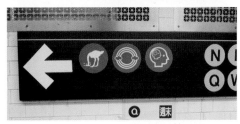

SUBWAY SIGNAGE PROPOSAL 2002

and oceans of billboards we have come to read as architectures of the real world.

McGinness adopts the didactics of representation as the elements of style, disseminating his dissembled narratives like a meme that can attach itself to anything. And what makes anything more of a painting than, say, a sneaker? They are both products of non-hierarchical distinction in Ryan's eye. Wherever we see the undeniable impressions of the artist's hand, they are registered like the traces of a touch that is as much reproduced as rendered. Figuration becomes the abstract cipher by which we can read the nullification of meaning as an autonomous zone. Abstraction itself is just another way in which we see how meaning piles up as an accumulation of signs in the void of authenticity. What we see is what we read, and what we read is how the universality of commonalty (does not every expression register an emotion?) has collapsed whatever fictional delusions we may still have to hold subjective understanding apart from objective truth. The picture is an advertisement for itself.

MOMA POSTCARD
1999, offset printed postcards inserted into postcard racks
in The Museum of Modern Art Bookstore, completed piece
includes postcard, receipt, and bag, approx. dimensions
11 x 8 in., edition unknown

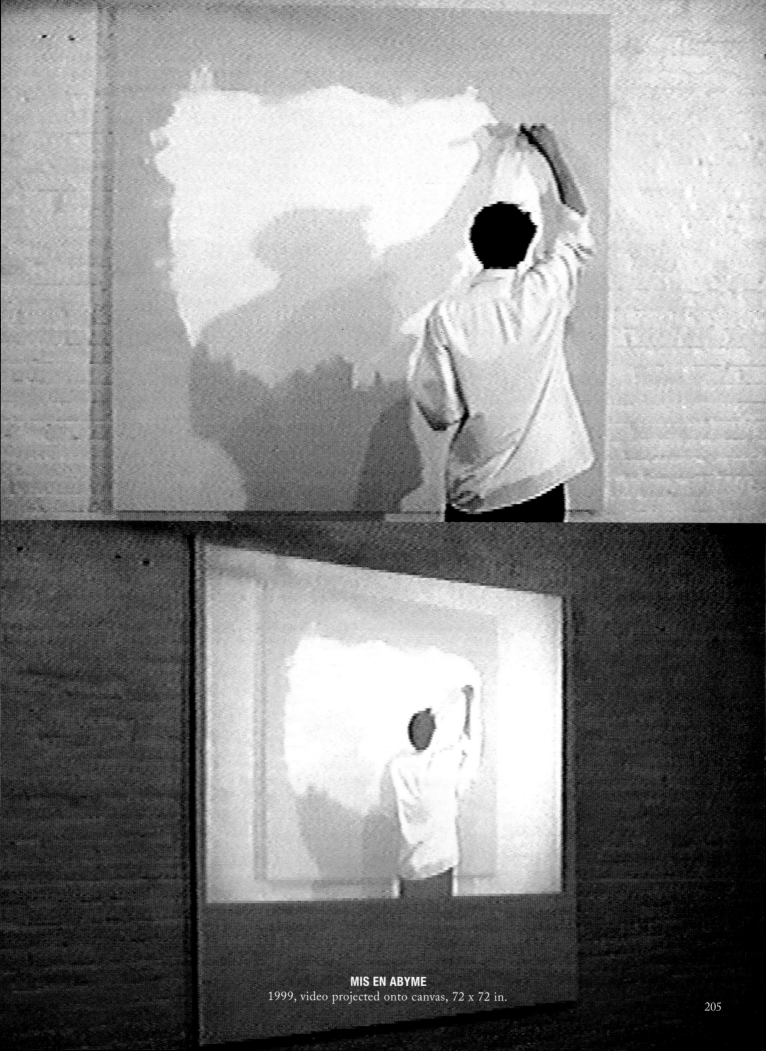

MIS EN ABYME
1999, video projected onto canvas, 72 x 72 in.

⑤

⑥

⑦

GROUNDS FLOW FROM
BOOK.

THESE GROUNDS PROVIDE THE ENVIRON
FOR THE FAMOUS PENCIL SHARPENE

ZOOM IN ON
TIP OF HAPPY TBOW.

THESE SHAPES BUILD UP
TO CREATE THE ENVIRONME
FOR THE PENCIL SHARPENE
ANIMATION

BACKGROUND SHOULD
BE BROWN,
AUSE SLIGHTLY BEFORE
OMING IN FURTHER
OWARDS MUSICIANS

SWIRLS
FLOW FROM
MUSICIANS

MAN RISES UP FROM
TIP OF HAPPY TBOW.

BOOK ICON
OPENS

MORE
CLOUDS
FLOAT BY.

PENCIL REPORTER GETS G
POPS OFF & FALLS DOWN
ZOOM IN ON HEAD.

SOME Hot
ICON ACTION
ROLLS DOWN
BRANCH.

BODY EMERGES FROM HANDS,
ARMS EMERGE FROM BODY,
ZOOM IN ON THIS SECTION AS
THESE ACTIONS ARE HAPPENING,
SMALLER HAND EMERGES
FROM OPEN HAND, GROWS
TO LEFT, PLANT GROWS UP
TO POINT OF DAGGER.
BLUE DOTS EMERGE &
FALL FROM PLANT.

⑱

⑲

⑳

MORE Hot ICON
ACTION BEGINS AGAIN.

GROUNDS CONTINUE TO RIGHT,
BUT BLUE LINES DROP
DOWN & CAMERA FOLLOWS
THIS ACTION.

ZOOM IN ON
UPSIDE DOWN MAN AT
MICROPHONE.
MAN HANGS DOWN AS
CLOUD COMES IN FROM
LEFT W/ MAN POINTING UP.

TAN
BACKGROU

IS IS THE MOST PSYCHEDELIC
CTION OF THE VIDEO. FAST.
UTTERFLIES' WINGS FLAP AS MORE
ND MORE BUTTERFLIES EMERGE
GROW FROM CENTER. THE LAST
UTTERFLY TO EMERGE IS A PAIR
OF OPEN HANDS THAT OPEN & CLOSE
ND LOOK LIKE A BUTTERFLY.
ANDS FLY UP & FILL PICTURE PLANE.

CAMERA FOLLOWS
FALLING BLUE DOTS
DOWN TO ANOTHER
BODY TO EMERGE
FROM LARGE
BUTTERFLY HANDS.
DAGGER ARM EMERGES
FROM BODY & THEN OPEN
HAND EMERGES TO
RELEASE MORE
HAND BUTTERFLIES.
ONE HAND BUTTERFLY IS
SINGLED OUT & FILLS UP SCREEN

HANDS STOP FLAPPING &
45° GROUNDS GROW TO
RIGHT.

TRANSITION FROM THIS
SCENE TO NEXT IS UNCLEAR,
BUT WITH A LITTLE FAITH, IT
WILL REVEAL ITSELF.

* CLOUD DROPS
& * ZOOM OUT VERY QUICKLY TO REVEAL
ALL THAT ACTION HAVING TAKEN PLACE
IN A WHITE DROPLET.

CLOUD MOVES IN FROM LEFT, STOPS ABOVE HEAD, & RAINS DOWN UNIVERSAL KNOWLEDGE ONTO BROWN PICTURE PLANE. TREE GROWS FROM TOP EDGE & INTO BRAIN. BRANCHES SPREAD OUT INTO HEAD. ZOOM IN ON BLUE INK DROP FALLING FROM PEN.

BACKGROUND SHOULD BE BROWN.

BACKGROUND SHOULD BE BLUE.

RAINBOW CIRCLE ANIMATION. ELECTRIC SPARKS FLOW IN OPPOSITE DIRECTIONS. ZOOM IN ON CENTER ICON.

MUSHROOMS GR OUT OF WOMA HEAD, ZO IN ON MUSHRO

21

22

23

24

25

26

POWER ICON BEATS TO THE BEAT OF THE SONG (♪) TREE GROWS OUT OF PRISONER'S HEAD.

LEGS ARE WALKING IN PLACE.

HEAD BOBS SLIGHTLY BACK & FORTH. ZOOM IN ON HEAD.

VICTORY COUPLE EMERGES FROM WHEEL BARREL JUNK & PLANT GROWS UP FROM HEAD.

HEAD OPENS. DESK EMERGES FROM BASE. CONDUCTOR EMERGES FROM DESK. DOTS FLOAT AWAY. ZOOM IN ON DOT.

KEYBOARD EMERGES FROM TOP EDGE OF RECTANGLE. COMES DOWN LIKE A WINDOW SHADE.

MEETING PEOPLE AT TABLE FALL FROM KEYBOARD.

TOWER GROWS UP AFTER MEETING PEOPLE FALL. CASTLE EMERGE FROM TOP OF TOWER. ZOOM IN ON CASTLE WINDOWS

SHOULD BE WHITE ON BLUE BACKGROUND.

27

28

29

30

31

...TER ZOOM, ...GHT PAUSE, ...E SPORES ...AT UP INTO ...E SPACE. ...M IN ON ONE ...PORE.

WORLD ZOOMS UP FROM CENTER OF BLUE SPORE.

ARROWS ROTATE ONCE & THEN WHITE HEART APPEARS & PUMPS A FEW TIMES BEFORE CAMERA ZOOMS OUT TO SHOW BLUE SPORE AS A BUTTON ON CELL PHONE.

BUTTONS LIGHT UP, BLUE SCREEN COMES DOWN, MEN FLOW INTO SCREEN BACK & FORTH & THEN TURN TO FACE EACH OTHER, ZOOM IN.

ZOOM IN ON HANDSHAKE.

HANDSHAKE GROWS TO RIGHT INTO 45° SHAPES

WHITE FINGER HAND GOES UP TO TOUCH THE "OFF" BUTTON TO END VIDEO. FADE TO BLACK AS SONG FADES OUT.

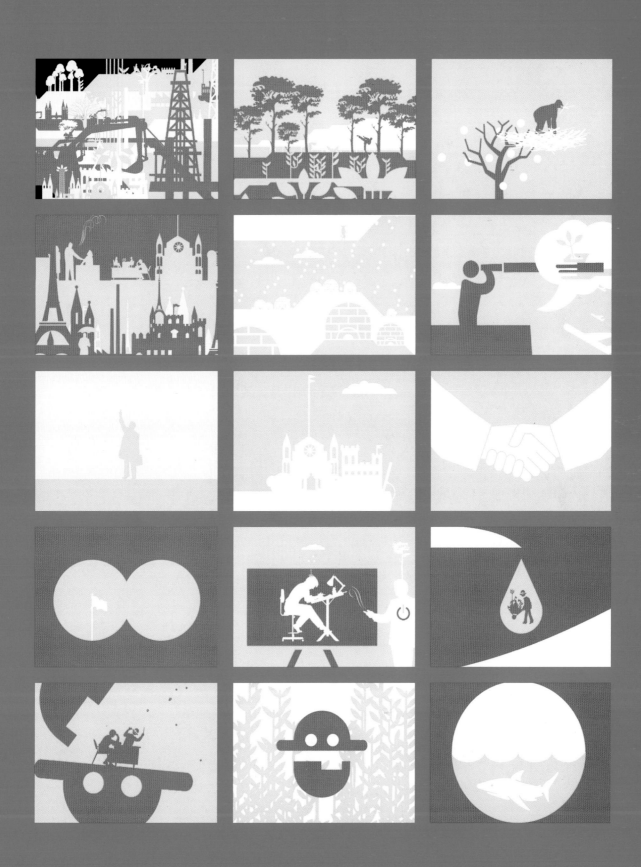

NORTH STAR
2002, video co-directed with Bill McMullen, 3:40 min., dimensions vary

Art and Entertainment

Randy Gladman

A small TV in a corner of the gallery projects a video of your worst nightmare. Office hell: A shallow space with white walls and whiter lighting, a nondescript table, and a generic clock, hung low on the wall so it appears in the tight camera angle view. The time is apparently twenty-one minutes past the hour, and a skinny dude in a white business shirt sits at the table in obvious discomfort. He looks bad. Hurting pretty badly. He rubs his hand across his clean-shaved head, a six-pack of Pabst Blue Ribbon beer on the table and a shot glass in his hand. With the passing of every minute, he downs a shot of beer and then pours himself another. In a perverse funk, this character attempts to drink a shot of beer every minute for an hour. The first highlight of the video occurs just after the twenty-third shot, when the drinker pukes all over the table. Without cleaning it up, he pours himself another ounce and waits for the next minute to arrive.

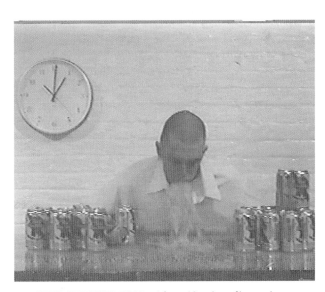

HOUR OF POWER 2001, video, 60 min., dimensions vary

He vomits two more times before the hour concludes.

The actor/guinea pig is Ryan McGinness. He is also the producer, director, writer, and cameraman. Relying heavily on a dose of influence from his Pop-art predecessors but injecting it with sensibilities based in hip-hop hype, skater style, and graffiti guerilla warfare, McGinness has pioneered a new territory in the realm of contemporary art. He inhabits the thin layer of skin that separates design from art, armed with an aesthetic philosophy now known as *Flatnessisgod*, a sense of worship of the importance of surface and the pervasive coolness present in all forms of contemporary pop culture.

Sometime in 2000 a schism split McGinness' body of work into a new direction. His work popped into a mature style, one that embraced his background and training in graphic design. Though still planted firmly in the rich soil of Pop, this new body of imagery boldly speaks a fresh language and brought McGinness sustained international attention and solo exhibitions in Paris, Munich, Tokyo, Vancouver, and Madrid. To explore McGinness' work thoughtfully is to take two separate journeys: one through the early work before 2000, filled with direct allusions to the original authors/auteurs of Pop imagery, and one along an original and cunning visual linguist's trail of icons, wordplay, and narrativeless storytelling.

UNTITLED 1989, silkscreen ink on newsprint, 24 x 18 in.

Throughout his early work, McGinness extracts ideas, shared experiences, and materials from pop culture and elevates them in an attempt to delineate what brings us together as consumers and producers. Such works as *Conspiracy Theory* (1994) blatantly betray the artist's exploration of Andy Warhol's silkscreening techniques and use of silvered canvas. *Nurse Alien* (1994) and *Mr. Magoo* (1994) admire David Salle's layering and use of painted line drawing. The wickedly self-congratulatory *Trophy Series* (1999) practically bows to the kitsch ready-made genius of Jeff Koons. In the sixty-minute video discussed above, *Hour of Power* (2001), he employs beer and a college tradition to comment on corporate exploitation of the workforce and the role of ritualized substance abuse. Although the artist often uses traditional media such as paint on canvas, he continues to exploit less precious materials culled from daily existence. The intent is to democratize art in order to make it more accessible. Like a modern Robin Hood, he perverts expected capitalist infrastructures with a cunning slight of hand. In 1999, McGinness first caught art press attention by screwing with gift shops in major New York City museums. He fabricated postcards identical to those sold by museum shops, complete with the same fonts, bar codes, and logos of the institutions, but he replaced the images of, say, van Gogh's *Starry Night* with depictions of his own art works. After infiltrating the postcard racks with his own cards, he arranged for friends and sympathizers to attempt to purchase the moles. Although the postcards remained as the residue of the installation/performance, the real artistic object of the work was the commotion it caused at the checkout counter of the shop when the computerized cash registers refused to recognize the product.

In 2000, McGinness first ventured into the skate world with a series of hand-painted skateboards. Although painting on wood panels has been a tradition in art for centuries, the pill-shaped oval of the skateboard deck afforded a new format, and McGinness was attracted to the medium for its fresh formal qualities and its value as a symbol of youth culture. At the time McGinness was first creating these paintings, he was invited by the owner of Supreme to design a series of skateboards for the company. Now years later, he finds himself sometimes inserted into the skate tradition of great companies sponsoring spectacular riders.

The year 2000 ended with McGinness' solo gallery show in Seattle with a mandate focusing on young, urban art. The exhibition, a symphony of variations on a skateboard theme, was titled *Shtick*, referring to both the slang term for a skateboard (stick) and the gimmick-like approach of much of McGinness' work of this early period. Alongside skateboard paintings and sculptural ramps made from cardboard and glue was hung a series of grip-tape paintings. Formally referencing twentieth-century abstract paintings by artists such as Ellsworth Kelly in their flat fields of color and subtly curving lines, these pieces are amplified by their 1980s nostalgia-inducing fluorescent hues. The curves they depict evoke those of transition ramps so familiar to McGinness from the skate parks of his youth. Their surfaces are not painted but rather carefully cut and applied grip tape. These works offer flat imagery reduced from pop culture and reuse common non-art materials in non-traditional manners, a method adopted from previous generations that becomes very important for McGinness in his later Language Period.

UNTITLED 1990, marker on paper, 24 x 18 in.

Early in 2001, the trajectory of McGinness' work shifted dramatically, resulting in what has effectively turned out to be an entirely new chapter in the artist's career. Although McGinness had previously flirted with clip-art and played with the iconography of the universal language of signage, these visual devices took on a new importance in his work. The resulting studio output defines the artist's Language Period.

The *Denim Product Paintings I–V* of 2001 provide the pivot point from the early work into the mature movement. This series of acrylic and enamel paintings on

stretched Levi's denim presents the first time McGinness uses flat, highly recognizable silhouetted forms on flat backgrounds as the dominant element on the picture plane. Using a simple combination of images such as a cowboy and a cowgirl pulling on opposite sides of a rope under a crown (*Untitled Denim Product Painting III*, 2001), the artist creates a simple and ambiguous idea, in essence a visual word. He playfully manipulated highly recognizable iconographic elements taken from the public domain, such as the universal image of a seated person, and played with them using a designer's sense of composition and hard-edged line.

The artist first exhibited these nearly indestructible works in a Brooklyn gallery. In hindsight, it can be seen that this exhibition was McGinness' first solo effort as an artist with a mature style of his own.

POINTER SPEECH BUBBLES
1998, oil and silkscreen ink on canvas, 12 x 12 in.

An untitled skateboard deck applied with custom vinyl stickers from this same period shows the artist speaking a more comprehensible visual statement. Silhouettes of tanks, riflemen, military choppers, and fighter jets are juxtaposed with wound up businessmen in suits making a deal above gasoline fuel pumps. A similar skateboard deck speaks of the opposite side of American culture. White vinyl icons of trailers, a picnic table with a television on top, a man in a wifebeater tank top and a woman with curlers in her hair, empty moonshine bottles, chickens, pigs, and plastic flamingos speak of white trash aspects of the American identity. McGinness reduces these complex ideas down to their barest essentials with highly simplified yet delicately applied silhouette icons, and though it is impossible to tell if he is critical of these aspects of culture, they are clearly inspired by his upbringing in Virginia and the time he spent during high school working on a Navy base where he designed flyers, posters, and mess-hall menus.

In 2002, these ideas evolved further, from sentences into full paragraphs and even stories. By layering solid color sentences onto different color sentences, the works progress into much more complex structures. The picture planes are loaded with elements, many of which refer directly to art history, politics, science, big business,

and even the division between church and state. As 2003 rolled around, signifiers of wealth and pageantry, such as chandelier forms, signature crests, fleurs-de-lis, troubadours and baroque arabesques start to proliferate across the surfaces of the works, as do organic plant forms, laurel wreaths, tree roots, abstracted genitalia and modified animals like unicorns. The stories become dense and irregular, open to wide interpretation like mysterious modern hieroglyphs. Nonsense comfortably infects the images, not unlike the cut-up works of William Burroughs or the Dada ramblings of Tristan Tzara, with whom McGinness shares the desire to denigrate and reform the structures of language.

McGinness paints with icons in all of his work now. Using tools such as software vector drawing, silk-screening, and industrial fabrication, McGinness updates a Warholian strategy of mass production to inject his body of work and mainstream culture at large with thoughtful content, innovative design, and intricate storytelling in a previously unheard voice.

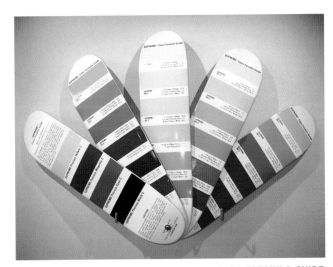

SUPREME COLOR FORMULA GUIDE
2000, oil on skateboards, 32 x 8 in. ea. ed. of 500 ea.

Gorging on the icons and symbols of mass communication, McGinness digests chips of visual pop culture and regurgitates a rehydrated paste of common experience. Whether it cameos in his artist videos, appears partially concealed in layers of vinyl icons, or gets widely dispersed around Manhattan by randomly applied stickers carrying his sarcastic criticisms of art itself, his work forces a second consideration of our consumerist habits and afflictions. By resuscitating the leftovers created by the American culture machine and marrying them to a keen concept of art and value, McGinness has stepped into a space where gallery-style contemporary art meets popular entertainment and enjoyment.

AMBITIOUS OUTSIDERS
2003, oil enamel and silkscreen ink on linen, 48 x 36 in.

EXCUSES AND CURSES
2003, oil enamel and silkscreen ink on linen, 48 x 36 in.

MIDDLE CLASS FANCY
2003, oil enamel and silkscreen ink on linen, 48 x 36 in.

PROGRAMMED TO RECEIVE
2003, oil enamel and silkscreen ink on linen, 48 x 36 in.

THE I LOVE YOU MACHINE
2003, oil enamel and silkscreen ink on linen, 48 x 36 in.

POOR OR RICH, THE SAME IN DEATH
2003, oil enamel and silkscreen ink on linen, 48 x 36 in.

COSTUME RENTAL LIVES
2003, oil enamel and silkscreen ink on linen, 48 x 36 in.

GOD LUCK UNIVERSE
2003, oil enamel and silkscreen ink on linen, 48 x 36 in.

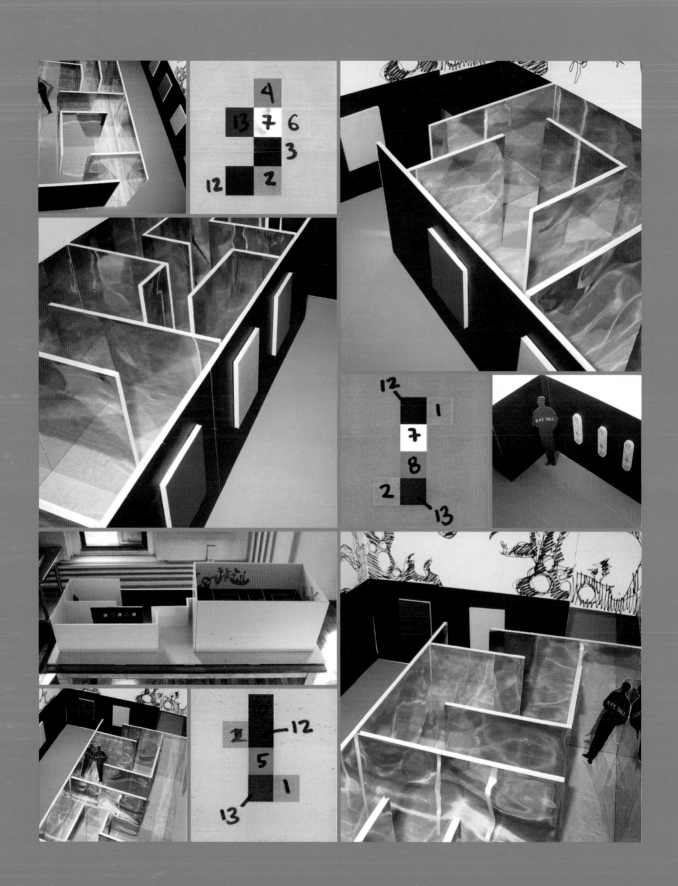

WORLDS WITHIN WORLDS (MODEL, SKETCHES, AND COLOR STUDIES)
2003, mixed media, dimensions vary

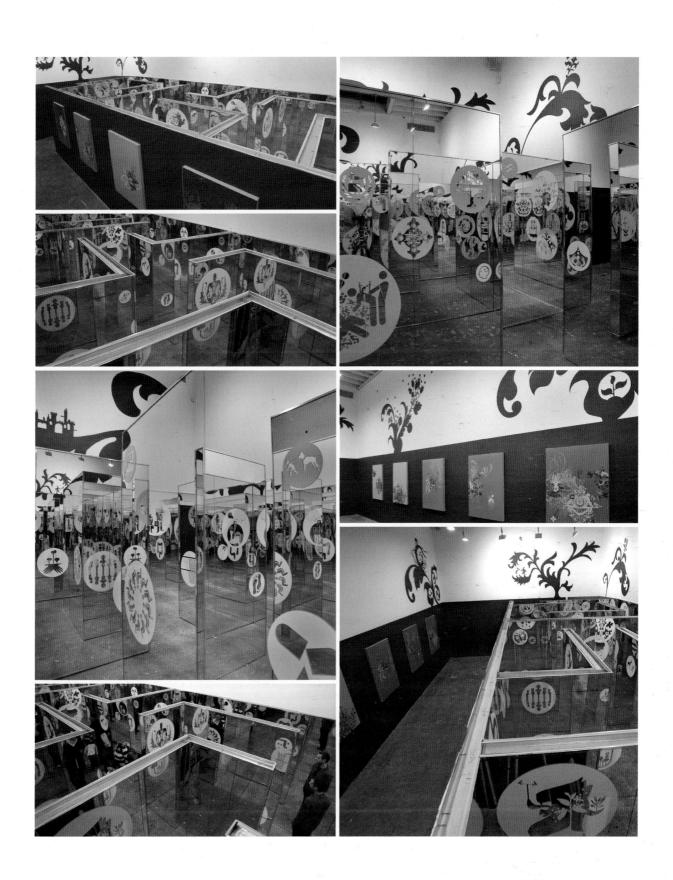

WORLDS WITHIN WORLDS
2003, installation view, Deitch Projects, New York

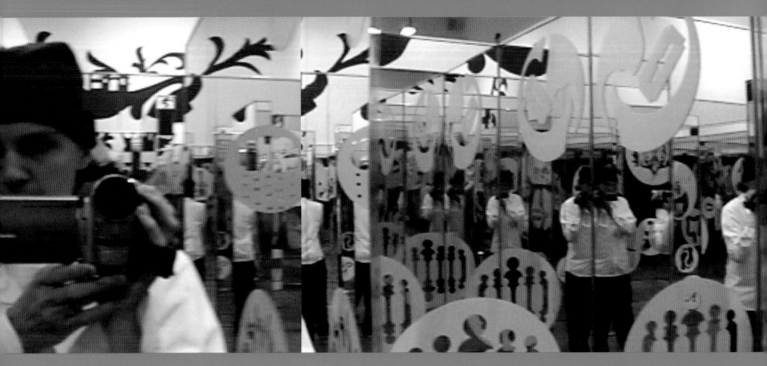

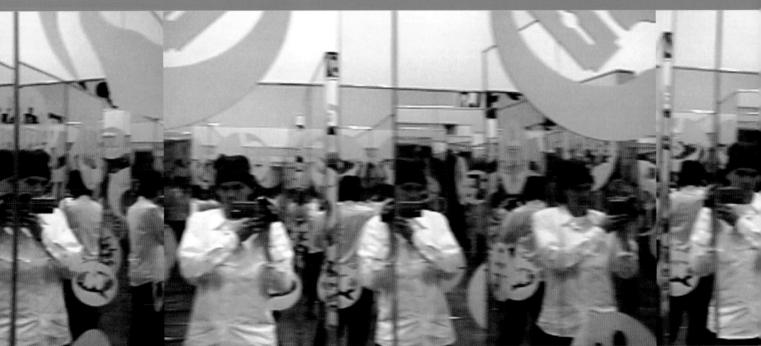

WORLDS WITHIN WORLDS (VIDEO WALK-THROUGH)
2003, video, approx. 15 min., dimensions vary

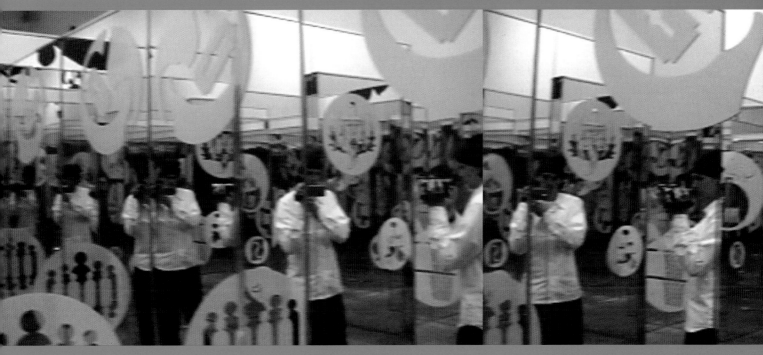

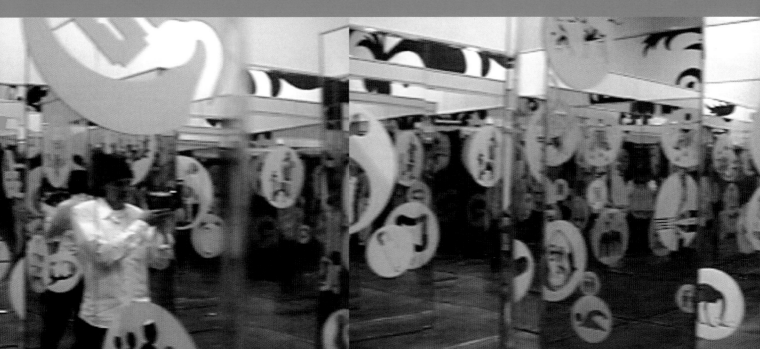

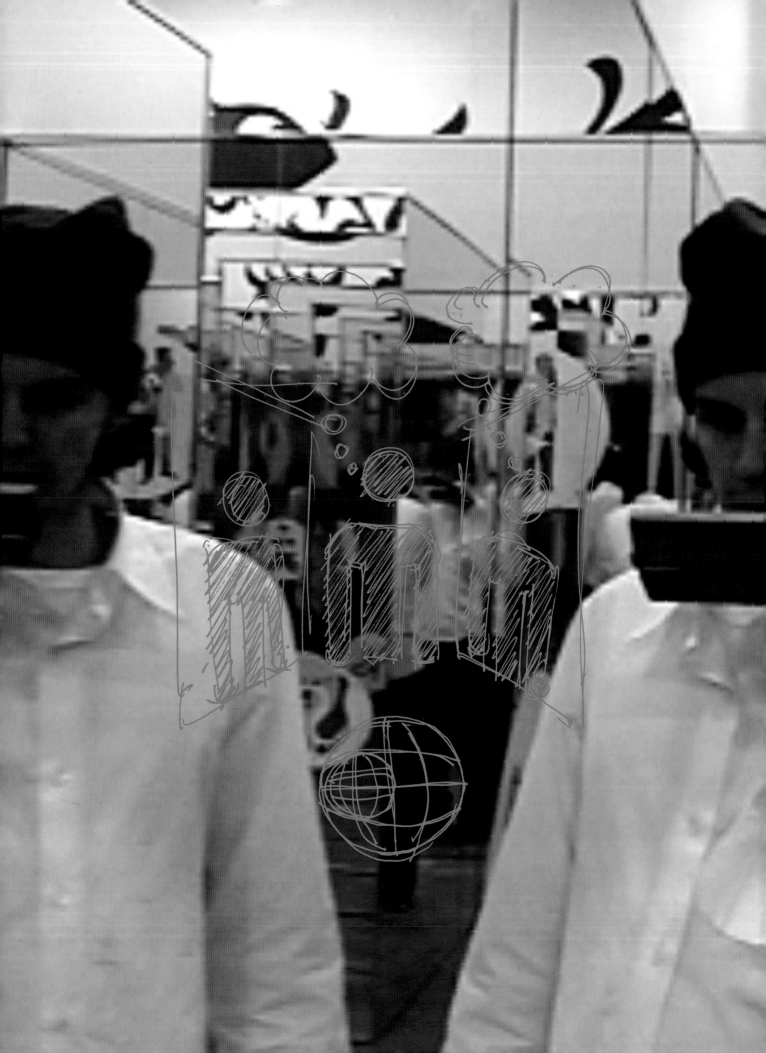

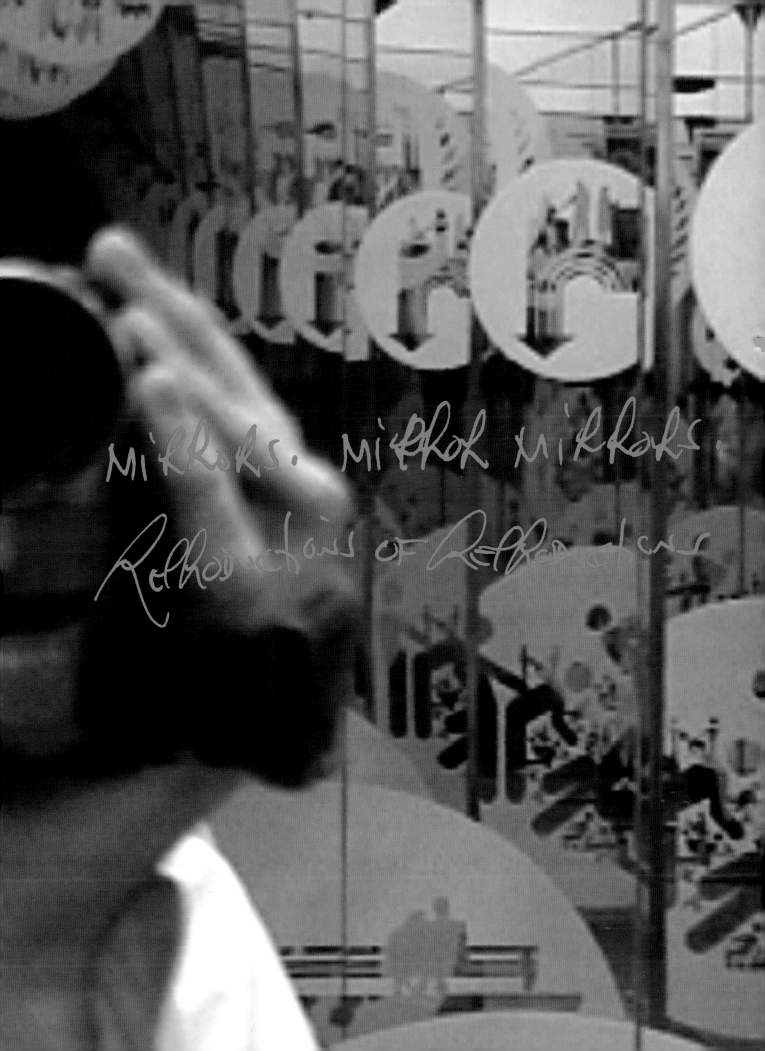

MIRRORS. MIRROR MIRRORS.
Reproductions of Reproductions

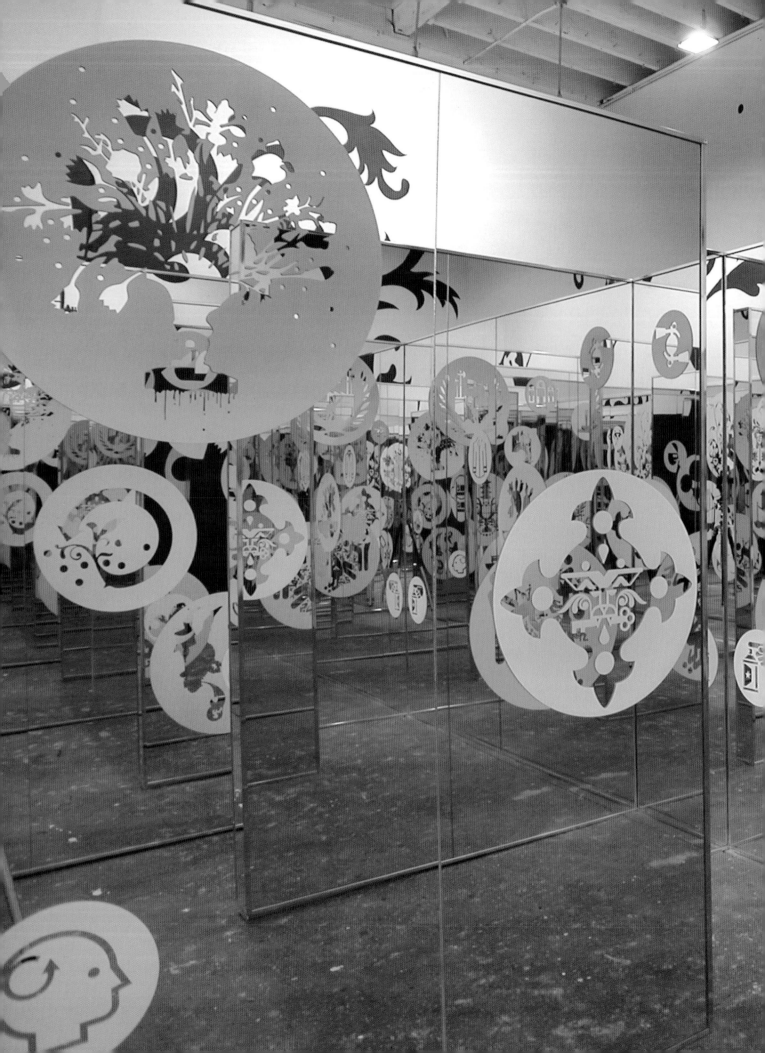

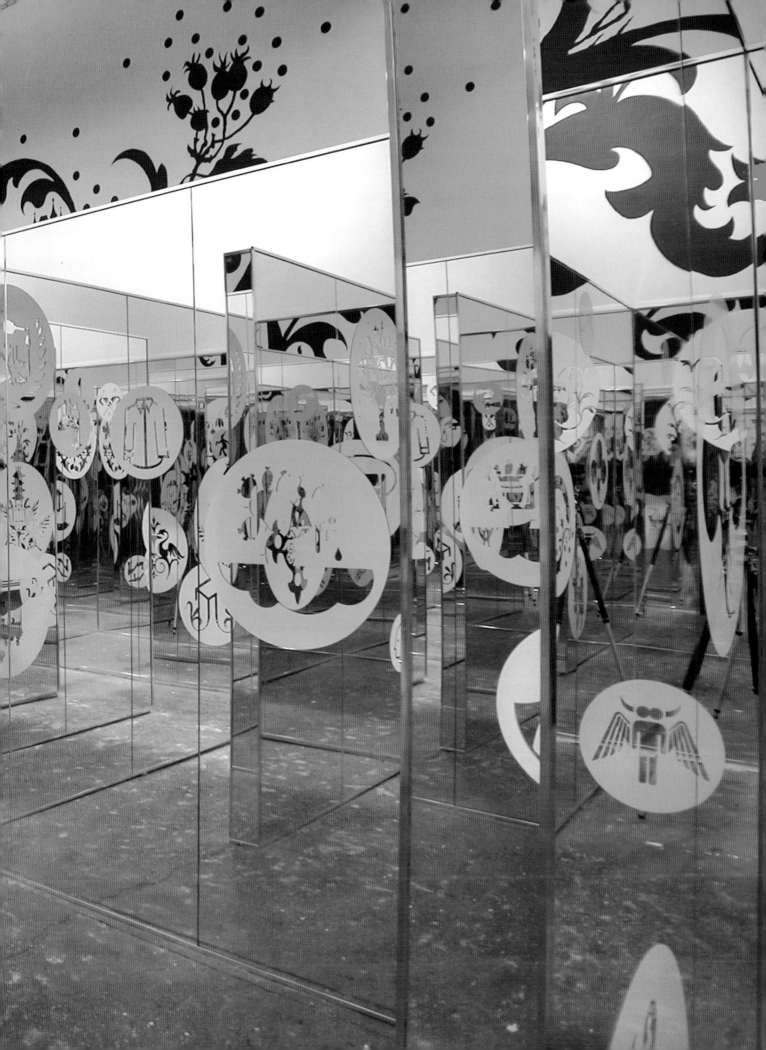

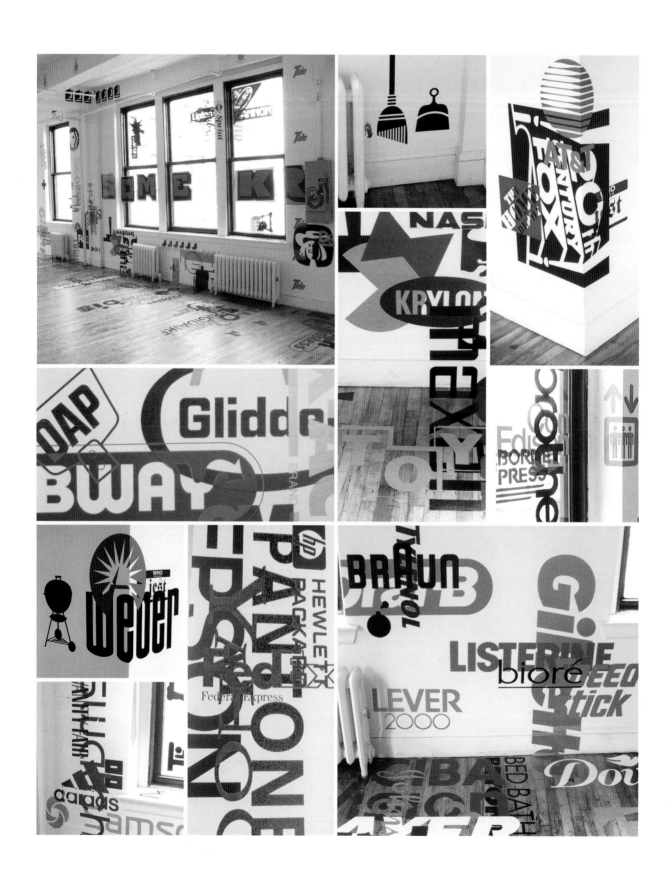

SOME KR
2001, reproduction of home in logos, installation views, New York

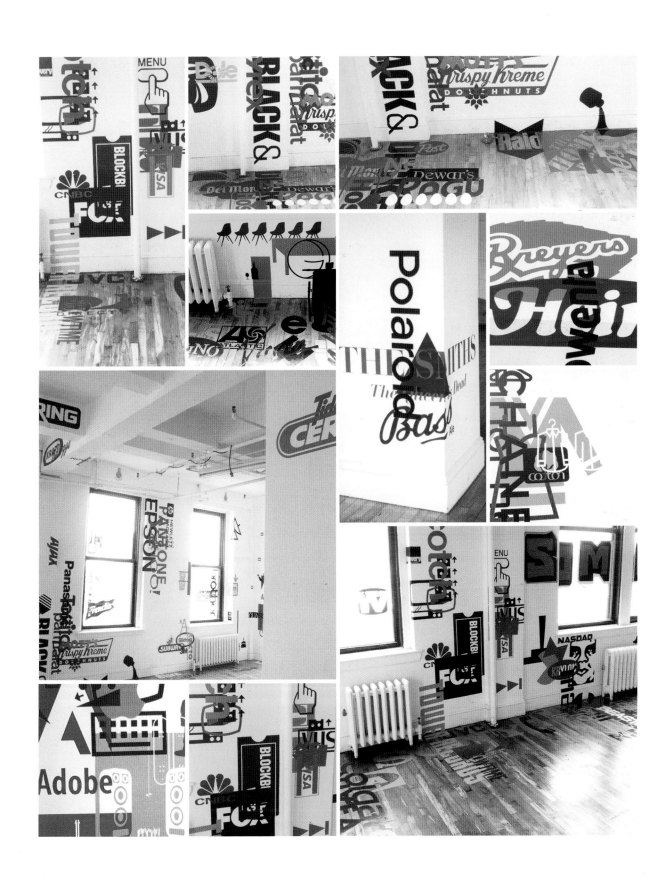

SOME KR
2001, reproduction of home in logos, installation views, New York

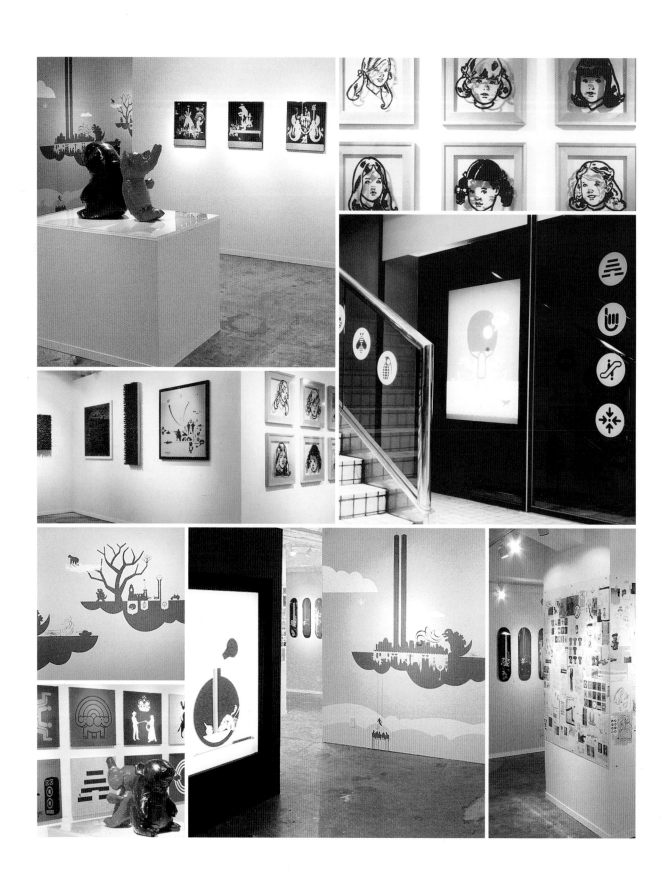

EVOLUTION IS THE THEORY OF EVERYTHING
2001, installation views, Parco Gallery, Tokyo

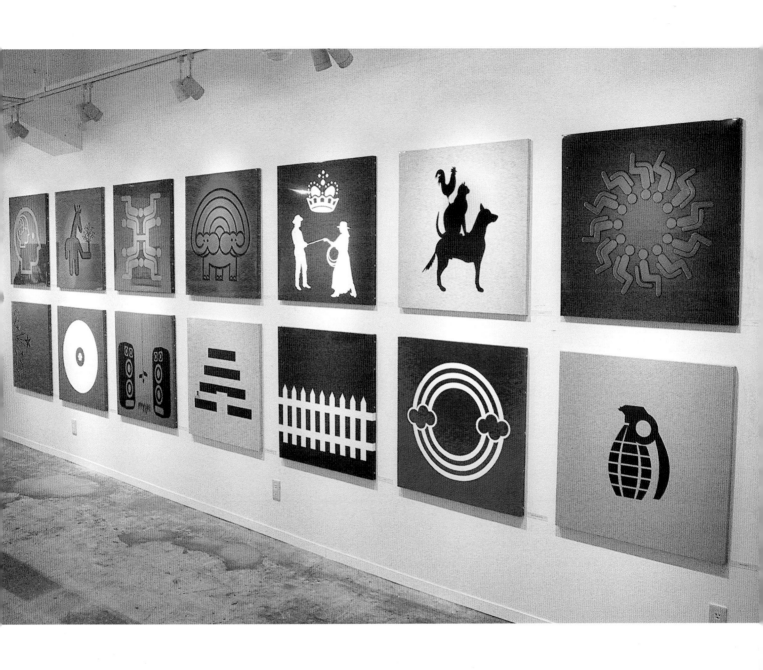

EVOLUTION IS THE THEORY OF EVERYTHING
2001, 14 vinyl on aluminum panels, 36 in. sq. ea., installation view, Parco Gallery, Tokyo

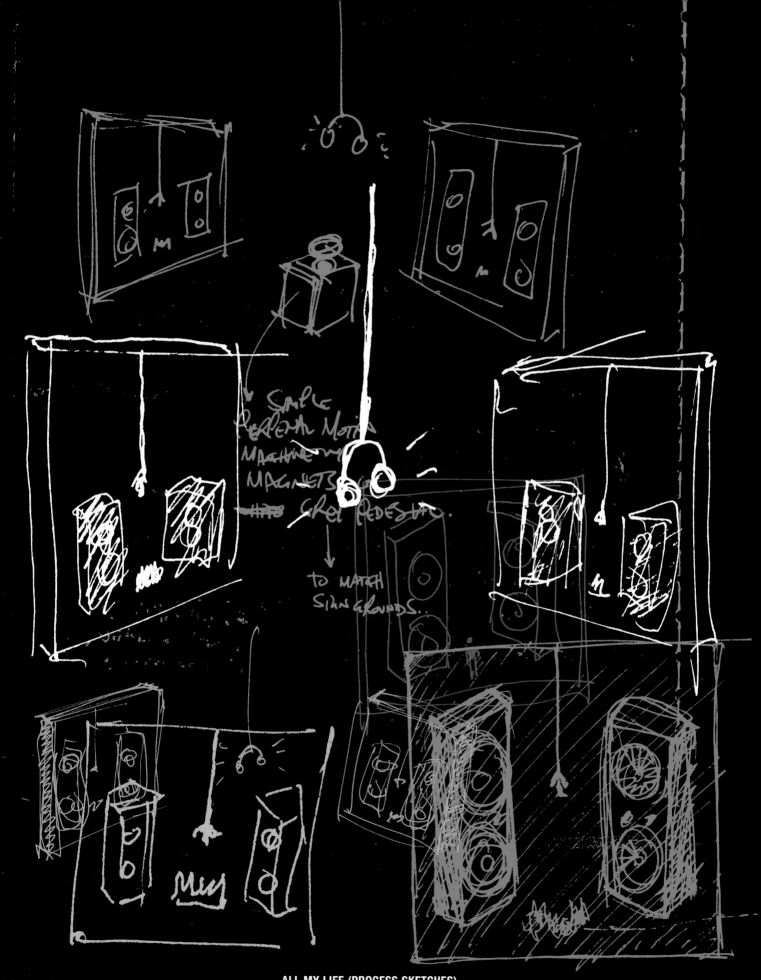

ALL MY LIFE (PROCESS SKETCHES)
2004, ink on paper, dimensions variable

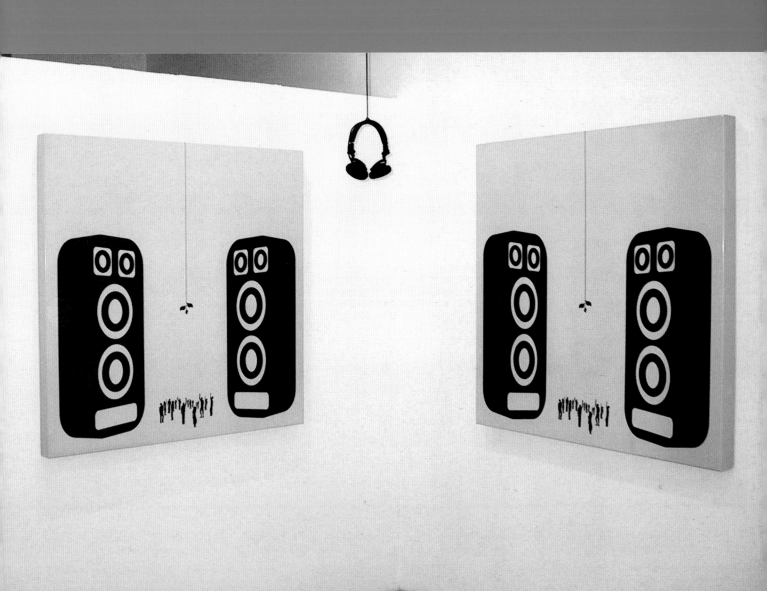

ALL MY LIFE
2001, porcelain-baked enamel on steel panels, 48 x 48 in. ea., out-of-reach headphones,
and audio track, installation view, Mixed Greens, New York

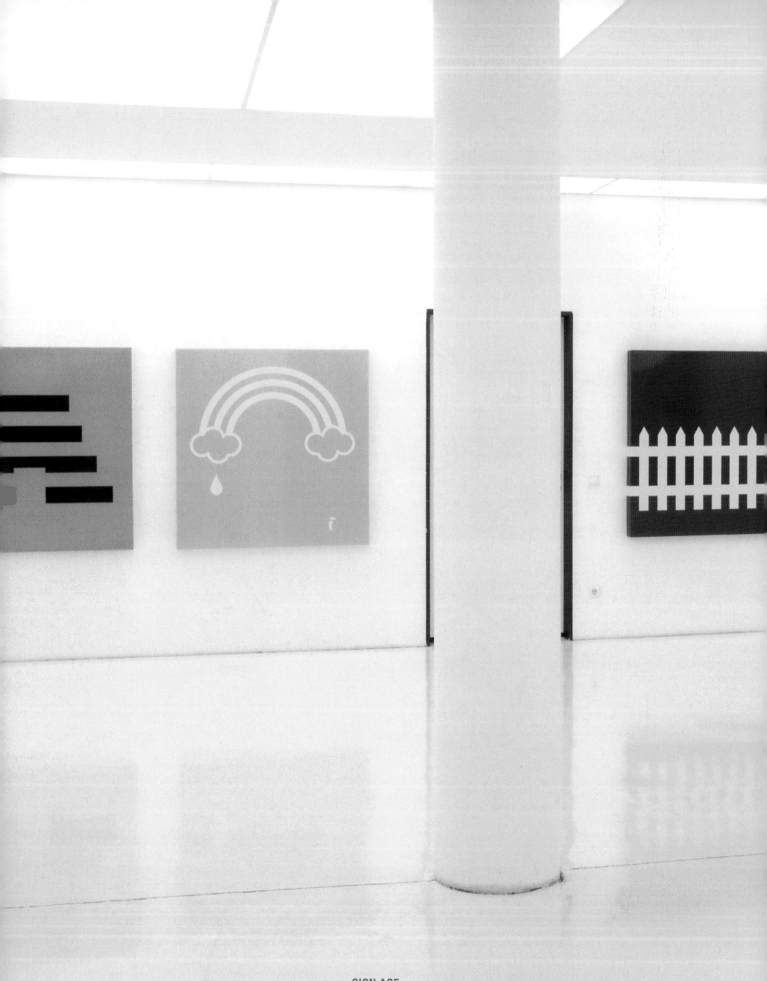

SIGN AGE
2001, porcelain-baked enamel on steel panels, 48 x 48 in. ea., installation view,
Galerie de Miguel, Munich

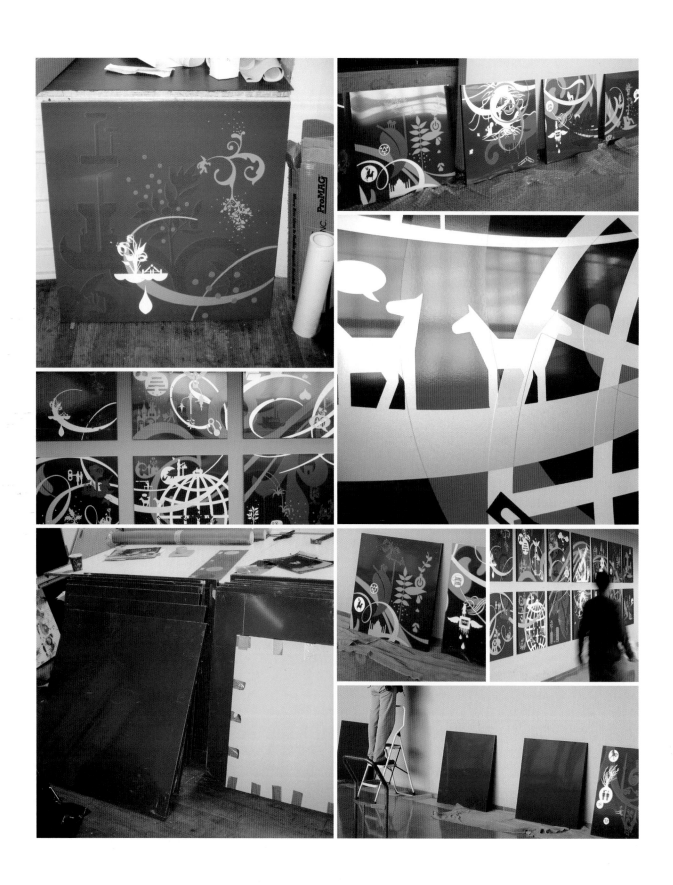

CHIC LUSH (FABRICATION/INSTALLATION PROCESS & DETAILS)
2004, 16 vinyl on aluminum panels, 36 x 36 in. ea.

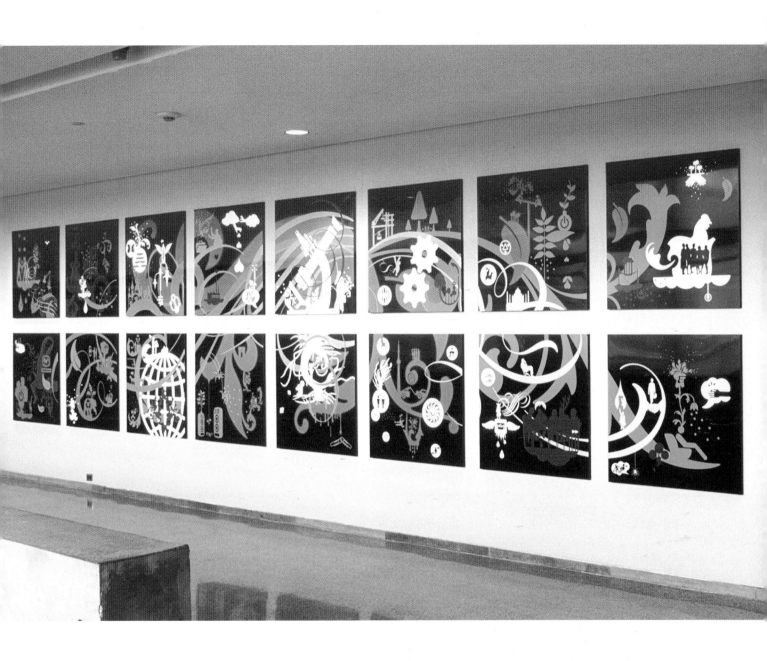

CHIC LUSH
2004, installation view, 78 x 330 in., Schulich School of Business, Toronto

UNTITLED (PROCESS SKETCHES)
2004, ink on paper, dimensions vary

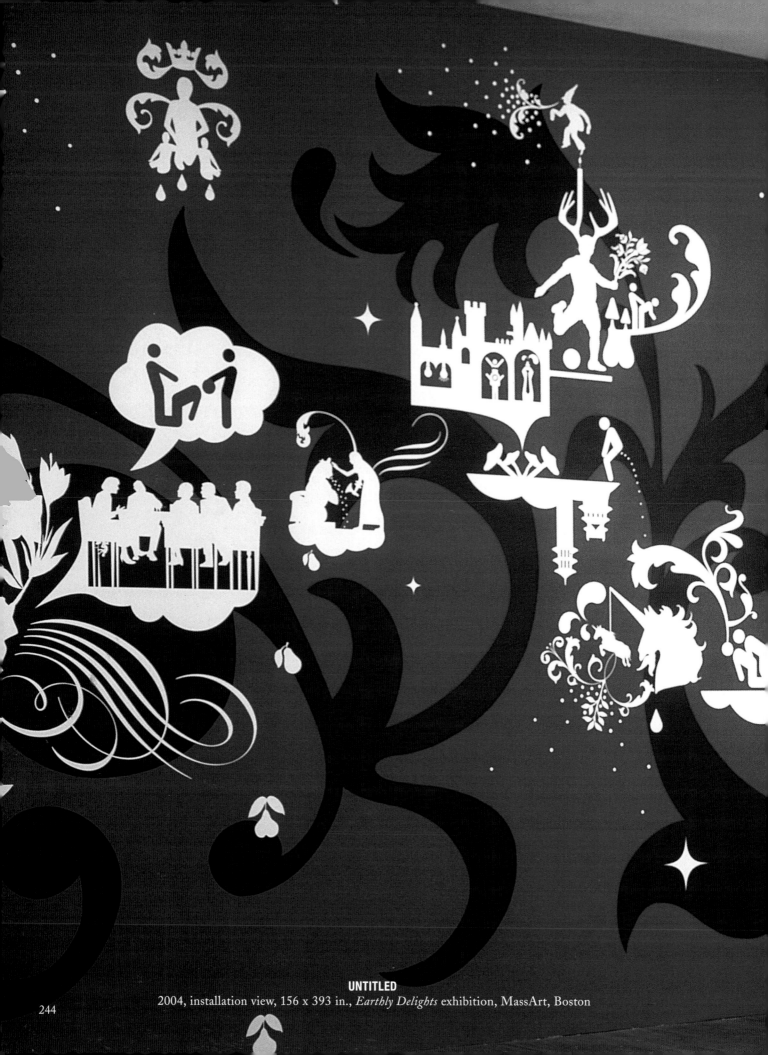

UNTITLED
2004, installation view, 156 x 393 in., *Earthly Delights* exhibition, MassArt, Boston

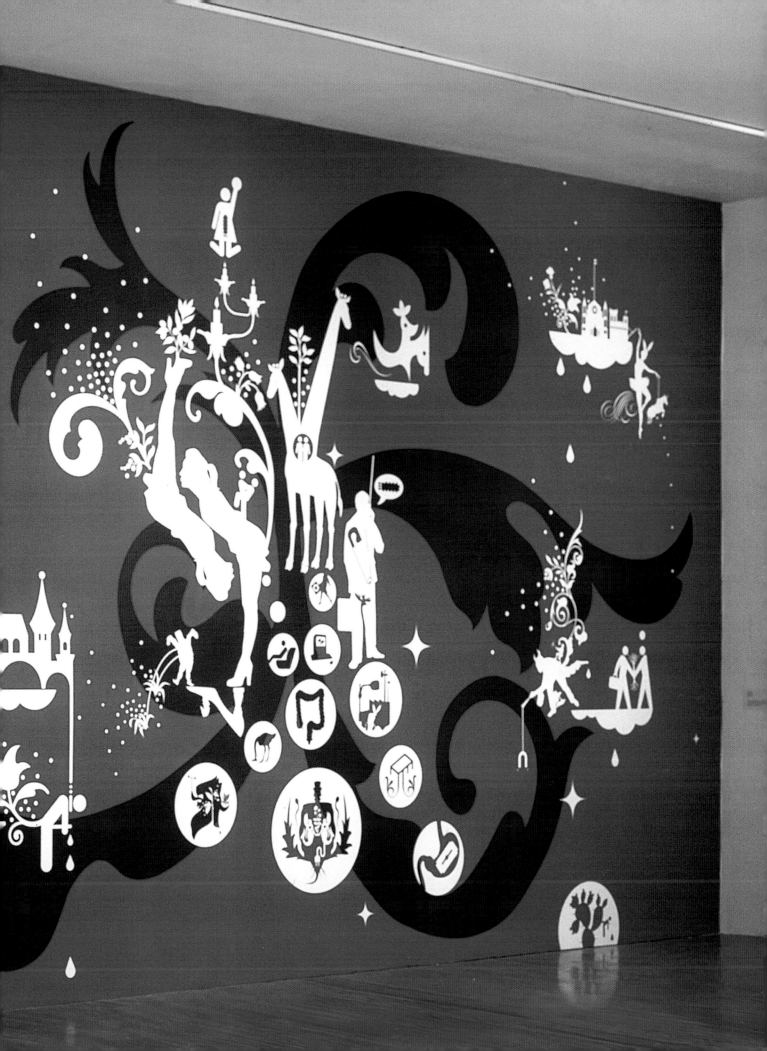

LIVING SIGNS (PROCESS SKETCHES)
2004, ink on paper and vector drawings, dimensions vary

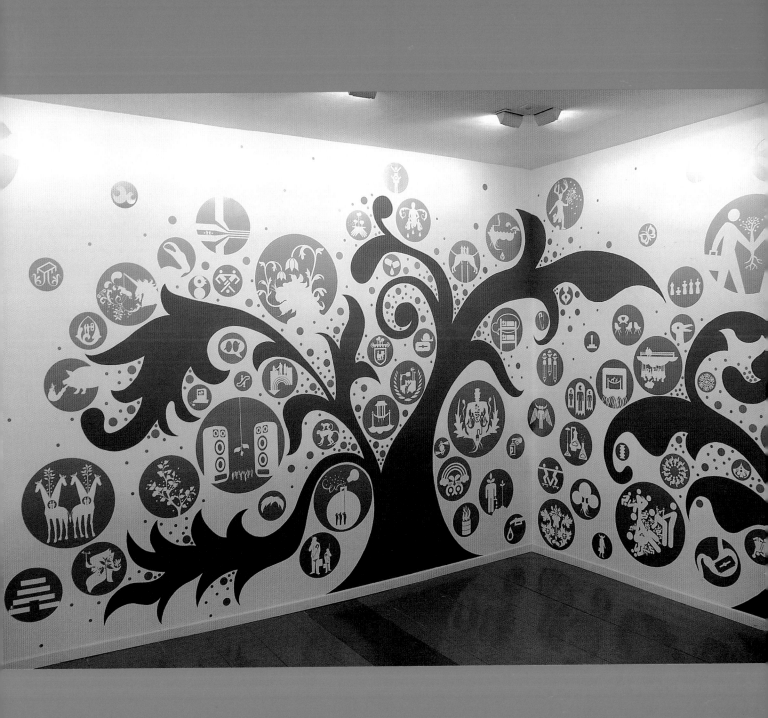

LIVING SIGNS
2004, installation view, Galeria Moriarty, Madrid

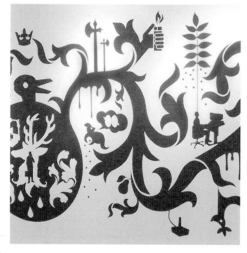
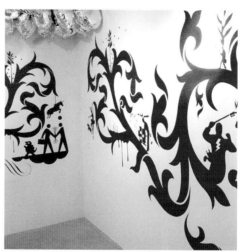

THIS DREAM IS SO LIFE-LIKE (DETAILS)
2002, installation views, Gas Gallery, Tokyo

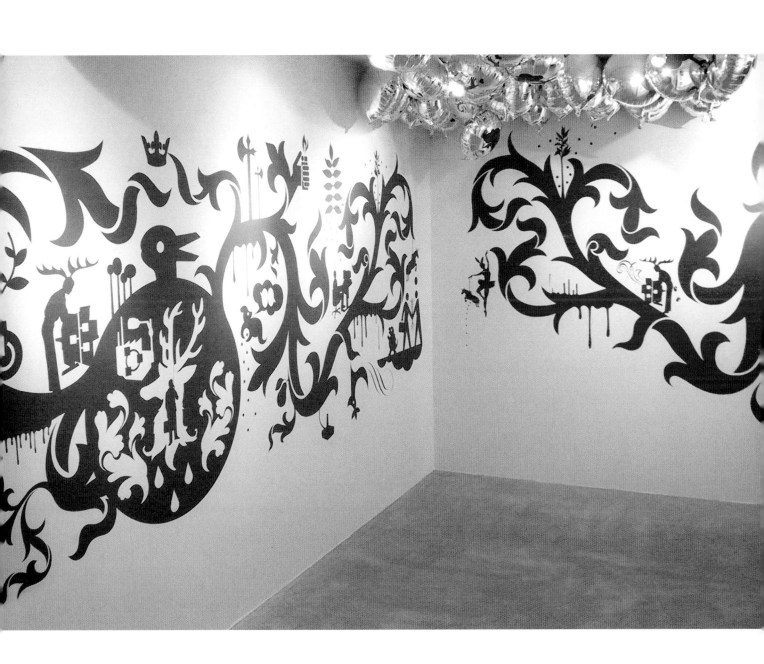

THIS DREAM IS SO LIFE-LIKE
2002, installation view, Gas Gallery, Tokyo

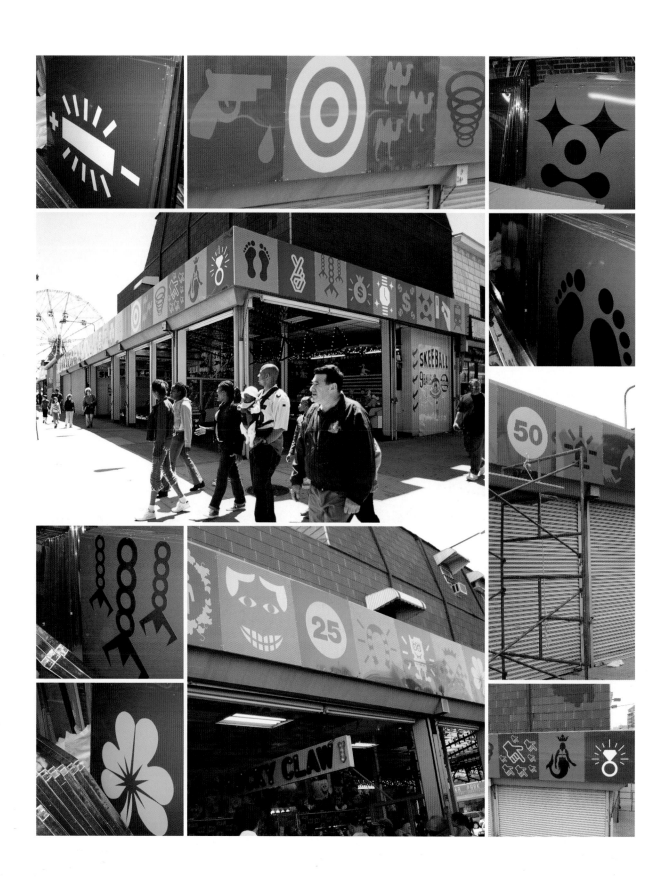

DREAMLAND ARTIST CLUB AT CONEY ISLAND
2004, Presented by Creative Time, 34 vinyl on aluminum panels,
48 x 48 in. ea., Coney Island

DREAMLAND ARTIST CLUB AT CONEY ISLAND (PROCESS SKETCHES)
2004, ink on paper and vector drawings, dimensions vary

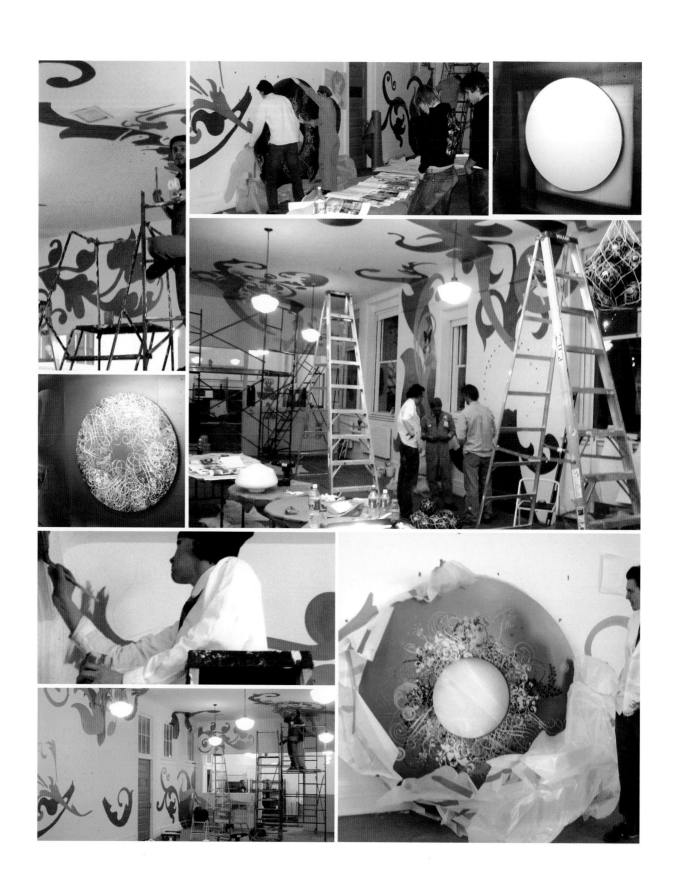

NOW FOREVER (INSTALLATION PROCESS)
2005, installation view, *Greater New York* exhibition, P.S.1/MoMA, New York

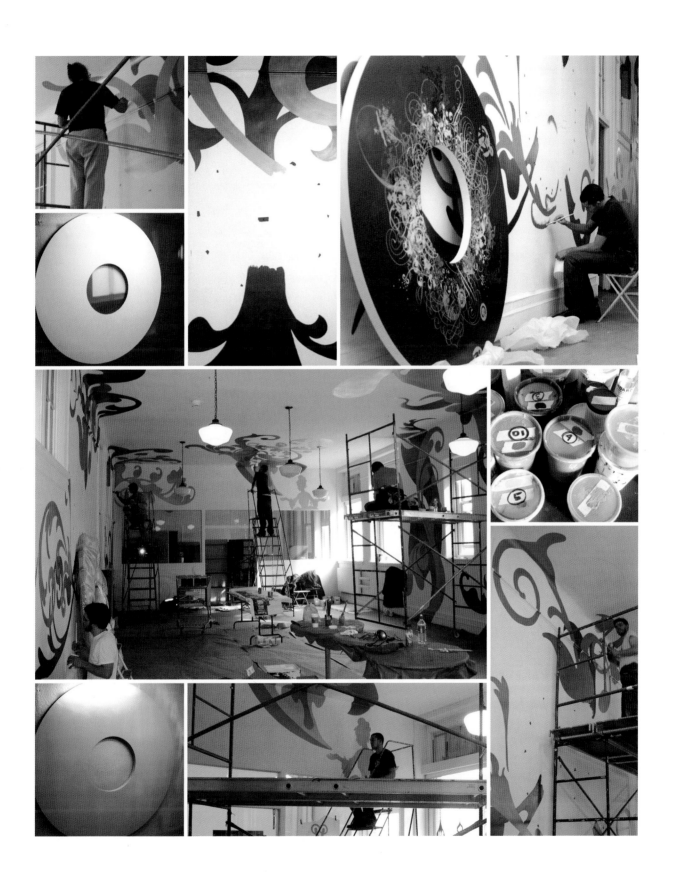

NOW FOREVER (INSTALLATION PROCESS)
2005, installation view, *Greater New York* exhibition, P.S.1/MoMA, New York

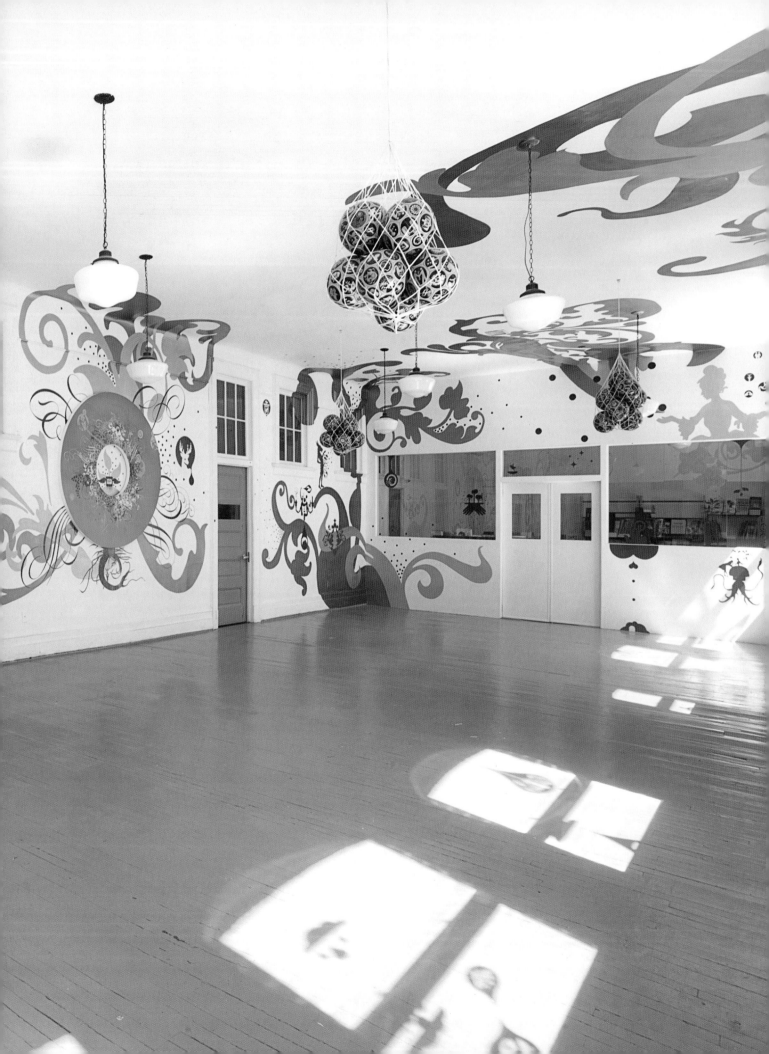

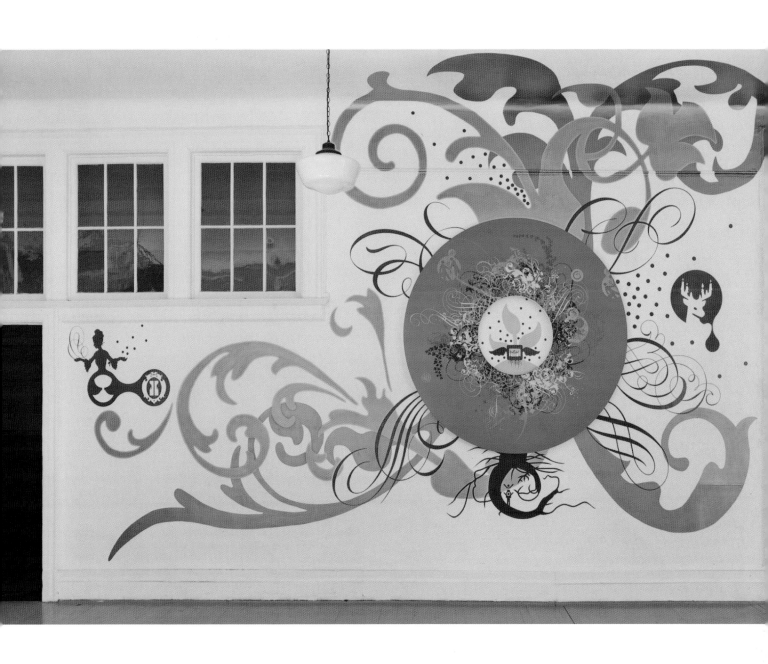

NOW FOREVER
2005, installation view, *Greater New York* exhibition, P.S.1/MoMA, New York

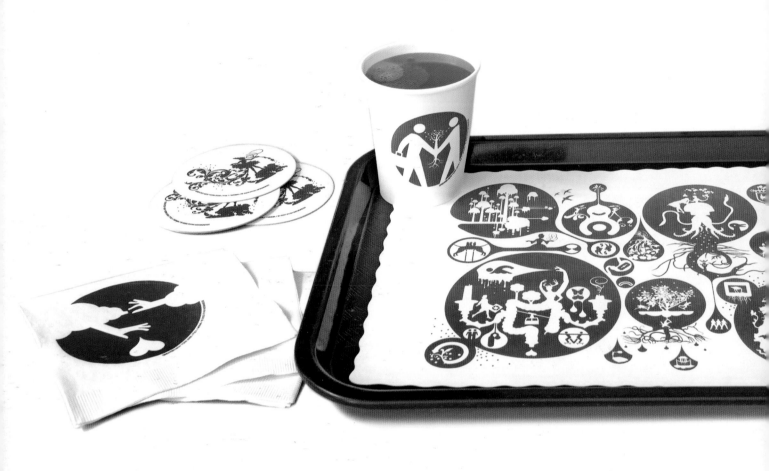

NOW FOREVER (CUPS, COASTERS, NAPKINS, & PLACEMATS)
2005, *Greater New York* exhibition, P.S.1/MoMA, New York

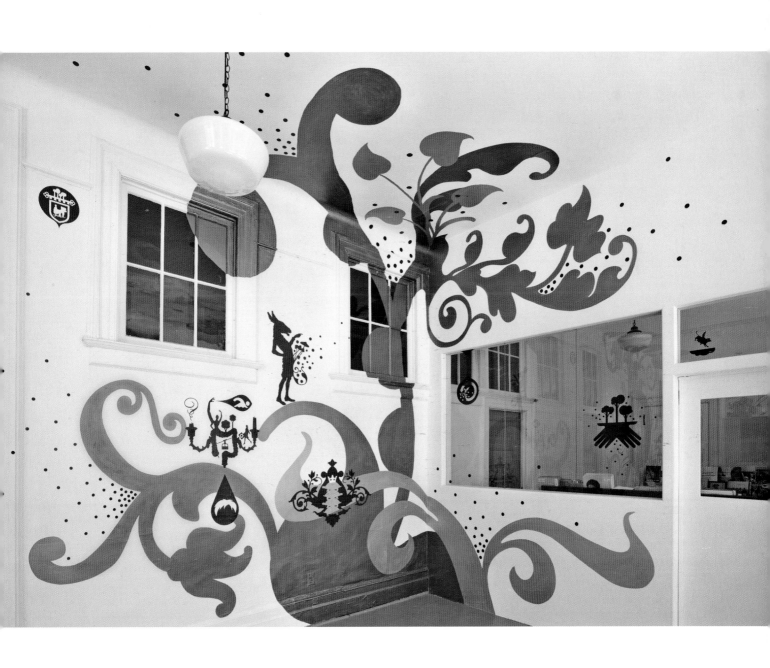

NOW FOREVER
2005, installation view, *Greater New York* exhibition, P.S.1/MoMA, New York

THE FALSE FICTION DILEMMA
2005, acrylic on linen, 48 in. diameter

NOW FOREVER
2005, acrylic on wood panel, 72 in. diameter

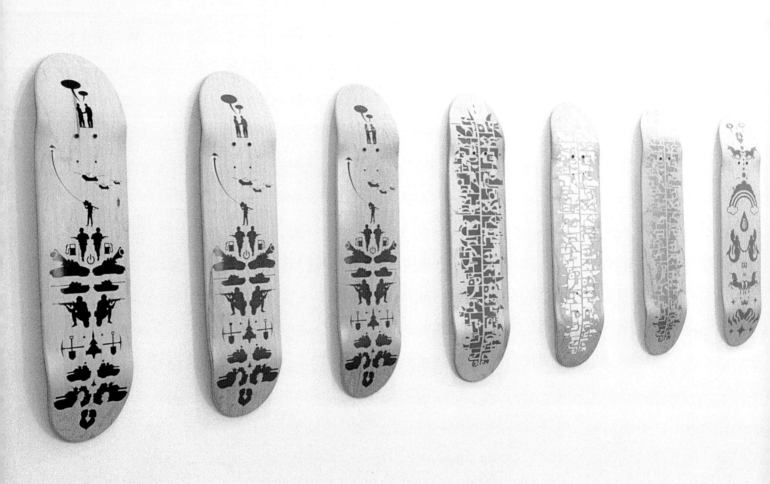

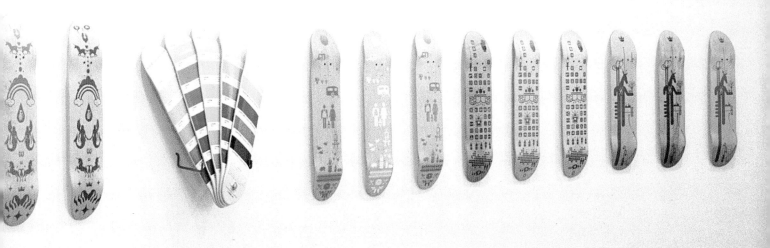

VOCABULARYTEST
2001, installation view, Joseph Silvestro Gallery, New York

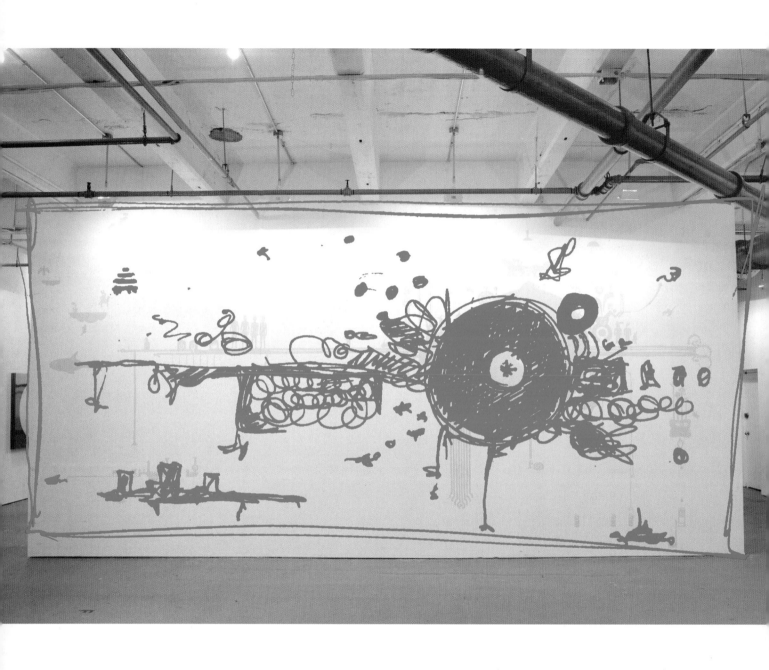

VOCABULARYTEST (PROCESS SKETCH)
2001, installation view, Joseph Silvestro Gallery, New York

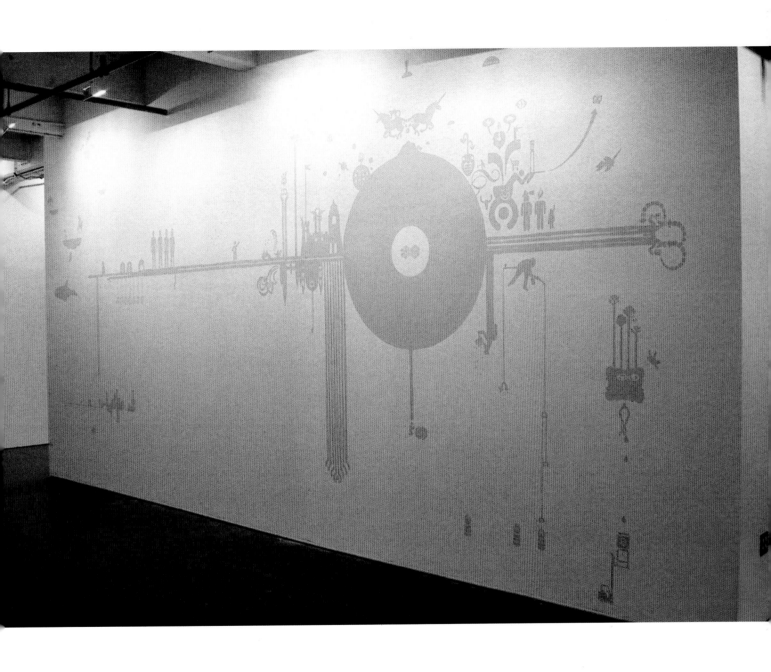

VOCABULARYTEST
2001, installation view, Joseph Silvestro Gallery, New York

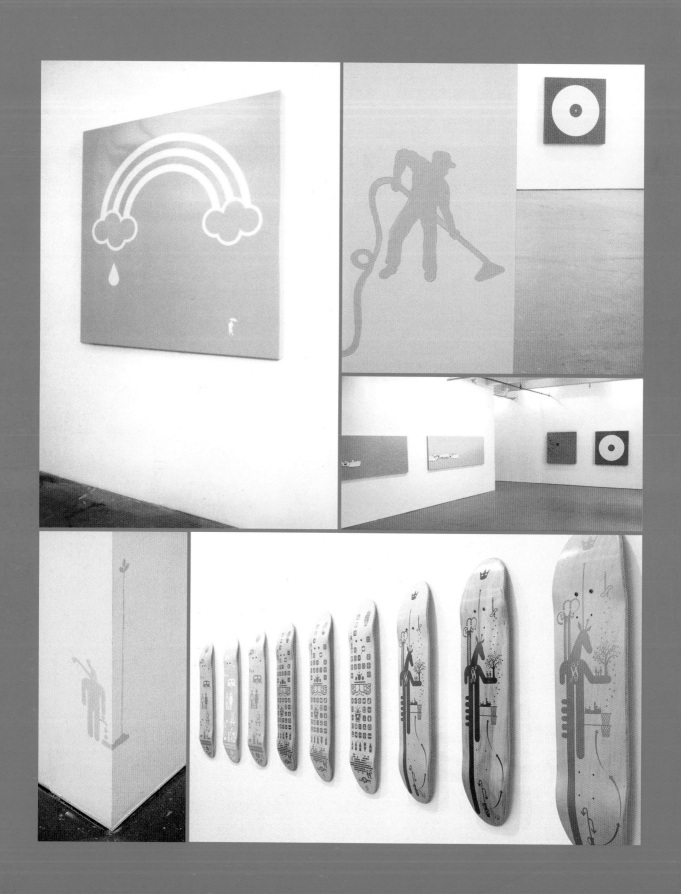

VOCABULARYTEST (DETAILS)
2001, installation views, Joseph Silvestro Gallery, New York

DRAWING PROCESS 2000-2001, ink on paper

POW *&* **THE DIFFERENCE BETWEEN HOPE AND PRAYER**
2001, porcelain-baked enamel on steel panels, 48 x 48 in. ea.,
installation view, Joseph Silvestro Gallery, New York

CLEANLINESS AND GODLINESS & **I AM A LIVING SIGN**
2001, porcelain-baked enamel on steel panels, 48 x 48 in. ea.,
installation view, Joseph Silvestro Gallery, New York

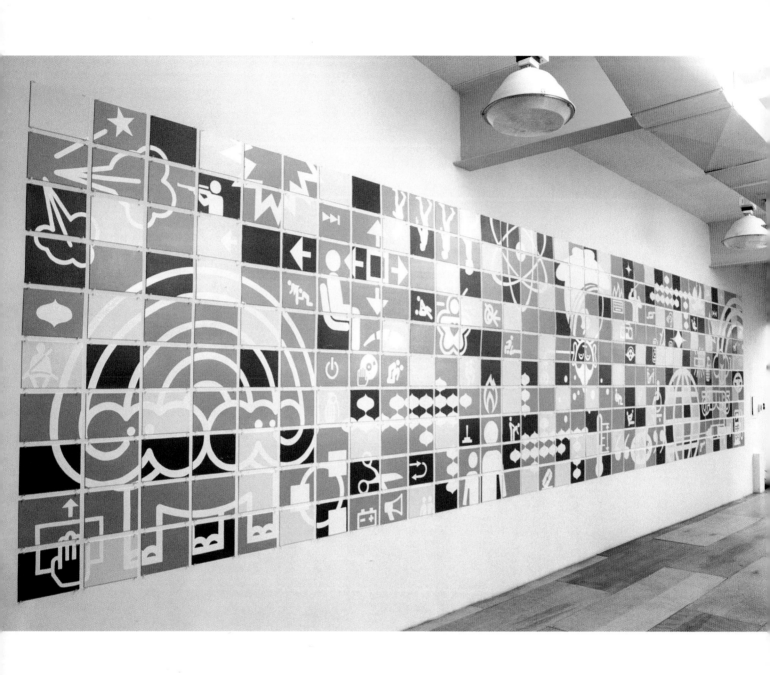

PART OF EVERYTHING
2000, enamel on 360 canvas boards, installation view, 96 x 480 in., Alife, New York

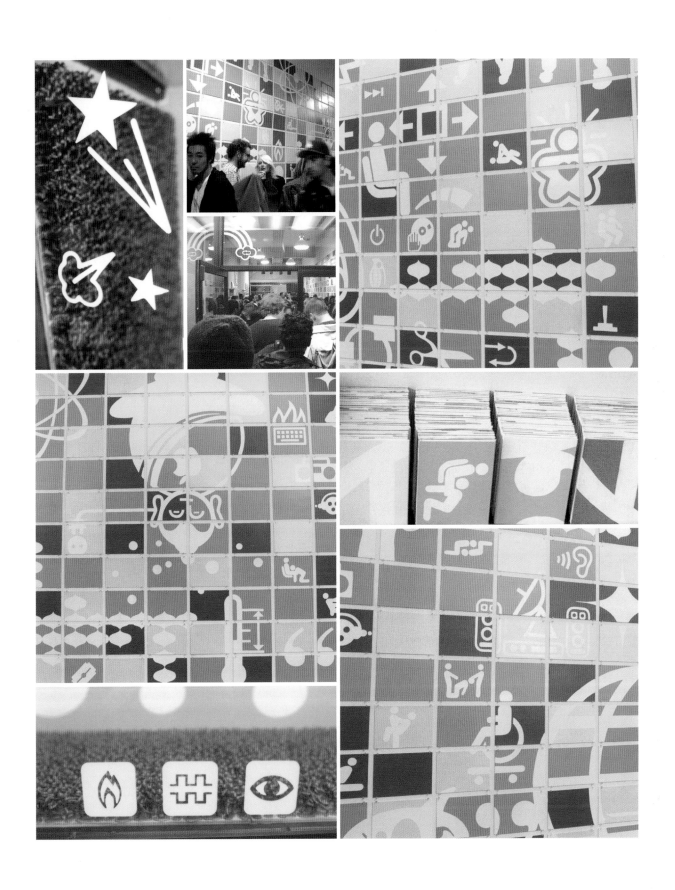

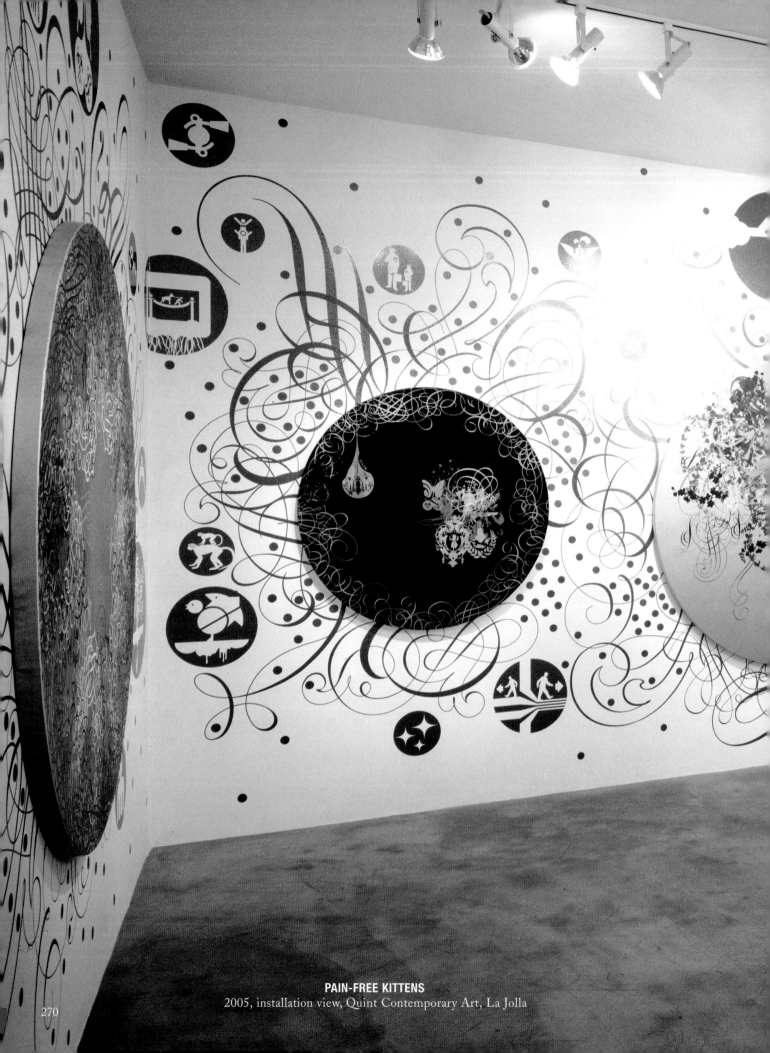

PAIN-FREE KITTENS
2005, installation view, Quint Contemporary Art, La Jolla

270

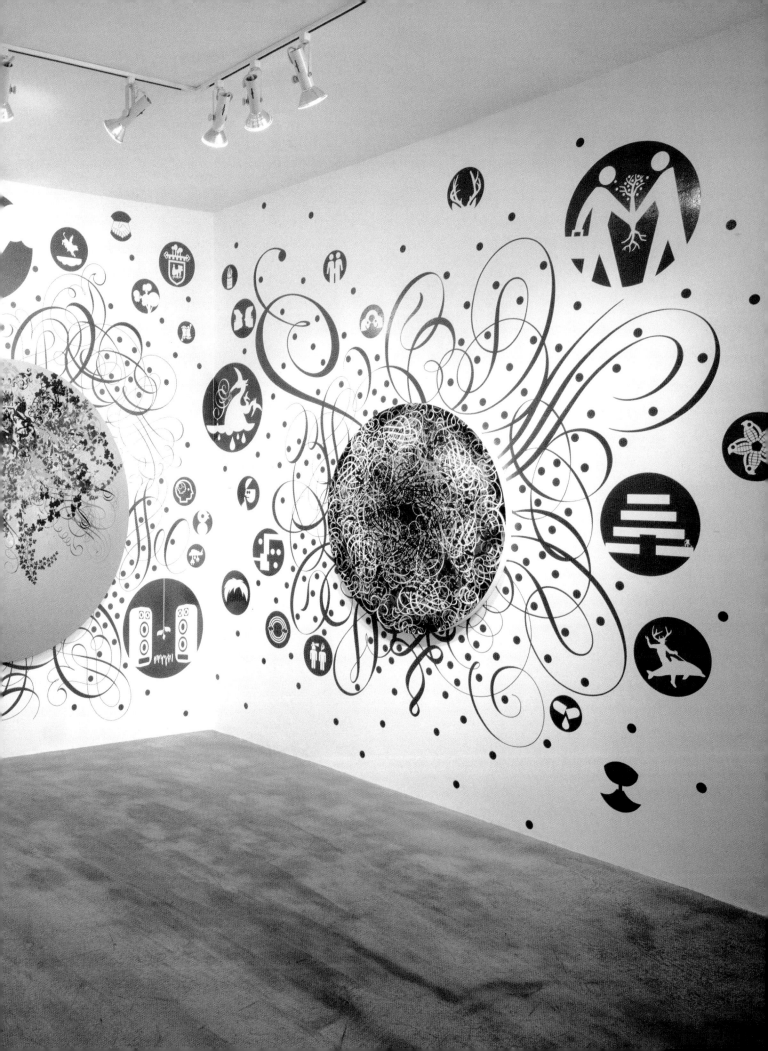

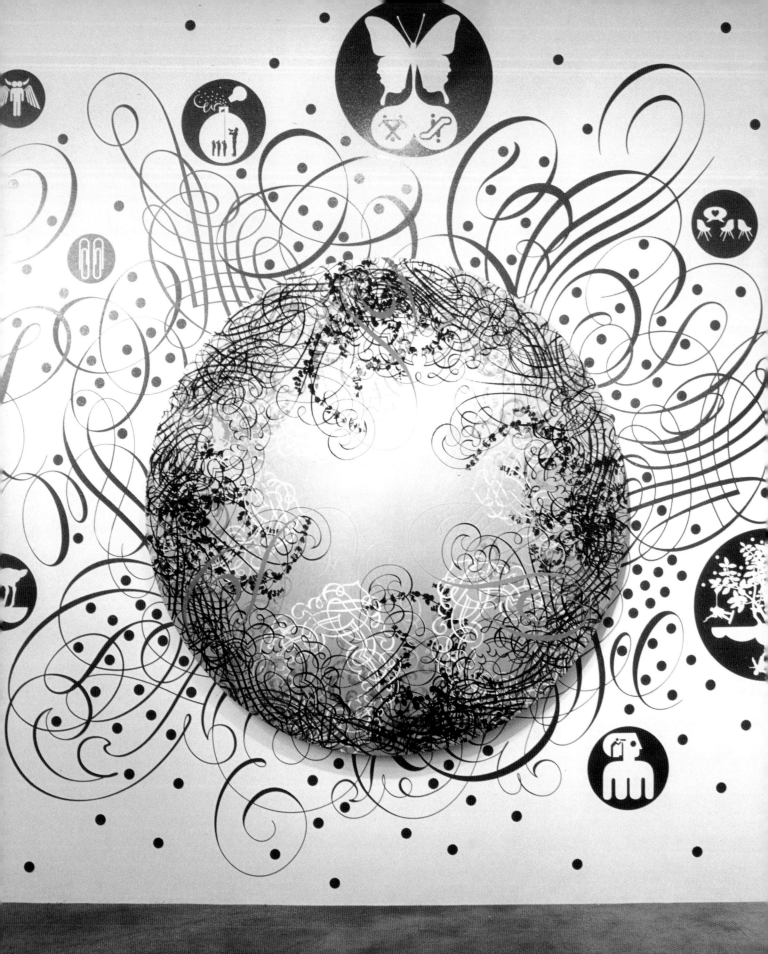

111,111,111 x 111,111,111
2005, acrylic on linen, 72 in. diameter,
installation view, *Pain-Free Kittens* exhibition, Quint Contemporary Art, La Jolla

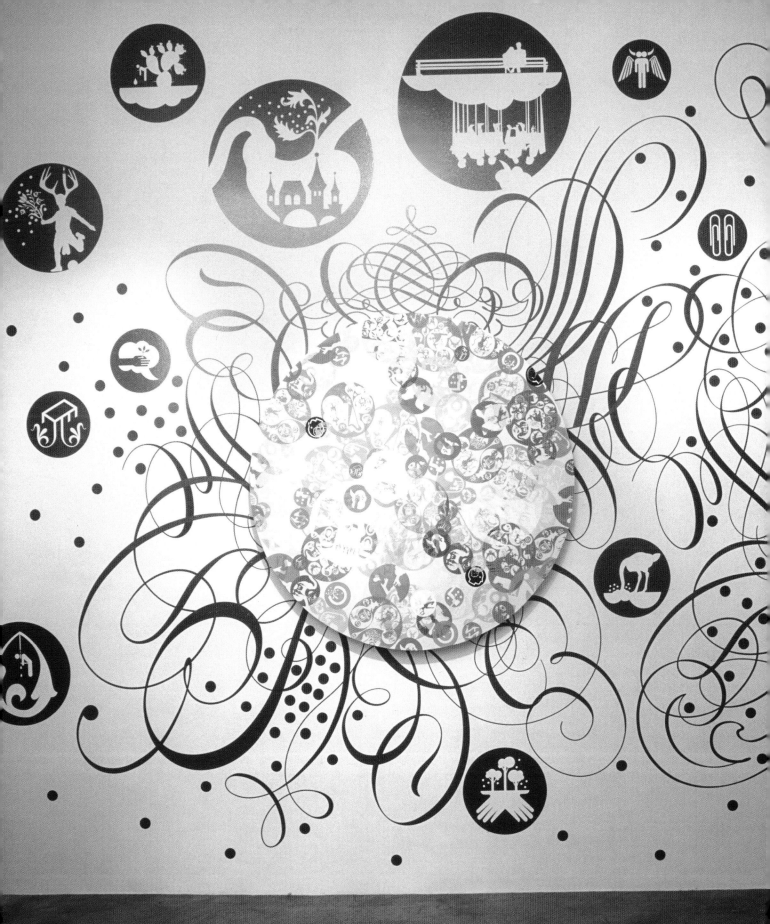

LET'S MUNCH NUTS EXCESSIVELY, OKAY?
2005, acrylic on wood panel, 48 in. diameter,
installation view, *Pain-Free Kittens* exhibition, Quint Contemporary Art, La Jolla

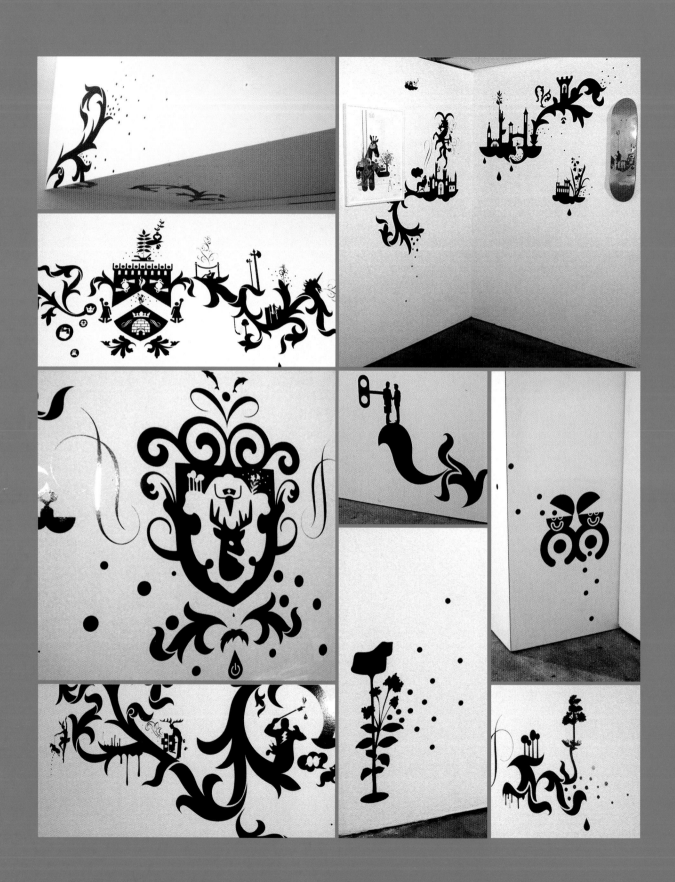

PRODUCTS ARE THE NEW ART
2002, installation views, Printed Matter, New York

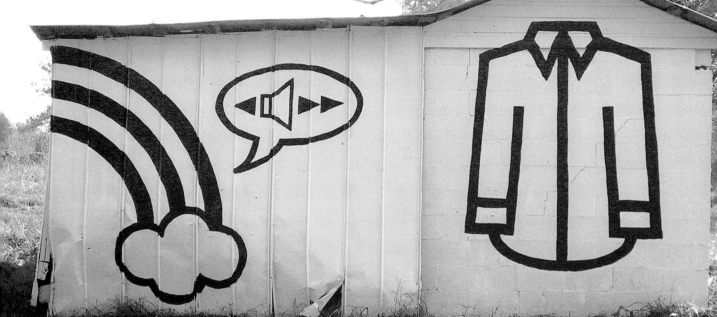

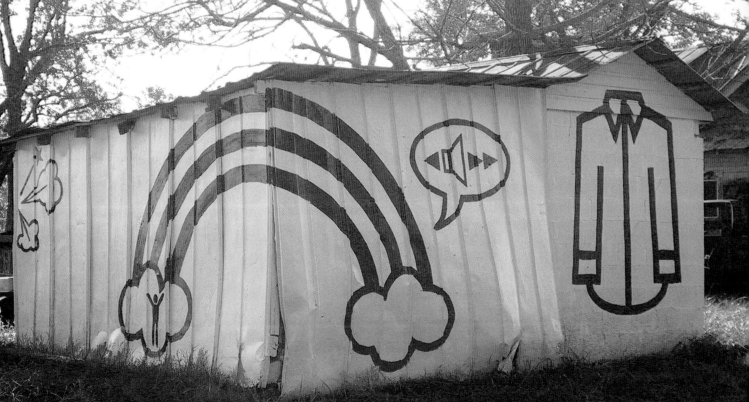

UNTITLED
2000, painted barn, Barnstormers project organized by David Ellis,
Cameron, North Carolina

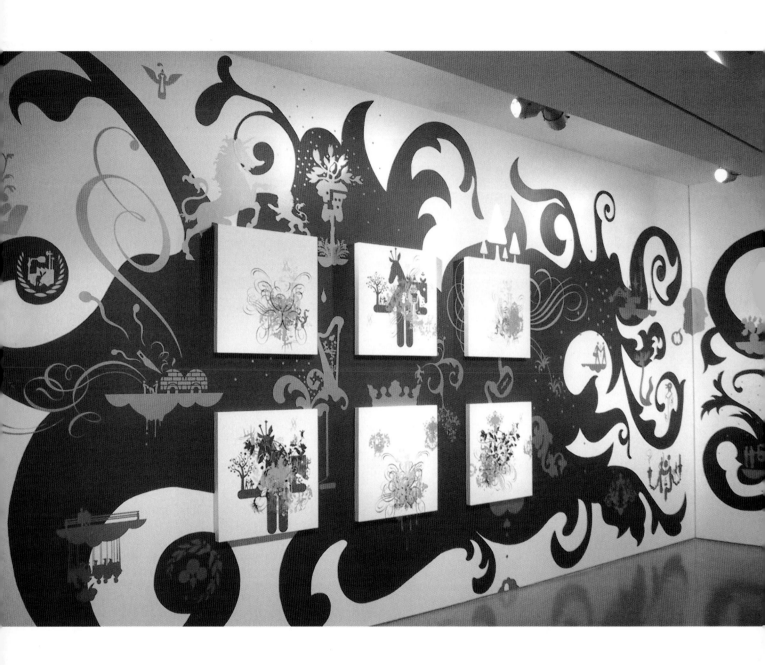

FLOCCI NON FACIO
2004, installation view, *Beautiful Losers* exhibition, Contemporary Arts Center, Cincinnati

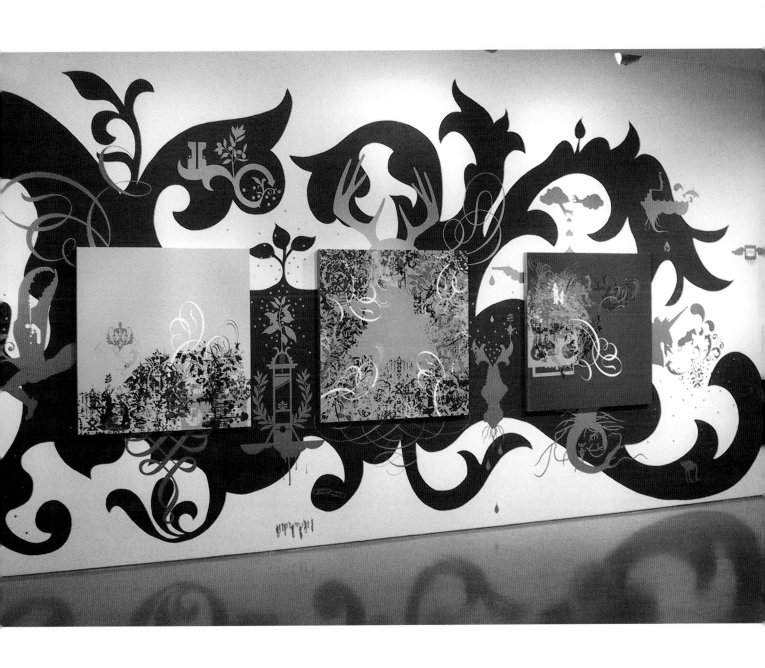

FLOCCI NON FACIO
2004, installation view, *Beautiful Losers* exhibition, Contemporary Arts Center, Cincinnati

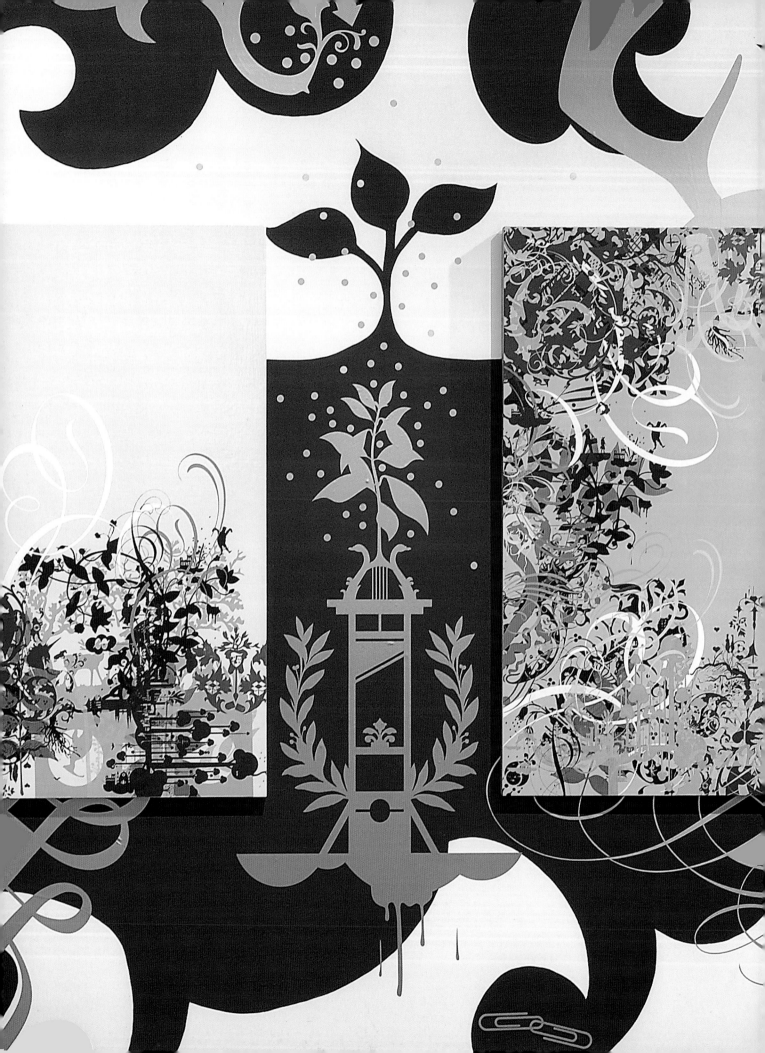

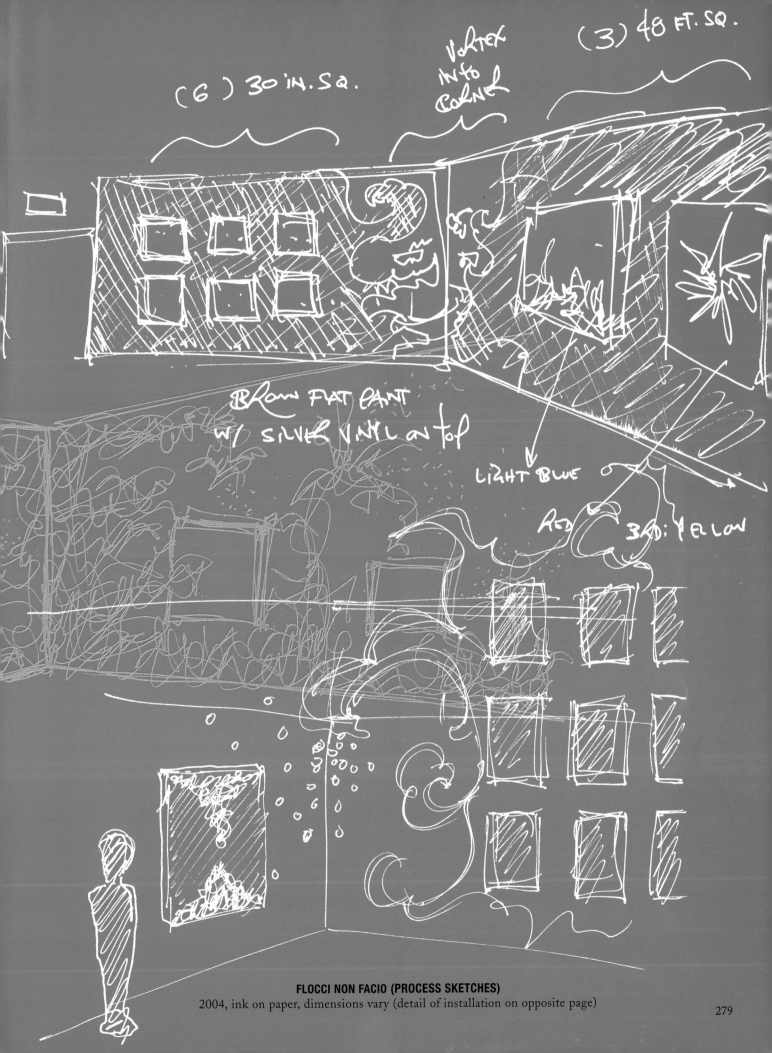

FLOCCI NON FACIO (PROCESS SKETCHES)
2004, ink on paper, dimensions vary (detail of installation on opposite page)

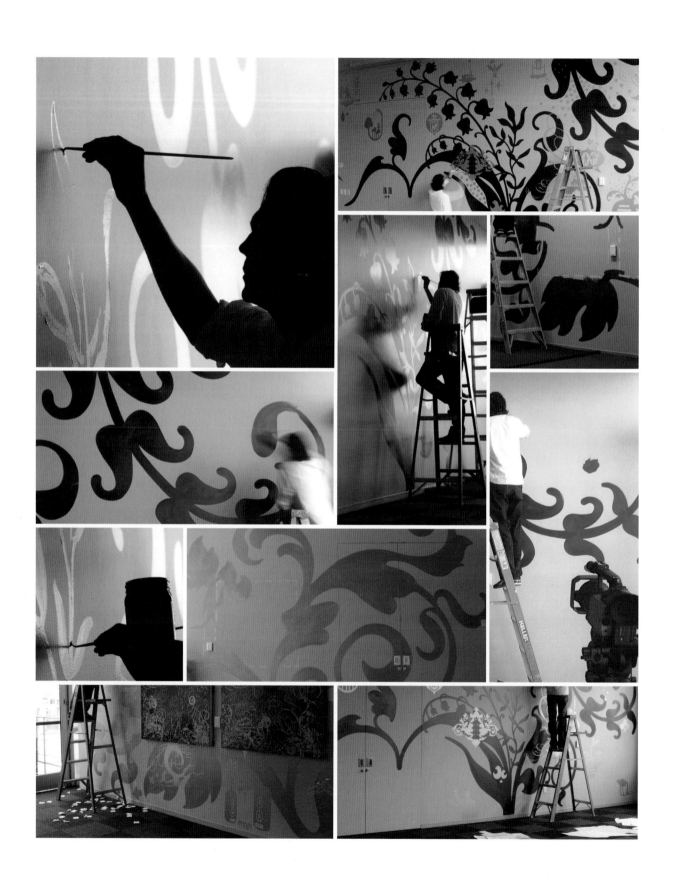

UNTITLED (INSTALLATION PROCESS)
2005, installation views, Orrick, Herrington & Sutcliffe LLP, San Francisco
(detail of installation on opposite page)

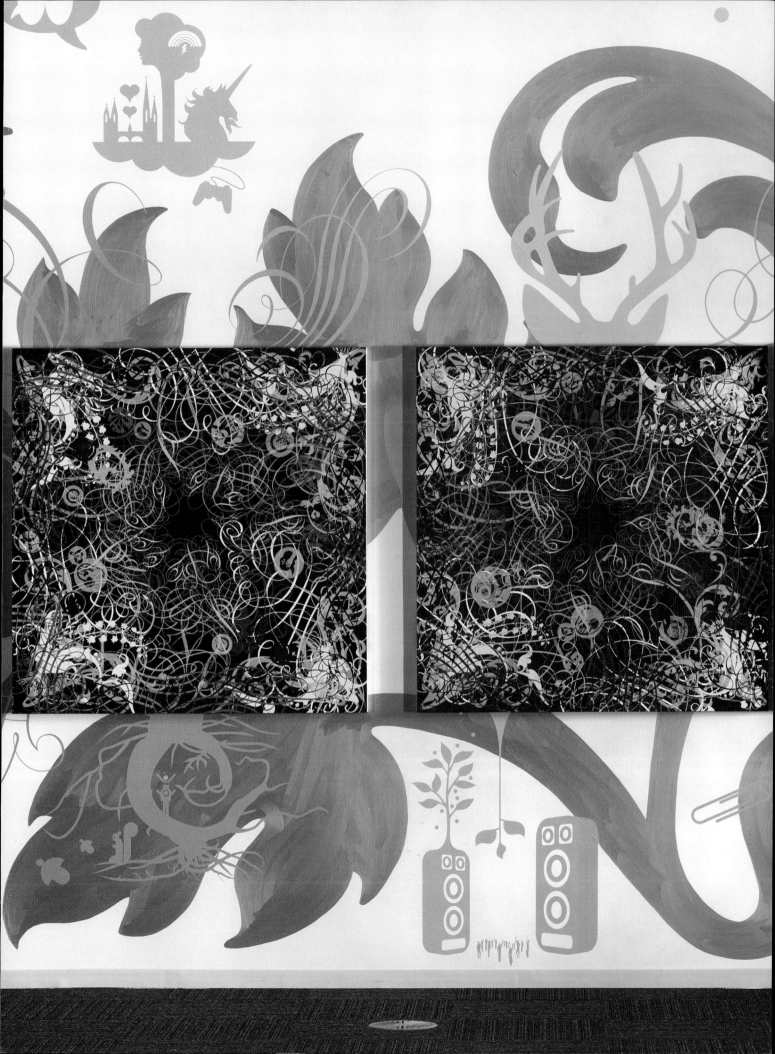

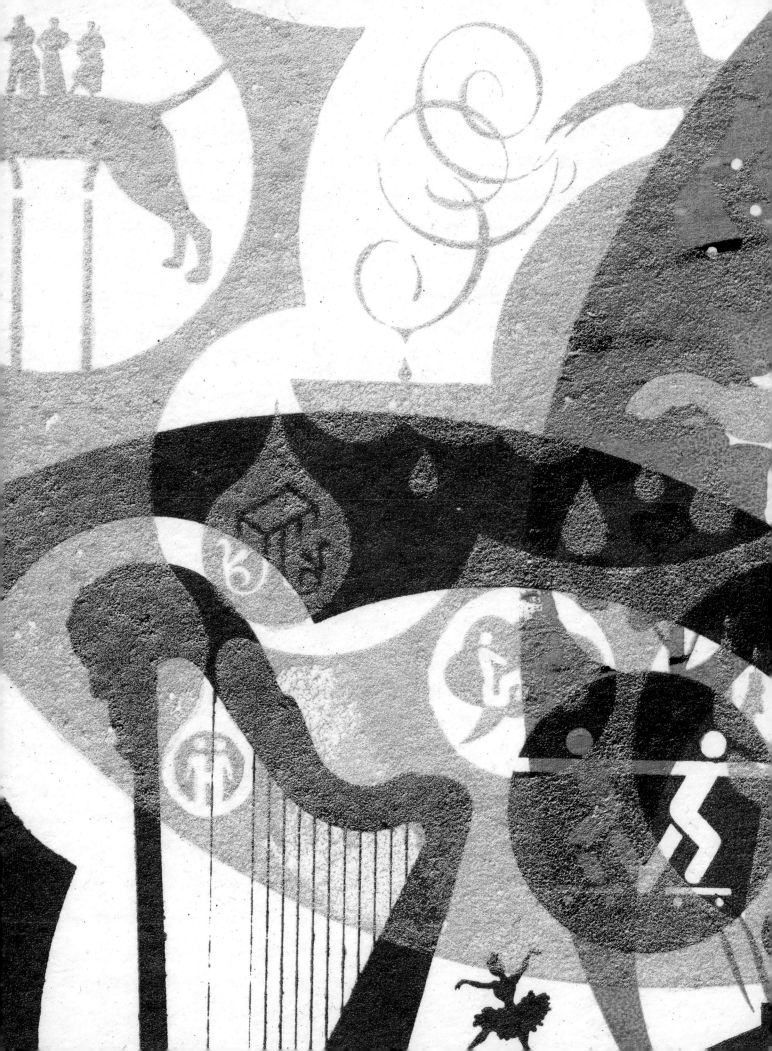

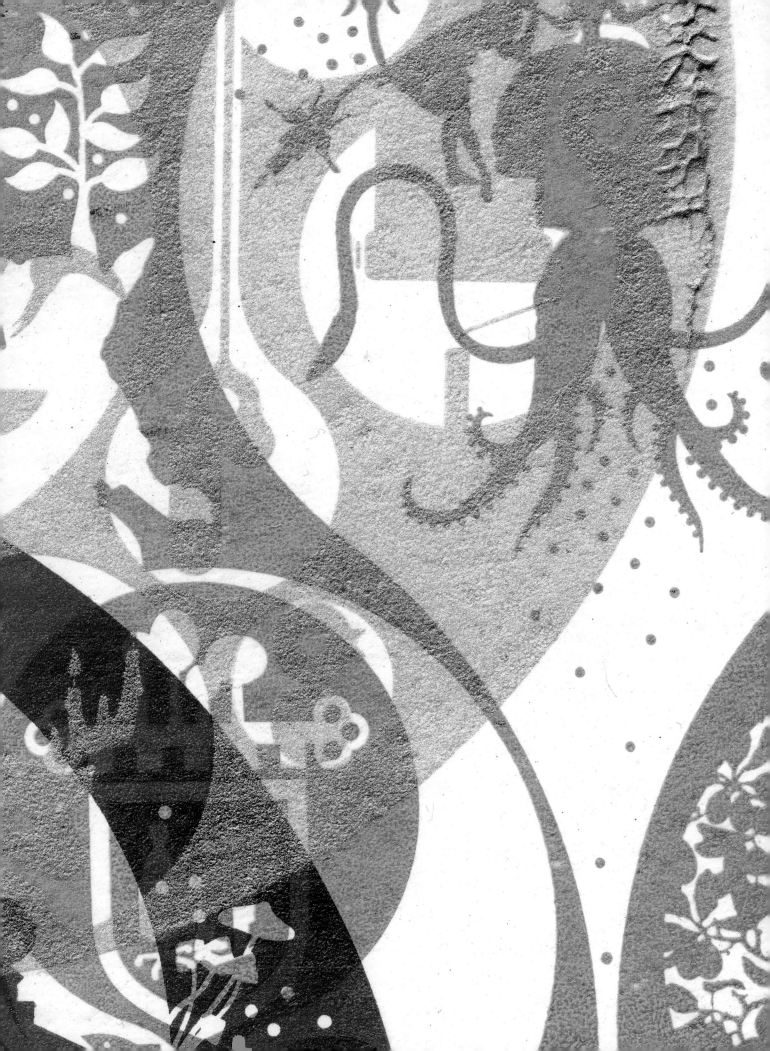

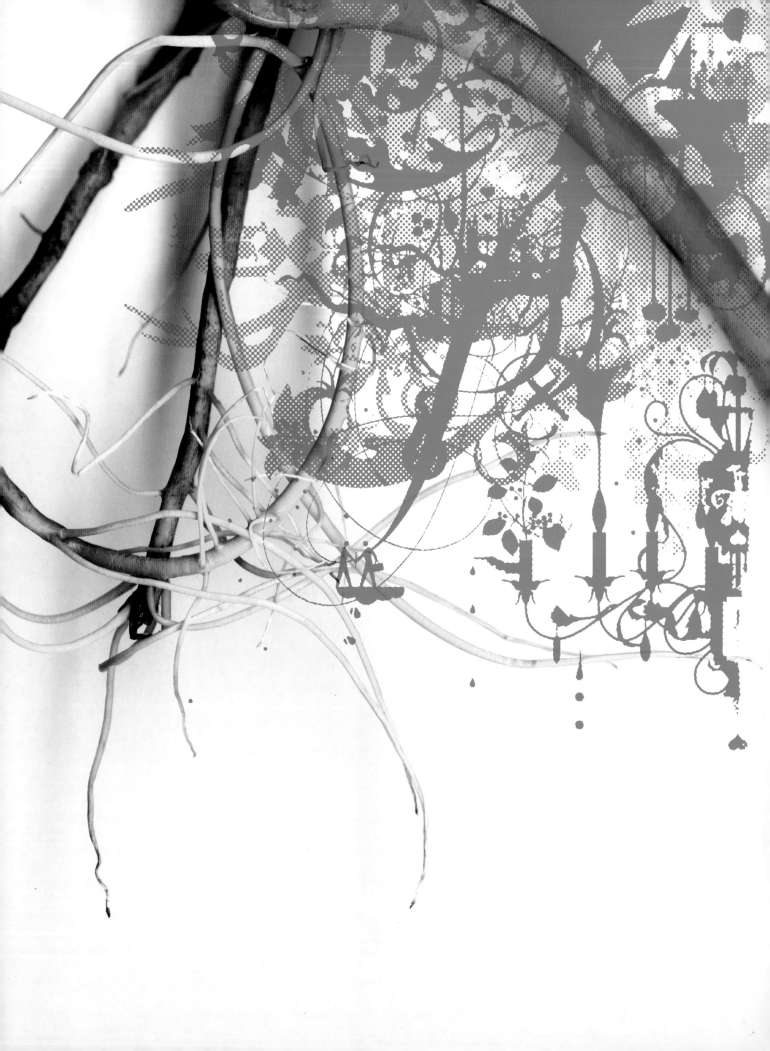

CONTRIBUTORS

AA Bronson is an artist based in Toronto and New York, and Director of Printed Matter.
Jeffrey Deitch is an art advisor, art writer, exhibition organizer, and founder of Deitch Projects.
Randy Gladman is an art writer and curator based in Toronto.
Carlo McCormick is a popular culture critic and curator based in New York.

PHOTOGRAPHY CREDITS

Awad, Michael: pp. 240, 241
Blackwell, Ben (Ben Blackwell Photography): p. 281
Darwish, Tim: pp. 16, 26, 94-99, 212, 213, 260-262, 264, 266-269
Demura, Haruka: p. 78
Dianda, Kirk (DC Shoes): pp. 252, 253, 280
Galeria Moriarty: pp. 188, 191, 247
Galerie du Jour: pp. 88, 115-121
Goodwin, Patricia: p. 200
Guttelewitz, Eric: p. 190
Hong-Porretta, Souris: pp. 68, 70, 200
Kodani, Akane: p. 105
Miller, Dana: pp. 252, 253
Porello, Roy: pp. 270-273
Powel, Tom (Tom Powel Imaging): front cover, pp. 12, 13, 35, 69, 71, 88, 90-93, 102-105, 112, 113, 128-132, 135, 144, 145, 148-151, 153-157, 168-173, 178-181, 186, 187, 189, 192, 194-199, 216-223, 225, 230, 231, 254-259
Rexroad, James: back cover, pp. 11, 105, 122
Samuels, Charlie: p. 250
STScI/NASA: pp. 8, 9, 36, 38, 39, 41
Tardif, Pierre: pp. 81, 200, 252, 253
Thompson, Dana: p. 81
Turner, Nat: p. 19
Waddell, Ann: pp. 244, 245
Walsh, Tony: p. 278
Westphal, Dirk: p. 1
Zangheri, Antonella: pp. 78, 82-87
All remaining photographic material is from the archives of Ryan McGinness Studios, Inc. Every effort has been made to identify the photographers whose work is included in *installationview*. Any omissions herein are unintentional. Please contact the publisher with any updates or corrections.

PHOTOGRAPHY RETOUCHING

Lars Kremer

STATEMENT CREDITS

The statements by the artist which appear throughout *installationview* have been drawn from his sketchbooks and a variety of published sources. In some cases they have been slightly modified. Grateful acknowledgment is made to the following:
Beatty, Dustin, "Ryan McGinness," *Anthem*, USA, No. 8, Spring 2003, pp. 62-69
Gibb, Brian, "Ryan McGinness," *Art Prostitute*, USA, Issue 4, Summer 2004, pp. 69-79
Glickman, Adam. "The Disobedients: Ryan McGinness Interview," *Tokion*, USA, May/June 2002, pp. 32-34
Iwakoshi, Yuka/Noe, Rain. "Ryan McGinness," *Educated Community*, USA, Issue 5, Spring 2001, pp. 10-12
Nakamura, Eric. "Ryan McGinness," *Giant Robot*, USA, Issue 37, 2005, pp. 36-41, 82
Sastre, Leticia, "Ryan McGinness," *Vanidad*, Spain, No. 107, July/August 2004, p. 45
Stochl, Gerhard, "A Conversation with Ryan McGinness," *Lodown*, Germany, No. 37, Fall 2003, pp. 62-68
Von Poggensee, Amanda. "Reconstructing Reality," *Zink*, USA, October 2004, pp. 216-217

"We all share the same backyard."
In Loving Memory of Evelyn McGinness, 1948-2004

THE SYMBOLS DO NOT REPRESENT ANYTHING
OTHER THAN THEMSELVES.